Shakespeare and the Modern Dramatist

Michael Scott
Professor of English
Sunderland Polytechnic

MACMILLAN

ALBRIGHT COLLEGE LIBRARY

© Michael Scott 1989

All rights reserved. No reproduction, copy or transmission
of this publication may be made without written permission.

No paragraph of this publication may be reproduced, copied
or transmitted save with written permission or in accordance
with the provisions of the Copyright Act 1956 (as amended),
or under the terms of any licence permitting limited copying
issued by the Copyright Licensing Agency, 33–4 Alfred Place,
London WC1E 7DP.

Any person who does any unauthorised act in relation to
this publication may be liable to criminal prosecution and
civil claims for damages.

First published 1989

Published by
THE MACMILLAN PRESS LTD
Houndmills, Basingstoke, Hampshire RG21 2XS
and London
Companies and representatives
throughout the world

Typeset by Wessex Typesetters
(Division of The Eastern Press Ltd)
Frome, Somerset

Printed in Hong Kong

British Library Cataloguing in Publication Data
Scott, Michael, *1949*–
Shakespeare and the modern dramatist—
(Contemporary interpretations of Shakespeare).
1. Shakespeare, William—Influence
2. Drama—20th century—History and criticism
I. Title II. Series
809.2′04 PN1861
ISBN 0–333–36021–4

822.33
5 428s

222732

To Eirlys

Contents

Acknowledgements

I am most grateful to the Leverhulme Trust for a grant towards the research for this book. My thanks go also to Arnold Hinchliffe and to Jeremy Hawthorn for reading through the typescript and for making useful suggestions which have been incorporated into the text. I was grateful for the opportunity to try out work in progress by presenting papers over the last year or so at the National Theatre, Durham University and Loughborough University of Technology and appreciated comments and suggestions made. I would like to thank also my undergraduate and postgraduate students at Sunderland Polytechnic, especially Dermot Cavanagh, for their interest in the work. Thanks too to the Sunderland Polytechnic library staff and also the staff at the University Library, Newcastle-upon-Tyne, the Shakespeare Centre Library, Stratford-upon-Avon and the British Library, London, for their assistance. My greatest debt of gratitude is to my wife, Eirlys, who has helped with the work throughout and to our daughters Jane and Jennifer who have kept us laughing.

The author and publishers wish to thank the following who have kindly given permission for the use of the copyright material: Faber & Faber and Grove Press Inc., for the extracts from Tom Stoppard's *Rosencrantz and Guildenstern are Dead*, Copyright © 1967 by Tom Stoppard; and Methuen and Grove Press Inc., for the extracts from Harold Pinter's *The Homecoming*, Copyrights © 1965 and 1966 by Harold Pinter.

NOTE ON THE SHAKESPEAREAN TEXT

Unless otherwise stated all quotations from Shakespeare are to the Alexander Text first published in 1951.

1

Introduction:
Re-Interpreting
Shakespeare

Shakespeare could be considered a thief. I am not referring to his
poaching exploits on the Charlecote estate but to his plays.
Shakespeare 'stole' his stories from historical chronicles, prose and
poetic romances, classical, medieval and Tudor drama. He recreated
stories for public and private stages during a particular historical
period. Professional theatre was his career and he was successful
in it. He was intrinsically involved on its business as well as its
artistic side, having a financial investment in his company and
its theatre. He remains big business today, recreationally and
educationally. His texts are set for intermediate, advanced and
degree level examinations. In Stratford, England and 'Stratfords'
elsewhere, he has theatres and companies in his name, dedicated
to performing his work. Over recent years the BBC has presented
all thirty-seven known plays written by him and exported them
throughout the five continents. He is ranked with the very few –
Beethoven, Mozart, Leonardo da Vinci, Michelangelo, Picasso,
Tolstoy – as one of the greatest artists of Western civilisation; a
man who Ben Jonson proclaimed was for all time. Yet as a dramatist
his 'universality' is peculiar in that his artifacts are not 'fixed'.
Stanley Wells writes:

> If Shakespeare is, in Ben Jonson's phrase, 'for all time', this is
> partly because he demands the collaboration of those who
> submit themselves to him, – demands not merely intelligence of
> response, such as is demanded by, for instance, *Paradise Lost* or
> *Middlemarch*, but demands a more creative response, and
> demands it from the reader as well as the performer . . . this is
> to some extent a feature of the medium in which he was working.
> Compare, for example, a play with a film. A film is fixed,
> determined. Like a play, it is a collaborative product; but the

1

collaboration is simultaneous, and once it has occurred it is over. A film, like a naturalistic painting, is closed, final, of its age, a period piece. But plays go on growing and developing. They are capable of having a life of their own.[1]

Although the text of a play must be located within the particular historical period in which it was first composed, it is not fixed to that period in terms of its life in performance. Dramatic texts are imperfect artifacts in that their creators, the dramatists, do not have complete authority over what is performed. Implicit within the composition by a playwright of a dramatic text there is an instability which the nineteenth-century Swiss innovator of theatrical lighting Adolphe Appia claimed results in a weakening of drama as an artistic form of expression:

> In every work of art there must be a harmonious relationship between feeling and form, a perfect balance between the idea which the artist wishes to express and the means he uses to express it. If one of the means seems to us clearly unnecessary to the expression of the idea, or if the artist's idea – the object of his expression – is only imperfectly communicated to us by the means he employs, our aesthetic pleasure is weakened, if not destroyed.[2]

Certainly the experience of twentieth-century dramatists has shown them not to have control over the final product of their drama. Chekhov almost despaired at Stanislavski's interpretation of his plays which turned his comedy of *The Cherry Orchard* into a naturalistic tragedy. Ionesco records his surprise on seeing the first performance of his play, *The Bald Prima Donna*, dealing with the tragic absurdity of the human condition, being received with joyful hilarity by the audience. Bernard Shaw wrote meticulous stage directions and prefaces to instruct his directors and actors as to exactly how he wanted his plays performed. Practice demonstrates, however, that such instructions can be considered, followed or left at the directors' and actors' discretions. Edward Bond attempts to be involved with major productions of most of his plays but still complained, for example, of the RSC's use of music within Barry Kyle's production of *Lear* in 1983.[3] Like all artists the dramatist has no control over the reception of his work but neither has he over the collaborative creative interpretation demanded by his art form.

Even in the dramatist's own day he/she is faced with the problem of creative collaboration. Shakespeare's famous admonishment of his clowns in *Hamlet* (3.2.36f.) has no doubt found sympathy with many playwrights. With 400-year-old drama there is the added problem of what Shakespeare actually wrote. The plays were pirated, changed, developed. Improvisations were not recorded. Rival companies cheated. The first publication of *Hamlet*, the Bad Quarto (1603), was pirated and as such is fragmentary, as the soliloquies as well as other factors indicate. Compare, for example, the following extracts from the first quarto with the speeches as they are generally recorded in any modern edition where the editors rely more heavily on the second publication, the Good Quarto (1604), and the first collected edition, the First Folio (1623). I will give an extract first from probably the most famous speech in the play as found in the New Penguin edition (1980) which is widely employed theatrically and educationally, and follow this by an extract from the Bad Quarto. As will be seen the Bad Quarto's lines for the soliloquy are something of a hotchpotch:

> To be, or not to be – that is the question;
> Whether 'tis nobler in the mind to suffer
> The slings and arrows of outrageous fortune
> Or to take arms against a sea of troubles,
> And by opposing end them. To die, to sleep –
> No more – and by a sleep to say we end
> The heartache and the thousand natural shocks
> That flesh is heir to. 'Tis a consummation
> Devoutly to be wished. To die, to sleep –
> To sleep – perchance to dream. Ay, there's the rub . . .

> New Penguin edition 3.1.56–65

> To be, or not to be, I there's the point
> To Die, to sleepe, is that all? I all:
> No, to sleepe, to dreame, I mary there it goes,
> For in that dreame of death, when wee awake,
> And borne before an euerlasting Iudge,
> From whence no passenger euer retur'nd,
> The vndiscouered country, at whose sight
> The happy smile, and the accursed damn'd . . .

> Bad Quarto[4]

Similarly the earlier soliloquy 'O, what a rogue and peasant slave am I' as printed in the Bad Quarto (where in fact it is a later soliloquy!) might prove surprising. Again I will begin with the opening lines in the New Penguin edition:

> Now I am alone.
> O, what a rogue and peasant slave am I!
> Is it not monstrous that this player here,
> But in a fiction, in a dream of passion,
> Could force his soul so to his own conceit
> That from her working all his visage wanned,
> Tears in his eyes, distraction in his aspect,
> A broken voice, and his whole function suiting
> With forms to his conceit? And all for nothing.
> For Hecuba!
> What's Hecuba to him, or he to her,
> That he should weep for her? . . .

> New Penguin edition 2.2.546–57

> Why what a dunghill idiote slauve am I?
> Why these Players here draw water from eyes:/
> For Hecuba, why what is Hecuba to him, or he to Hecuba?
> What would he do and if he had my losse?
> His father murdred, and a Crowne bereft him,
> He would turne all his teares to droppes of blood,
> Amaze the standers by his laments,
> Strike more then wonder in the iudiciall eares,
> Confound the ignorant, and make mute the wise,
> Indeede his passion would be general . . .

> Bad Quarto[5]

Textual scholars attempt in their editions and writings to approximate the original design and content of the Shakespearean play which is not necessarily its first edition or indeed any single edition. When we talk therefore of the 'authentic Shakespearean text', we are employing a misnomer. What is usually being referred to is the text as edited and reconstituted from the various Elizabethan and Jacobean Quartos and the Folio that have survived.

The textual history of the plays is different from the performance history. From their first appearance Shakespeare's plays have been

subject to adaptation and recreative interpretation. The most famous seventeenth-century re-write is probably Nahum Tate's *King Lear* (1681) with its happy ending. But Tate's version of *King Lear* is less revolutionary than many other versions of Shakespearean plays throughout the centuries.[6] Titles were changed, characters edited out or their lines increased. *The Merchant of Venice* for example in 1701 became under George Granville (Lord Lansdowne) *The Jew of Venice*, being 'improved' with lines such as the following for Shylock:

> 'I have a Mistress, that outshines 'em all –
> 'Commanding yours – and yours, tho' the whole Sex.
> 'O may her Charms encrease and multiply:
> 'My Money is my Mistress! Here's to
> 'Interest upon Interest.

> *Drinks*[7]

During the nineteenth century, in particular, there was a vogue for Travesties and Burlesques comically feeding off Shakespearean plays and enjoying titles such as *The Rise and Fall of Richard III; or A New Front to an Old Dicky* (1868) or *A Thin Slice of Ham let!* (1863) in which Hamlet soliloquises:

> Dad's widow and his brother joined in one,
> Makes me her nephew and my uncle's son!
> A nice mixed pickle I am in; no doubt,
> 'Twould puzzle Lord Dundreary to find out
> My kindred to my dear aunt-mother here,
> But that I am my own first cousin's clear.[8]

One such burlesque by W. S. Gilbert, *Rosencrantz and Guildenstern* (1874) has an affinity this century with Tom Stoppard's *Rosencrantz and Guildenstern are Dead*.[9] Some of the finest 'adaptations' of Shakespeare, however, were to take place towards the end of the nineteenth century in terms of Verdi's translations of Shakespearean plays into opera. His *Macbeth* (1847, rev. edn 1865), *Otello* (1887) and *Falstaff* (1893) are within an artistic tradition of creating opera from Shakespearean texts as with for example Rossini's *Otello* (1816) and Bellini's *I Capuleti e i Montecchi* (1830) or in the present century Benjamin Britten's *A Midsummer Night's Dream* (1960). In

ballet Prokofiev's masterpiece, *Romeo and Juliet* (1938) must rank as one of the finest interpretations made of a Shakespearean play, although one dependent in its theatrical interpretation on its various choreographers over the years: Lavrosky, Ashton, MacMillan, Nureyev. Main-line Shakespearean production in the nineteenth century allowed for interpolations and was often followed by dramatic squibs, dances or other entertainments. Henry Irving allowed for elaboration and spectacle in his Shakespearean productions, and was not averse to interpolating an episode in order to enhance his interpretations of the play. As Shylock, for example, he made what has become a famous addition to the action, showing the Jew returning to his home unaware of Jessica's recent elopement:

> The scene showed the Jew's house, "with a bridge over the canal which flows by it, and with a votive lamp to the Virgin on the wall. There a barcarolle is sung by some Venetians on a gondola, and a number of masqueraders rush merrily past." As the sound of their laughter and music died away, the curtain descended. . . . After a few moments, the curtain was raised once more, showing the same scene, but now silent and deserted. Shylock appeared, "lantern in hand, advancing, bent in thought," and as he drew close to the house – still unaware that it is now empty – the curtain fell. In later performances, he sometimes knocked at the door.[10]

Towards the end of the nineteenth century the Meiningen Company under the Duke of Saxe-Meiningen and his director Chronegk began a European movement to invest Shakespearean production with an historical authenticity, although one that related *Julius Casear* for example to a nineteenth-century rather than an Elizabethan historical view of Rome. The Meiningen experiments were overtaken by the naturalist movements in acting perpetrated by Antoine and Stanislavsky, a form of acting prevalent to the present day. In the early part of this century attempts were made by William Poel and Harley Granville-Barker to return to the 'authentic' Elizabethan texts and performances and since then similar experiments have continued periodically in a variety of theatres. Plans are presently afoot to recreate the second Globe Theatre on London's South Bank. What is interesting for our discussion is the realisation that a Shakespearean play is not a stable entity.

Surrounding what we popularly consider to be Shakespeare's *Hamlet* or *The Merchant of Venice* is both a textual and an intertextual history. The former refers to literary attempts to discover the text, the latter to the traditions that have grown around it through its performance over the centuries. Actors continue, develop or react against certain traditions. As will be noted later,[11] Henry Irving's portrayal of Shylock was one staging post in the creation of a theatrical character going back to the eighteenth-century actor Charles Macklin, who himself was reacting against another tradition, and looking forward to Laurence Olivier or Emrys James. When in 1984/85 Antony Sher shocked audiences by his portrayal of Richard III as a spider-like creature on crutches, he was necessarily reacting against a modern audience's intertextual acquaintance with the character as portrayed by Laurence Olivier in his 1955 film. Olivier's portrayal, however, was itself a development of an existing tradition of acting the role going back through the centuries. Even though Sher affronted audience expectation by playing against the Olivier tradition he still fed off the intertextual life of the play. Keir Elam drawing on work by Julia Kristeva, has instructively written about the intertextual nature of a play:

> Appropriate decodification of a given text derives above all from the spectator's familiarity with *other* texts . . . the genesis of the performance itself is necessarily intertextual: it cannot but bear the traces of other performances at every level, whether that of the written text (bearing generic, structural and linguistic relations with other plays), the scenery (which will 'quote' its pictorial or proxemic influences), the actor (whose performance refers back, for the cognoscenti, to other displays), directorial style, and so on. 'The text', remarks Julia Kristeva, 'is a permutation of texts, an intertextuality. In the space of a single text several *énoncés* from other texts cross and neutralize each other'.[12]

One of the dangers with such intertextual neutralisation is that Shakespeare ceases to challenge or confront audiences but rather declines into mundanely fulfilling or extending certain expectations. This in turn can lead to a deadly theatre; a processed culture which has no significant communicative value. Perhaps it was with such a tamed Shakespeare in mind that the French dramatic theorist, Antonin Artaud (1896–1948) proclaimed 'Elizabethan theatre works stripped of the lines; retaining only their period

machinery, situations, characters and plot'. Artaud was concerned about the inertia that he saw as being prevalent in the common presentation of classic drama. In his seminal work *The Theatre and Its Double* he advocates the need to regain theatre's mythic strength which he believes is required for the sake of mankind:

> Either we will be able to revert through theatre by present-day means to the higher idea of poetry underlying the Myths told by the great tragedians of ancient times, with theatre able once more to sustain a religious concept, that is to say without any mediation or useless contemplation, without diffuse dreams, to become conscious and also be in command of certain predominant powers, certain ideas governing everything . . . or else we might as well abdicate now without protest, and acknowledge we are fit only for chaos, famine, bloodshed, war and epidemics.[13]

In this respect Artaud, whilst admitting that 'the Theatre I wanted to create presupposed a different form of civilisation',[14] advocates a theatre where the dreams, desires and fears of the audience are distilled by the dramatic performance. The theatre for Artaud has to be appropriate to present reality not to the past. The notion of classic drama is a dangerous anachronism and one which must be reacted against:

> Past masterpieces are fit for the past, they are no good to us. We have the right to say what has been said and even what has not been said in a way that belongs to us, responding in a direct and straightforward manner to present-day feelings everybody can understand. . . . In the long run, Shakespeare and his followers have instilled a concept of art for art's sake in us, art on the one hand and life on the other, and we might rely on this lazy, ineffective idea as long as life outside held good, but there are too many signs that everything which used to sustain our lives no longer does so and we are all mad, desperate and sick. And I urge *us* to react.[15]

The extent of Artaud's influence on the development of contemporary theatre and particularly on the adaptation of Shakespearean drama is hard to judge. Some dramatists such as Edward Bond,

have gone to some pains to deny an affinity between Artaudian theory and their work. Charles Marowitz on the other hand has explicitly promoted Artaudian ideas both in his productions and in his writing although he is clearly not solely dependent on the French dramatic theorist. Connections could also be detected between some of the apocalyptic Artaudian theory and absurdist drama particularly that of Ionesco. It is no coincidence that the first English translation of Ionesco's *Macbett* was made for the stage, in the USA by Marowitz. In the 1960s Peter Brook with the Royal Shakespeare Company staged a number of Artaudian experiments with his famous *Theatre of Cruelty* season and to a lesser extent with his 1962 *King Lear*. In each case Marowitz was involved.

Although Artaud recognised that the theatrical revolution which he advocated was necessarily dependent upon a change in social order his work lacks the political motivation found in the theory and much of the drama of Bertolt Brecht (1898–1956). Yet there is an affinity in their belief that Shakespearean drama has ceased to retain its Elizabethan force. In his sonnet *On Shakespeare's Play Hamlet* Brecht debunks the Prince of Denmark and bourgeois attitudes towards him and his play:

> Here is the body, puffy and inert
> Where we can trace the virus of the mind.
> How lost he seems among his steel-clad kind
> This introspective sponger in a shirt!
>
> Till they bring drums to wake him up again
> As Fortinbras and all the fools he's found
> March off to win that little patch of ground
> 'Which is not tomb enough . . . to hide the slain.'
>
> At that his solid flesh starts to see red
> He feels he's hesitated long enough
> It's time to turn to (bloody) deeds instead.
>
> So we can nod when the last Act is done
> And they pronounce that he was of the stuff
> To prove most royally, had he been put on.[16]

Clearly it was the nodding Shakespeare audience Brecht wanted

to challenge with his adaptations of a number of plays, including his renowned *Coriolanus* (which wasn't actually realised in production until after his death).[17] Brecht wished to break down audience expectations of classic drama in order to rescue them from decadent empathetic responses. For him the malaise was one detectable throughout theatre:

> . . . our enjoyment of the theatre must have become weaker than that of the ancients, even if our way of living together is still sufficiently like theirs for it to be felt at all. We grasp the old works by a comparatively new method – empathy – on which they rely little. Thus the greater part of our enjoyment is drawn from other sources than those which our predecessors were able to exploit so fully. . . . Our theatres no longer have either the capacity or the wish to tell these stories, even the relatively recent ones of the great Shakespeare, at all clearly. . . . We are more and more disturbed to see how crudely and carelessly men's life together is represented, and that not only in old works but also in contemporary ones constructed according to the old recipes. Our whole way of appreciation is starting to get out of date.[18]

It is this reaction too which many of the dramatists of the plays considered in this book are attempting to correct in one way or another. The selection chosen for discussion demonstrates how a variety of dramatists – all of whom are still writing – have fed off, re-written or brought into question both the textuality and intertextuality of the Shakespearean canon.[19] On the one hand, for example, Edward Bond reacts against the notion of a universal Shakespeare, a man for all time. He creates in *Lear* a socialist drama, specifically re-aligning the *King Lear* myth for the late twentieth century. On the other hand Tom Stoppard is happy to proclaim the Elizabethan's universality stating in a 1980 lecture *Is It True What They Say About Shakespeare?* that Shakespeare 'calls spirits up from the vasty deep, spirits which manifest themselves into a paradigm of human emotion, action and expression, and when he calls them up they come'.[20] His *Rosencrantz and Guildenstern are Dead* rather than re-aligning the *Hamlet* myth, forms instead a commentary in comedy on the play, thereby providing a further interpretative perspective which may well send the audience back to Shakespeare refreshed and ready to see his work anew.[21]

Stoppard in other words despite the zaniness of his drama works within the boundaries of bourgeois theatre whilst Bond attacks them, trying to free his theatre from them. Not all the plays discussed, however, were written with a Shakespearean model in mind. Beckett's *Waiting for Godot* and *Endgame* for example and to a lesser extent Pinter's *The Homecoming* have provoked a critical and sometimes theatrical response whereby they have naturally been compared to Shakespearean models. The discussion considers how or why these plays have provoked such reactions. Marowitz and Wesker are considered together in their reaction to *The Merchant of Venice* which they both find to be an offensive play for modern society. Their reaction, however, raises issues of the intertextual life of the play which has conditioned their response. Marowitz's name constantly crops up in a variety of contexts. In many ways he has been to the forefront in experiments concerning the adaptation of Shakespearean drama. Chapter 8 considers three of his collages.

Many of these 'feed offs' or what Ruby Cohn terms 'off shoots' of Shakespeare can prove difficult at first acquaintance. The aim of this book is to introduce some of them to those interested in Shakespearean or modern drama or both. To do this most of the chapters provide an analysis of the stated plays attempting to show how they operate, the reasons behind their composition and to some extent what they signify. The Postscript extends this investigation to a brief consideration of production trends in Shakespeare particularly by the Royal Shakespeare Company in the 1970s and early 1980s.

Theatre is not the examination of static scripts. It is the creation and re-creation of dramatic scores on a living stage. The play texts introduced here are designed for performance. Some, such as the Stoppard and the Bond, have enjoyed significant productions in major theatres or by major companies, others such as Wesker's *The Merchant* or Ionesco's *Macbett* await the courage to be shown in this country by one of the subsidised theatres in affording them a significant production. Primarily these plays were not scored by their dramatists to be 'read' or to be 'written about' but to be performed. Shakespeare's contemporary dramatist, John Marston, rightly advised:

Comedies are writ to be spoken, not read.
Remember the life of these things consists in the action. . . .[22]

The life of these plays consists in their own action and they may
lead us also to consider questions concerning the dramatic actions
of Shakespeare.

2
Parasitic Comedy: Tom Stoppard, *Rosencrantz and Guildenstern are Dead*

Criticism of *Rosencrantz and Guildenstern are Dead* has generally looked for the immediate influences on Stoppard's writing of the play. It has concluded that in the main these are Beckett's *Waiting for Godot* and T. S. Eliot's *The Love Song of J. Alfred Prufrock*. Stoppard himself has taken this further stressing that Beckett's influence came as much from his novels as *Godot*:

> It's only too obvious that there's a sort of Godotesque element in *Rosencrantz*. I'm an enormous admirer of Beckett, but if I have to look at my stuff objectively, I'd say that the Beckett novels show as much as the plays. . . . There's an element of coincidence in what's usually called influence. One's appetites and predilections are obviously not unique. They overlap with those countless other people, one of whom – praise be God – is Samuel Beckett.[1]

To Eliot and Beckett, other names have also been added, Pirandello, Kafka, James Saunders, leading to a critical contest to decide the principal influence. One of the most recent critics, Tim Brassell, asserts:

> Eliot seems to exert a special hold on Stoppard's imagination, and the greatest influence derives from Prufrock, the character and the poem. Throughout Stoppard's writing characters struggle to orientate themselves properly to their puzzling or disturbing worlds. He is constantly fascinated by the problem of the victim, the second-rate, the also-ran, and Prufrock is an archetype of sorts for these people. It is quite probable indeed, that Eliot's poem . . . rather than the writings of Pirandello, Kafka, Saunders, Beckett or even perhaps *Hamlet* itself, provides the real genesis of *Rosencrantz and Guildenstern are Dead*.[2]

13

This may be so in terms of literary influence over the style of the play but it has to be stated from the outset that *Rosencrantz and Guildenstern* works as a play through an audience's knowledge of *Hamlet*. This can make the play vulnerable, leading critics to complain of its parasitic nature. Arnold Hinchliffe writes of the play's first London performance:

> It opened in 1967 to great acclaim not merely by the public but also by critics. This is puzzling since as the play opens we recognize Theatre of the Absurd. What remains then, is, to what purpose and how well and the answer must be to little purpose and no more than competently. National Theatre audiences were familiar with *Hamlet* and less so with Absurd Theatre, so the play could work well but this cannot explain the excitement of critics who should have known better. The idea basically is excellent but it is not endowed here with any great weight. What we see is a clever author manipulating rather than exploring, a parasite feeding off Shakespeare, Pirandello and Beckett and however ingenious the idea, the over-long execution is relentlessly familiar.[3]

A parasite need not necessarily be destructive and Hinchliffe here is perhaps reacting too strongly against the critical acclaim that followed the National Theatre's production. *Rosencrantz and Guildenstern are Dead* is a parasitic play in which the dramatist takes a major cultural artifact, *Hamlet,* and looks at it from a comic point of view, imaginatively investigating some of the lines of enquiry within and beneath the text.

Hamlet is often considered as a play of word preventing action. When action does occur it can appear irrational and cruel. Why should Rosencrantz and Guildenstern be put to death? What fault have they committed in the play? Does the fact that they obey the dictates of the King, without knowing that he is a usurper and a murderer, really necessitate their executions? Is the Hamlet figure who in the conclusion is to right the universal wrongs of time through his blood revenge over Claudius, diminished by his conduct over Rosencrantz and Guildenstern or is his conduct necessary, galvanising him into action rather than thought, which on his return to Elsinore will necessarily mean that justice will be carried out? Are the deaths of Rosencrantz and Guildenstern a necessary prelude to the death of Claudius or are they an unneces-

sary act of cruelty on the part of Hamlet? Stoppard's view is with the latter:

> Hamlet's assumption that they (Rosencrantz and Guildenstern) were privy to Claudius's plot is entirely gratuitous. As far as their involvement in Shakespeare's text is concerned they are told very little about what is going on and much of what they are told isn't true. So I see them much more clearly as a couple of bewildered innocents than a couple of henchmen, which is the usual way they are depicted in productions of *Hamlet*.[4]

Stoppard's reaction to *Hamlet* is one of sympathy for two of the characters sacrificed by the action. It is a reaction, he states, that is possibly contrary to most performance interpretations of the play but it is a credible one and perhaps one shared by many others in experiencing the work. His view is naturally subjective, taken from within the world of Shakespeare's drama. He is reacting to the action of *Hamlet*, taking in earnest what was written in game in the sense that he is involved with the plight of these two fictional characters. From that starting point we can look at his play since out of his subjective reaction to *Hamlet*, Stoppard has created another play – influenced of course by other writers, which other critics have discussed – which in turn manipulates his audience into the world of game. One line of critical enquiry therefore is to ask how *Rosencrantz* works as a drama? What does it play off in audience knowledge? How does it comment on and complement Shakespeare's original work?

To answer these questions three areas of common interest between the two plays can be considered: Sanity/Insanity; Players and the Play within the Play Motif; Death.

SANITY/INSANITY

Shakespeare's play confronts us with questions about whether Hamlet is sane or mad. Involving us in its action it asks us as readers or audience what we think. Is Hamlet feigning his insanity? Is he sometimes insane, sometimes not? Is the proof of sanity the ability to tell the difference between a hawk and a handsaw? Where do you find a touchstone for sanity?

One proof of sanity may lie in the individual's ability to order

experience in a logical manner. Stoppard opens his play with the motif of the tossing of the coins. First and foremost this is a comic routine. Stoppard is altering the Shakespearean tragic genre. Throughout there is going to be an absurdity which proves to be in the best tradition of English comedy. Rosencrantz and Guildenstern are presented as a comic duet, Guildenstern initiating action, Rosencrantz receiving its benefit. The humour depends on a frustration of logic. It can be said, of course, that 'heads' is significant because by the end of the play the two characters will lose their 'heads' but it is the humour of the situation which is the immediate impact followed by the commentary on its banality. Guildenstern's first lines establish his vulnerability as a Woolworth's-philosopher:

> There is an art to the building up of suspense.
>
> . . .
>
> If that's the word I'm after
>
> . . .
>
> A weaker man might be moved to re-examine his faith, if in nothing else at least in the law of probability.[5]

It is precisely within the law of probability, the logic of action that the confusions of the play are to build. The capacity for thought and for predicting the consequences of one's action are firstly equated with a belief that a harmony can be found in life but then immediately frustrated in the realisation of the fallibility of that belief:

> We have been spinning coins together since I don't know when, and in all that time (if it *is* all that time) I don't suppose either of us was more than a couple of pieces up or down. I hope that doesn't sound surprising because its very unsurprisingness is something I am trying to keep hold of. The equanimity of your average tosser of coins depends upon a law, or rather a tendency, or let us say a probability, or at any rate a mathematically calculable chance, which ensures that he will not upset his opponent by winning too often. This made for a kind of harmony and a kind of confidence. It related the fortuitous and the ordained into a reassuring union which we recognized as nature. The sun came up about as often as it went down, in the long run, and a coin showed heads about as often as it showed tails.

Then a messenger arrived. We had been sent for. Nothing else
happened. Ninety-two coins spun consecutively have come
down heads ninety-two consecutive times . . . p. 12

Something incomprehensible, first signified by the messenger, has
occurred and the stability of logic has been undermined through
the comic metaphor of the spinning coin. Strange sounds are to
be heard, drums and a flute. Logic and place are 'out of joint', the
laws of probability have failed. The two characters, throughout,
test their sanity, in a perceptively dislocated world, by a series of
exercises and/or experiments. The first recourse is one to memory.
Where have you come from? Why are you here? What is the first
thing you remember?

Ros Ah. (*Pause.*) No, it's no good, it's gone. It was a long time
 ago.
Guil (*patient but edged*): You don't get my meaning. What is the
 first thing after all the things you've forgotten?
Ros Oh I see. (*Pause*) I've forgotten the question. p. 11

A later one is geographical, an attempt to prove where they are:

Guil (*clears his throat*): In the morning the sun would be easterly.
 I think we can assume that.
Ros That it's morning?
Guil If it is, and the sun is over *there* (*his right as he faces the
 audience*) for instance, *that* (*front*) would be northerly. On
 the other hand, if it is not morning and the sun is over
 there (*his left*) . . . *that* . . . (*lamely*) would *still* be northerly.
 p. 41

Each attempt to find a logic of their situation breaks down since,
as so often with Hamlet in Shakespeare's play, their proofs are
cerebral speculations divorced from the reality of the situation in
which they find themselves: a situation dictated by agencies and
events outside their control. As with Hamlet, therefore, Stoppard's
Rosencrantz and Guildenstern are left with questions and words.
Guildenstern states,

Words, words. They're all we have to go on. p. 30

– but under pressure they find that even their words break down

as the incomprehension of their situation absurdly spreads:

Ros I want to go home.
Guil Don't let them confuse you.
Ros I'm out of my step here –
Guil We'll soon be home and high-dry and home – I'll –
Ros Its all over my *depth* –
Guil – I'll hie you home and –
Ros – out of my head –
Guil – dry you high and –
Ros (*cracking, high*) – over my step, over my head body! . . .

 p. 27

Language, that distinguishing feature of the human species, breaks
down, in the illogicality of the situation. Yet Rosencrantz and
Guildenstern still believe that words, questions, should work
everything out to a satisfactory conclusion as they play act how
they will interrogate Hamlet.

Ros So-so your uncle is the king of Denmark?!
Guil And my father before him.
Ros His father before him?
Guil No, my father before him.
Ros But surely –
Guil You might well ask.
Ros Let me get it straight. Your father was king. You were his
 only son. Your father dies. You are of age. Your uncle
 becomes king.
Guil Yes.
Ros Unorthodox.
Guil Undid me.
Ros Undeniable . . . p. 35

The simplicity of words will neither reveal the truth nor confirm
the stability of existence. The parody of one of the central concerns
of Shakespeare's drama is clearly seen.

In the episode of the recorders in *Hamlet* the protagonist on
proving Guildenstern's musical impotence on the instrument, turns
on him:

Why, look you now, how unworthy a thing you make of me!
You would play upon me; you would seem to know my stops;
you would pluck out the heart of my mystery; you would sound
me from my lowest note to the top of my compass; and there is
much music, excellent voice, in this little organ, yet cannot you
make it speak . . . 3.2.353–60

Hamlet's 'mystery' has constantly been foregrounded by romantic
and character criticism – still the dominant critical form in Shake-
spearean study – as something which cannot be solved by question-
ing, it goes beyond language to the essence of the character
displaced in the context of Claudius's court. Stoppard's parody
therefore concentrates on the failure of language in an
incomprehensible situation. For Rosencrantz and Guildenstern
neither logic nor words retain meaning. Rosencrantz turns to the
audience and cries out 'Fire' (p. 43) but no one moves. There is an
implausibility in his words in the established context of a theatrical
performance. The characters spinning their coins are like the
Chinese philosopher:

A Chinaman of the T'ang Dynasty – and, by which definition, a
philosopher – dreamed he was a butterfly, and from that moment
he was never quite sure that he was not a butterfly dreaming it
was a Chinese philosopher. Envy him; in his two-fold security.
 p. 43

It is a matter of heads or tails. The context provides no stability
but merely proves their impotency. It is an absurdity but one which
reflects as much on Hamlet's situation in Shakespeare's play as
that of Rosencrantz or Guildenstern.

THE PLAYERS AND THE PLAY WITHIN THE PLAY MOTIF

The players in *Hamlet* are employed partly to demonstrate the
protagonist's own impotence in action: 'Is it not monstrous that
this player here,/But in a fiction, in a dream of passion . . .'
(2.2.544f.) and to prove the guilt of Claudius: 'The play's the
thing/Wherein I'll catch the conscience of the King' (2.2.600–
1). Shakespeare, however, gives the players a further function.
Through their arrival at Elsinore he is able to comment briefly on

the contemporary situation concerning his acting company in London. The reason he gives for his actors being on the road is that the competition from the children's acting companies, at St Paul's and the Blackfriars' theatre, has been so keen in ridiculing the adult acting companies, including his own at the Globe theatre with its emblem of Hercules and his load, that the company has been forced to travel (2.2.316f.). In some respects it is a Shakespearean nonsense of course since *Hamlet* is being performed in London at the Globe, but it is an imaginative possibility: Shakespeare's company did feel the effects of what has become known as the War of the Theatres.[6] Stoppard takes the Shakespearean image further. Not only have Stoppard's actors been forced on to the road; they have been humorously reduced to Alfred and the *Rape of the Sabine Women*:

> No enigma, no dignity, nothing classical, portentous, only this –
> a comic pornographer and a rabble of prostitutes . . . p. 19

As Shakespeare asks questions concerning the relation of stage action and the world of the audience, so Stoppard's play investigates the interaction between actors and their act, enquiring into various levels of perception. For *Hamlet's* Polonius, the actors are to be employed according to their desert, though the 'best actors in the world' they are superfluous in his mind to the realities of the State and are therefore of passing importance. For Hamlet they are guides to the truth of his predicament. But the truth of their existence in their art relies upon their relationship with an audience. Claudius's interaction with the players and their play will reveal his guilt and define the existence of the fiction as a reality. The players thereby help to solve the sanity/insanity dilemma by allowing a context whereby fiction reveals truth. This can only happen however if an audience is present. Take away the audience and you reduce the players to nothing as Stoppard's First Player reflects:

> You don't understand the humiliation of it – to be tricked out of
> the single assumption which makes our existence viable – that
> somebody is *watching*. . . . There we were – demented children
> mincing about in clothes that no one ever wore, speaking as no
> man ever spoke, swearing love in wigs and rhymed couplets,
> killing each other with wooden swords, hollow protestations of

faith hurled after empty promises of vengeance – and every gesture, every pose, vanishing into the thin unpopulated air. We ransomed our dignity to the clouds, and the uncomprehending birds listened. (*He rounds on them*) Don't you see?! We're *actors* – we're the opposite of people! (*They recoil nonplussed, his voice calms*) . . .　　　　　　　　　　　　　　　　　p. 45

The world of fiction, as with the world of logic, is alien to the two characters, even though they are an integral part of that world, reminding the audience of their metadramatic existence in a play. Rosencrantz looking beyond the footlights comments:

I feel like a spectator – an appalling prospect. The only thing that makes it bearable is the irrational belief that somebody interesting will come on in a minute . . .　　　　　　p. 30

They are not however spectators but the actors of the play and as such as with Hamlet incapable of an existence outside its confines or an ability to alter the course of its events. In Act 2 they decide to trap Hamlet:

(*GUIL positions himself next to ROS, a few feet away, so that they are covering one side of the stage, facing the opposite side. GUIL unfastens his belt. ROS does the same. They join the two belts and hold them taut between them. ROS'S trousers slide slowly down.*)
(*HAMLET enters opposite, slowly dragging POLONIUS'S BODY. He enters upstage, makes a small arc and leaves by the same side, a few feet downstage.*)
(*ROS and GUIL, holding the belts taut, stare at him in some bewilderment.*)　　　　　　　　　　　　　　　　p. 65

The character is merely a function of dramatic communication. He has no life. He can wish to capture Hamlet only in the author's imagination, an imagination which in Stoppard's case reduces him to the comic spectacle of a man losing his trousers. Yet the character portrayed by the expert player can approximate to the truth, to the extent firstly of predicting the end of his own play, as occurs in the dumb show when Rosencrantz and Guildenstern uncomfortably but comprehendingly witness their own execution (p. 62f.); or secondly by making language comprehensible when all around him is chaos – the Player unlike Guildenstern can say

'high and dry' (p. 46); or thirdly by making one believe that what is a fiction, is a reality. Guildenstern cries out at the Player that although he may be able to play death he has never experienced it. His actions are merely fiction. The Player in return however makes Guildenstern believe the fiction to be reality:

> Guil . . . no one gets up after *death* – there is no applause – there is only silence and second-hand clothes, and that's – *death* – (*And he pushes the blade in up to the hilt. The PLAYER stands with huge, terrible eyes, clutches at the wound as the blade withdraws: he makes small weeping sounds and falls to his knees, and then right down:*)

It is a moment or double bluff. The first bluff is for Guildenstern who thinks he has killed the player, the second is for the audience who thinks that Guildenstern has killed the player. But for both the players and the audience it is in fact all a nonsense, a chimera, an imaginative fantasy as Shakespeare's Hamlet, himself fictitious, realised·

> Is it not monstrous that this player here,
> But in a fiction, in a dream of passion,
> Could force his soul so to his own conceit
> That from her working, all his visage wann'd;
> Tears in his eyes, distraction in's aspect,
> A broken voice, and his whole function suiting
> With forms to his conceit? And all for nothing!
> For Hecuba!
> What's Hecuba to him, or he to Hecuba,
> That he should weep for her?

> 2.2.544–53

DEATH

Shakespeare's *Hamlet* is preoccupied, of course, with the fact of death. Probably the most famous lines in English literature confront the issue of being or not being. The play opens with a messenger of death in the figure of the Ghost and progresses through questioning whether it tells the truth; whether it is really

a devil. It questions the notion of the after life in a speculative philosophical debate but it concludes only with the reality that is death; the rest is silence. The reality of death therefore becomes the predominant emblem of the drama. Although the play within the play will prove Claudius's guilt, to what extent is that proof significant in the face of the universal fact of death? Is a King any different from a beggar? Might not a King become nothing more than a plug in a barrel:

> Horatio 'Twere to consider too curiously to consider so.
> Hamlet No, faith, not a jot; but to follow him thither with modesty enough, and likelihood to lead it, as thus: Alexander died, Alexander was buried, Alexander returneth to dust; the dust is earth; of earth we make loam; and why of that loam whereto he was converted might they not stop a beer-barrel? 5.1.200–8

Stoppard reworks these preoccupations of Shakespeare's original concept within the context of his own system of dramatic signs. The barrel consequently figures on his stage in Act 3; not one but three of them from one of which the sound of the pipes can be heard and from which subsequently the players emerge. When the pirates attack, it is to the barrels that the characters go for rescue and through the barrel that Hamlet disappears.

Similarly the 'To be or not to be' soliloquy finds an echo throughout the play in the questioning games that the characters play:

> Guil Are you deaf?
> Ros Am I dead?
> Guil Yes or no?
> Ros Is there a choice?
> Guil Is there a God?
> . . .
> Ros What are you driving at?
> Guil (*with emphasis*) What's your name?!
> Ros Repetition. Two-love. Match point to me.
> Guil (*seizing him violently*) WHO DO YOU THINK YOU ARE?
> Ros Rhetoric! Game and match! (*Pause*) Where's it going to end?
> Guil That's the question
> Ros It's *all* questions. pp. 31–2

ALBRIGHT COLLEGE LIBRARY 222732

The play is going to end, of course, in the deaths of the protagonists. Its title has pronounced as much, Shakespeare's *Hamlet* has shown it to be so and the premonitions throughout confirm the fact for the audience. But such deaths are as phoney as the murder of The Player by Guildenstern. They have no basis in truth. A play is art and as such obeys its own laws of reality as The Player states:

> There's a design at work in all art – surely you know that? Events must play themselves out to aesthetic, moral and logical conclusion. p. 57

Add the reality of world outside the theatre into such art and it is ruined:

> I had an actor once who was condemned to hang for stealing a sheep – or a lamb, I forget which – so I got permission to have him hanged in the middle of a play – had to change the plot a bit but I thought it would be effective, you know – and you wouldn't believe it, he just *wasn't* convincing! It was impossible to suspend one's disbelief – and what with the audience jeering and throwing peanuts, the whole thing was a disaster! – he did nothing but cry all the time – right out of character – just stood there and cried. . . . Never again. p. 61

Stoppard is engaging in the debate about the reality and truth of art. The passage is similar to a story the Russian director, Meyerhold, tells of Chekhov:

> On the second occasion (11 September 1898) that Chekhov attended rehearsals of *The Seagull* at the Moscow Art Theatre, one of the actors told him that offstage there would be frogs croaking, dragon-flies humming and dogs barking. 'Why?' – asked Anton Pavlovich in a dissatisfied tone. 'Because it's realistic' – replied the actor. 'Realistic!' – repeated Chekhov with a laugh. Then after a short pause he said: 'The stage is art. There's a genre painting by Kramskoy in which the faces are portrayed superbly. What would happen if you cut the nose out of one of the paintings and substituted a real one? The nose would be "realistic" but the picture would be ruined.'[7]

The man hanged in the middle of a play destroys the fiction. The

truth of death is beyond the dramatic classifications of tragedy or comedy. It is with the world of the audience, the world of 'Imperious Caesar, dead and turn'd to clay'. These plays, Stoppard comically reflects, merely present a fictitious equation to that reality. They are the artistic passage of time in which nothing exists, in which even England can be thought by Guildenstern to be 'Just a conspiracy of cartographers'.

Stoppard in this early play presents a comic negative of Shakespeare's *Hamlet*. He displaces the central character and foregrounds two of the minor ones. He thereby builds on an audience's perception of another artifact but simultaneously reflects on the nature of such artifacts, whether by Shakespeare, Beckett, Eliot or himself. In doing so he creates a witty, technically brilliant extravaganza in its own right, a play indebted to others but existing in itself.

Yet despite all this there is something appropriate in Arnold Hinchliffe's reservations about the play. Firstly in drawing attention to its own artificiality it does so with a flippancy that underestimates the importance of metadramatic practice to elements in the Shakespearean drama. Secondly from the point of view of the 1980s this mid-1960s drama appears to have lost the edge it might have had in a manner that Bond's *Lear* and Beckett's *Waiting for Godot* have not. Why might this be so? Unlike Bond's play, which is to be considered in the next chapter, Stoppard's drama does not attempt to refashion the mythic elements of Shakespeare's drama for a modern audience but rather comments on the author's perception of, providing in comic terms his commentary on, *Hamlet*. Yet in doing this Stoppard's play is more closely tied to a particular line of Shakespearean interpretation than are the plays of Beckett or even Ionesco. Stoppard's evaluation of *Hamlet* is one largely effected by a 1960s interpretation of the play. The great Hamlet of that decade was David Warner in Peter Hall's 1965 Stratford production. Bedecked in a long university scarf, tall, lank and speaking with a Birmingham accent Warner presented an indecisive, politically apathetic Hamlet. The production has rightly become a landmark in the performance history of the play. Warner's protagonist was the student of the 1960s struggling with himself in a vacuum, the only escape from which appeared to be a statement of belief in himself. It was a Hamlet eventually asserting that for him, Hamlet the Dane, 'the readiness is all'. The characteristics of such a Hamlet could be seen to produce dilemmas for those around him, which

as Stoppard shows could soon be turned into comic routines. It was a liberal humanist Hamlet however which could be despised and ridiculed by Charles Marowitz precisely because of its apolitical stance.[8] The Hamlet of the late 1970s and the 1980s is, however, a slightly different creature. The portrayals of the character by Derek Jacobi for the Prospect Theatre Company (1977/8) and by Michael Pennington for the RSC (1980) confronted the audience with a protagonist deeply aware of his self-dramatisation and particularly in John Barton's 1980 RSC production, with a play constantly calling attention to itself as a dramatic construct. In Roger Rees's portrayal of the role for Ron Daniels's 1984 RSC production the emphasis was still on the mechanics of the drama although in this case it centred on the language and especially the development of the play through the soliloquies. Jonathan Pryce's controversial portrayal at The Royal Court in 1980 was radical in its internalisation of Hamlet for whom the ghost was merely a facet of his own psyche. The production was greatly disliked by Shakespearean 'purists' and interestingly enough by Stoppard whose disparaging literary rather than theatrical comments about it have been swiftly welcomed by some scholars.[9] The emphasis of these productions, in my view, derives textually not so much from the 'we defy augury' speech but rather from Hamlet's opening confrontation with the King and Queen and his distinction between what 'seems' and what 'is'. It is this dialectic which appears more appropriate to the 1980s than the 1960s image of student political apathy as projected by Hall and Warner.

Thus in Mrs Thatcher's Britain it can be suggested for example that there is something too near the bone in Stoppard's story of the man hanged in the middle of a play for stealing a sheep. There has been a political blurring of the boundaries between fiction and reality. The prime example came with the Falklands war in which the horrific reality of warfare was metamorphosed into a mass media communicative entertainment. News bulletins with theatrical descriptions – I counted them out. I counted them back – tended to fictionalise the crudity of battle transforming it into a grand competition or news-soap to be followed by its audience through update processed reports throughout the day.

It is not surprising that recent directors and actors have responded to *Hamlet* in a different way from Peter Hall in the 1960s. For society in the mid-1980s with a film actor as President of the United States and with Mrs Thatcher ruling Britain with the economic and

moralist philosophy of a Surbiton housewife, there are too few Hamlets to proclaim what 'is' and expose what 'seems'. In such a climate Stoppard's play can only appear as an extravaganza enjoyed by audiences who may be content with its flippancy concerning the play's metaphysics but are happy not to be provoked into considering those issues in the Shakespearean template which cry out in the 1980s to be heard.

3

A Divergent View of Human Nature: Edward Bond, *Bingo* and *Lear*

In Edward Bond's play *The Fool*, the poet, John Clare, is taken to Hyde Park by his society patroness Mrs Emmerson. Her aim is to see him inspired by the countryside:

> See, Mr Clare, we have grass and trees in this park. Do they not inspire you? O to be touched by the wings! The rushing of the spirit! We earthly ones can but crane our necks to watch you soar! . . . Notebook and pencil. It is my ambition to be at your side when the muse calls. I shall take down your words as you cast them on the air. When I'm old my nieces and nephews gathered at my skirts I shall take out this book and turn – commanded by their childish piping: it will be their habitual pleasure! – to the oft op't pages where I wrote the effusions of John Clare. 'Hyde Park Impromptu'.[1] p. 36

In the person of Mrs Emmerson, Bond riducules bourgeois notions of the inspired muse, of society poetry. Art that is as pretty decoration, a superficiality pandering to the readers' self-satisfied beliefs about themselves and their standing in society.[2] Bond rejects such notions of art and in the play juxtaposes Mrs Emmerson's prattle with a boxing bout that is taking place in the park. It is the boxing, not the grass and the trees, that interests Clare. He is dressed in a green jacket that belonged to Darkie, hanged earlier in the play for what the establishment would term revolutionary activity. One of the fighters is a Negro, the other an Irishman, twin examples of racial exploitation in British society. Throughout a long scene the fight continues as Clare is brought into discussion with Charles Lamb and his lunatic sister, Mary and with Clare's financial patron Admiral Lord Radstock. Lamb talks about truth, stating its ugliness and danger, the 'spit on god's face' (p. 38)

28

whilst backers variously place their money on the 'black man' or the Irishman. As the fight progresses the Admiral, who Mrs Emmerson comments 'has a statesman's experience' (p. 43), censures Clare for his 'smack of radicalism' and for the explicitness in his poem 'To Mary' whilst simultaneously he too engages his interest in the fight:

> Well done the black man! Had them on our ships. Go to pieces in a storm – all whites of eyes and flashing teeth – but put a cutlass in their hands and bellow at them – what soldiers! Counter attack the devil!　　　　　　　　　　　p. 45

The 'black man' wins the fight and for one of the backers some money. Bond's image is clear. The poet is as exploited as the boxer. He too is to be controlled by the money supply. He is not to write against the society that buys his book but rather entertain that society in its own self indulgence, like the two boxers destroying themselves in the ring. In the presence of Lamb the poet philosopher is a poor victim lost in the park, caged as '. . . a bird of prey, an owl' (p. 39) or roped like the boxers in the ring.[3] As yet Clare is innocent. He is being inaugurated to the world of supply and demand which destroys the poet by reducing him to its own value system. By the end of the play, Clare, who has been haunted by Darkie and one of the boxers, is in an asylum unable to speak whilst outside '*An owl calls in the trees*' (p. 69). The poet has been silenced but the poetry can still be heard.

Bond is concerned with the relation between the artist, his art and his society. The three are interwoven but their interaction requires careful and honest consideration. Art is not cosmetic, rather it is an essential element of human culture which was betrayed in the nineteenth century through a process of elitism on behalf of the ruling class. Bond states:

> Art is usually taken to be a very private experience. This goes back to the nineteenth century, the first age that tried to take art away from the masses of people. The nineteenth century pursued a lop-sided development, not the mutual cooperation of technology, politics and art, which is essential to culture. . . . There is a specialism in art just as there is in technology or politics. It only becomes embarrassing when the artist suggests he's a specialist in another, finer world. He's a specialist in describing

this world, and all art is realism. We're the product of material circumstances and there's no place in art for mysticism or obscurantism. Art is the illustration, illumination, expression of rationality – not something primitive, dark, the primal urge or anything like that.[4]

Bond therefore brings into question bourgeois notions of culture which regard art as isolated from social reality. It is this questioning that informs the two plays to be discussed in this chapter. In *Bingo* Bond relates his concern to the historical figure of Shakespeare and the Elizabethan's place of priority within English culture, whilst in *Lear* he tackles one of the most renowned plays in the English literary and theatrical tradition, *King Lear*.

The bedrock of English culture is Shakespeare. Nineteenth-century writers following the lead of Schlegel and Coleridge, in particular, almost deified him as having the greatest mind, the supreme wisdom of humanity. The legacy of the romantic's notion of Shakespeare continued into the twentieth-century and prevails today to the extent that Shakespeare is inseparably bound to a significant slice of the English way of life. Arnold Hinchliffe pertinently echoing a statement by Terry Hands, has noted for example that we have a *Royal* Shakespeare Company but no *Republican* Jonson Theatre.[5] In 1986 it was this Royal Shakespeare Company which won the Queen's Award for Export achievement. Shakespeare has been assimilated into a bourgeois cultural mode of thinking to the extent that the problems he discussed at a particular moment in history, can be misunderstood by the common means of 'cultural appreciation' employed by middle-class audiences. Such a situation in Bond's view reduced Shakespeare to nothing more than a game of bingo. Thus the modern dramatist gives an explanation for the title of his play:

> Art has very practical consequences. Most "cultural appreciation" ignores this and is no more relevant than a game of "Bingo" and less honest.[6]

In the opening scene of *Bingo* Bond confronts the problem of the impotent writer, written out, attempting to retire from the world in the security of his wealth. Shakespeare wishing to avoid the bankrupt fate that befell his father, has invested his earnings from the theatre in land. This land, however, is now the subject of

exploitation by the capitalist Coombe who wishes to institute an enclosure system. Shakespeare well knows the implications of such a policy:

> . . . A lot of the small holders don't have written leases. They just followed their fathers onto the land – and their fathers had followed *their* fathers. If you get rid of them and the short-lease tenants – there'll be more than seven hundred poor to feed. And if you grow less wheat the price of bread will go up –[7]
>
> pp. 5–6

The statement demonstrates Shakespeare's culpability. He signs a paper – the irony of the writer – which allows Coombe to exploit others as long as Shakespeare's own investment is protected.

The play examines the consequences of this deed. When challenged on the matter of the old woman, Shakespeare remains silent, shrugging off awkward questions with a glib statement that nothing is decided. But as the play progresses what is discovered is the apostasy of the artist. In the fourth scene Shakespeare is seen to become steadily drunk. The dramatist, Ben Jonson, is questioning him throughout about his writing:

Jonson	What are you writing?
Shakespeare	Nothing
	They drink
Jonson	Not writing?
Shakespeare	No.
Jonson	Why not?
Shakespeare	Nothing to say
Jonson	Doesn't stop others. Written out?
Shakespeare	Yes.
	They drink p. 29

Shakespeare is 'written out' because he has betrayed his art form in the values that he aspired to in the acquisition of his home New Place. Throughout the play the proximity of the home to the bells of the church across the street is stressed by Bond. Shakespeare has conformed to the bourgeois ideals of the middle class in the shade of their dominant morality. Jonson has little idea of the reality of the situation. For the drunken comic dramatist, Shakespeare has already begun to assume his mythic role. It is this which raises Jonson's hatred:

I hate you because you smile. Right up to *under* your eyes. Which are set the right distance apart. O I've wiped the smile off now. I hate your health. I'm sure you'll die in a healthy way. Well at least you're dying. That's incense to scatter on these burning coals. I hate your long country limbs. I've seen you walking along the city streets like a man going over his own fields. So simple. A simple stride. So beautiful and simple. You see why I hate you. How have they made you so simple? Tell me, Will? Please. How have they made you so good? p. 34

Shakespeare is 'simple', Shakespeare is 'good': the deity is being born but the situation as the play testifies is very different.

Bond faces a problem with the myth of Shakespeare. By placing him in the drama as a willing agent of capitalist values he wishes to shock his audience, yet the play simultaneously displays a sympathy for the protagonist in conflict with himself. Each act that Shakespeare attempts in the play, until the final one, is reductive of his art. In the opening scene he is confronted with the representative of the poor on stage. The Young Woman enters and Shakespeare offers money rather than food. Whilst in the house looking for his purse, his retainer, the simple Old Man, arranges for sex with the woman. Shakespeare returning with his charity finds himself impotent to help – the woman has disappeared. Shakespeare's charity, as the enclosure episode is to show, is false. It is one of appeasement to his own conscience rather than truth to the art that he created. A parallel is established between Shakespeare, the bard, and the Old Man, deranged by a hit on the head from an axe. Despite his simplicity the Old Man can show a warmth and concern. He may be willing to pay for sex with the Young Woman but he realises her humanity even with that payment. Her breast which he begins to feel is a testimony to her living beauty. When she is arrested for the second time, the Old Man is broken. He –

sits on the bench. He rests his elbows on his knees and his hands hang down between his legs. He rocks like a little boy. The basket is on the ground beside him. p. 19

Shakespeare has again proved impotent to help the Young Woman, this time against the accusations of his own daughter, Judith. The result is that the woman is hanged. Shakespeare's humanity is

seen to be reduced. In scene three Bond displays the gibbeted body as an emblem[8] of the dramatist's inability to care enough for his fellow beings in opposition to the deranged Old Man's ability to show warmth. Later the Old Man trudges through the snow to take one last look at the woman on the gallows. In contrast all Shakespeare can do is merely stand in front of her mouthing philosophical platitudes about the baiting of a bear.

Shakespeare's intellectual world is shown by Bond to have become incestuous to his own desires. The result is that he fails to communicate with those about him. His wife never appears in the play (Bond resisted the temptation of having her appear in the last act). She is described by Judith as the victim of Shakespeare's art:

> D'you know why mother's ill? D'you care? . . . I'll tell you why she stays in bed. She hides from you. She doesn't know who she is, or what she's supposed to do, or who she married. She's bewildered – like so many of us! p. 18

Shakespeare replies that Judith is speaking 'banalities', but it is he who is living the life of the banal throughout the play. Later he turns on Judith in a futile attempt to explain his feeling towards her. He is standing in the cold snow:

> Don't be angry because I hate you, Judith. My hatred isn't angry. It's cold and formal. I wouldn't harm you. I'll help you, give my life for you – all in hatred. There's no limit to my hate. It can't be satisfied by cruelty. It's destroyed too much to be satisfied so easily. Only truth can satisfy it now. I don't think all this matters to you, I can't hate you more than when I say that. p. 42

The hatred however is for himself torn by his inability to act, haunted by the memory of what he was. His role as a writer has usurped the myth of god. He has become the creator of characters and situations. But in assuming this deific function Shakespeare has failed to be true to himself. In the shadow of the gibbet he questions the history of his own self:

> They stand under a gallows and ask if it rains. Terrible. Terrible. What is the right question? I said be still. I quietened the storms inside me. But the storm breaks outside. To have usurped the place of god, and lied . . . p. 27

Yet even in this statement of apparent self-knowledge Shakespeare is still fantasising; he is not allowing his perception of the truth to influence his life, to galvanise himself into some form of social action.

On wandering in the cold snow in scene five he continues to meditate about himself and his situation whilst around him the labourers are filling in the ditches of the enclosure. It is an indictment of the poet living in the clouds of self satisfaction, a satisfaction even in the despair about one's own history. He muses whilst the Old Man is shot dead.

Bond's characterisation of Shakespeare here is reminiscent of Shakespeare's characterisation of the King in *Henry VI Part Three* in the episode where an old soldier discovers that in the civil war he has killed his own son, and a young soldier discovers that he has killed his father. Whilst both bewail their misfortune, the impotent King muses on their grief as it relates to him:

> Was ever king so griev'd for subjects' woe?
> Much is your sorrow; mine ten times so much . . .
> Sad-hearted men, much over-gone with care,
> Here sits a king more woeful than you are.

<div align="right">

H VI Pt III, 2.5.111–12, 123–4

</div>

At least Henry sees the wronged soldiers enter. Shakespeare in *Bingo* is oblivious to the labourers in revolt, so tied up is he in his own self. Bond, however, stops short of total condemnation of Shakespeare. Throughout his period of writing the play, as Malcolm Hay and Philip Roberts have shown,[9] Bond was concerned that he should not denigrate Shakespeare totally. Bond is an instinctive dramatist knowing his art form and its audience. To reject or ridicule Shakespeare outright would be to invite a rejection of his play rather than a consideration of the myth of Shakespeare by his audience. Bond employs a discipline in his writing to reveal complexities, making his audience think about the issues rather than reject outright the tenets of his argument. Secondly, and more important, Bond comprehends the problem Shakespeare faced in being caught at a specific moment of time. Ben Jonson's appearance in the play is no coincidence. With Drayton, Jonson was with Shakespeare in a final drinking bout which led to Shakespeare's death,[10] but more significant Jonson is responsible for the famous eulogy:

> . . . Soul of the Age!
> The applause! delight! – the wonder of our stage!
> My Shakespeare, rise; I will not lodge thee by
> Chaucer, or Spenser, or bid Beaumont lie
> A little further, to make thee a room:
> Thou art a monument, without a tomb,
> And art alive still, while thy book doth live,
> And we have wits to read, and praise to give.
> . . .
> Triumph, my Britain, thou hast one to show,
> To whom all Scenes of Europe homage owe.
> He was not of an age, but for all time![11]

It is precisely this sentiment which the materialist Bond is keen to dispel. Shakespeare, for Bond, was a significant dramatist at a particular period in history. His plays have to be seen as part of bourgeois art which he raised to its highest form. In doing so he also anticipated the degeneracy of that art which Bond has seen to result, in the present century, in the Theatre of the Absurd. Nevertheless Bond pays tribute to Shakespeare the writer of the tragedies as a dramatist of strength. In *The Rational Theatre* he writes of Shakespeare:

> He pursued his questions in many ages and countries, among many races and conditions of men. And although he could not answer his questions he learned to hear them with stoical dignity: this is at least an assurance that he was facing the right problems – otherwise his dramatic resolutions would have been sentimental and trite. Lear dies old, Hamlet dies young, Othello is deceived, Macbeth runs amok, goodness struggles, and there is no good government, no order to protect ordinary men. Shakespeare cannot answer his questions but he cannot stop asking them.[12]

For Bond Shakespeare should be seen, therefore, in terms of his historical period. The bardolatory from Schlegel to the present needs to be buried, the myth that Jonson is beginning to foresee and to hate in *Bingo* destabilised, and his eulogy over Shakespeare reversed. For Bond 'Shakespeare is not for all time, and even in his own time he was in many ways already out of date' (*The Rational Theatre*, p. x).

It is this vision of the dramatist which informs *Bingo* and through it Bond furthers his belief in the power of art as a social and political force at the time of its composition. Bond is not concerned to debate whether he gets his facts right about Shakespeare or whether it is historically permissible to invent the manner of his death by suicide. (In early draft versions of the play Shakespeare merely crumbled on the ground dead, as he watched the burial of the Old Man from his bedroom window.)[13] What matters for him is that Shakespeare is shown to realise his apostasy and that in the world of the drama he does something about it. In the end, therefore, Shakespeare in *Bingo* acts and in acting he realises the problem of his guilt in his dealings in life in relation to the truth of his art. By the conclusion the audience hopefully has become involved in the Shakespearean debate and comprehends beneath the demythologising of the dramatist a fuller reality, the need of the artist to be constantly truthful in his own time.

Bingo is a challenging play but it does cause some unease in ways other than those intended by Bond. The dialogue is often stiff and Bond sometimes feels the need to relate to historical facts in a rather laboured manner. Jonson for example is made to give a potted biography of his life culminating in his child's burial for which he still owes money. Bond in this respect seems to be constrained to make his social and political points through a rather tedious characterisation despite the humour he attempts to instill into the scene. At such times the writing can appear stilted and the aim of correcting a particular view of history can thereby be lost. In this respect Bond is sometimes reminiscent of Ben Jonson or Bernard Shaw in their attempts at a meticulous rendition of a particular moral line, which is diminished almost by trying to write too well.

No one can accuse Bond of being faint-hearted. In *Lear* he invites comparison with arguably Shakespeare's finest achievement. His success, as Tony Coult has remarked, is one whereby he creates a work that 'summons up Shakespeare's play, yet exists entirely free of it as an autonomous work of art'.[14] Almost since its first appearance in 1604–5 Shakespeare's *King Lear* has proved an offensive play. In it Shakespeare altered his sources to present a starkly violent picture of society, unrelieved by any comfortable conclusion.[15] In 1681 Nahum Tate, seeing Shakespeare's drama as a house of unorganised treasures, published his revised version which was to be the stage version of the play for almost a hundred

and fifty years. The Fool was eliminated, Cordelia fell in love with Edgar and neither she nor Lear died but rather at the end of the play Lear resumed his kingly role over a united country. Samuel Johnson entirely endorsed Tate's 'improvements' on the play. Shakespeare had offended 'natural justice' in the construction of a drama in which both Cordelia and King Lear died in unceremonious manner. The Tate version of *King Lear* held the stage until Macready in 1838 attempted a return to something like the original. In the present century a number of experiments have taken place to find a significant dramatological correlative for the text, allowing it to communicate with a modern audience only too sensitive to the absurdity of a world lacking a belief in a deity and capable of mass self-destruction. Peter Brook's renowned production at Stratford in 1966 heavily influenced by the plays of Samuel Beckett and the critical writing of Jan Kott and earlier G. Wilson Knight,[16] presented the naked violence of the play without even Shakespeare's gesture of residual humanity: Gloucester's eyes were prised out with a grotesque horror which went unrelieved by the servants concern to bathe them with flax and the whites of eggs in order to heal and soothe wounds. The episode, 3.7.98–106, was omitted. In 1982 Adrian Noble presented the play with a circus clown as the Fool mediating with athletic but essentially grotesque humour between the world (the audience) and the stage.[17] Following the judgement scene the Fool, taking refuge in a basket, was stabbed to death by the mad Lear; the mediator had been roughly and tragically eliminated. So compelling was the Fool's portrayal, however, that he was regarded by the company, the reviewers and the audiences alike as a second protagonist with the King, the two actors (Michael Gambon as the King, Antony Sher as the Fool) taking joint curtain calls.[18]

From Nahum Tate's no Fool to Noble's dominant Fool, many productions of *King Lear* have circled round the problems implicit in its raw dialectic concerning nature, natural justice and the function of politics. Shakespeare's original dramatological score is one of a series of stark visual emblems: Kent in the stocks, Lear stripping himself naked on the barren heath, Gloucester's sight being hacked out and trampled under foot, the blind man thrusting himself from the top of a non-existent cliff, the old King entering with the body of his dead daughter. These visual signs of the play are linked to the verbal remonstrations of the characters bewailing, manipulating, or loving in a world of power, violence and lust. It

is a world not dissimilar from our own but which can easily be detached from our experience. The Lear myth is known to the *cognoscenti* that makes up much of today's audiences. We can watch it and comment upon it relating Olivier to Scofield, Gambon to Porter, Hordern to Sinden, discussing Tate, Johnson, Wilson Knight, Jan Kott or Alan Sinfield and in so doing obliterating the significance of the original by concentrating on the changing nature of the signifier. In this respect *King Lear* for all its horror becomes non-offensive in its meaning and non-revolutionary in its production because of an over concentration on its mode of presentation and its emotional power. The play's complexity thereby becomes processed; its significance in offence easily relieved by a gin and tonic in the theatre bar.

For Bond the challenge is to demythologise Shakespeare's drama, finding a point of contact with the audience which disturbs, distracts and problematises the issues in a naked but rational manner. As with Shakespeare, Bond looks towards sexual violence but he places it within a new context. Early in Act One Fonantelle tells the audience of her disappointment with her husband. He fails sexually to satisfy and so she has to resort to other solutions:

> When he gets on top of me I'm so angry I have to count to ten. That's long enough. Then I wait till he's asleep and work myself off. I'm not making do with that for long. I've written to Warrington . . .[19] p. 10

The passage has a strange audience effect. There is a humour implied and shared with an audience alert to male dominance in sexual relations which habitually fail to satisfy the female. Yet simultaneously there is an offence to accepted dominant social decorum. The motif is examined in Trevor Griffiths' play *Comedians* (1975) where when Gethin Price devises a limerick on the same subject he is criticised by the music hall liberal teacher Waters for indulging in a vicious humour of hatred against women.[20] Price's anarchic hatred, however, as Griffiths' play goes on to show is not directed at women but at the social decorum which upholds a class system allowing prejudice and discrimination as part of the status quo. In *Lear* Bond creates a world where the frustration is found within the ruling class itself. Fontanelle's unfulfilled sexuality is emblematic of the tyranny to which she aspires and the political system of which she is a part. Her politics are themselves self-

abusive. Bond deliberately shocks and possibly offends his audience by attacking their sense of decorum but in doing so illustrates his point by heightening audience awareness. In its shock technique it is a dangerous strategy but an effective one if not overused. The portrait of Fontanelle is complemented by the violent physicality of Bodice who like her sister sexually desires Warrington. The parallel with Shakespeare's play at this point is with Goneril and Regan, both in love with Edmund and both planning to destroy each other so as to enjoy him in power. Bond is feeding off such residual knowledge in the audience yet creating a unique emblem of his own. Warrington in the following scene moves from being the Edmund figure to the Gloucester figure in that the women decide he is too dangerous and has to be silenced:

> Bodice He didn't attack my sister's men, so I couldn't risk him talking about my letter. I had his tongue cut out.
>
> p. 12

The self-indulgent sexuality continues in the sadistic delight with which both women go about the torture of Warrington. Fontanelle displays an ecstatic, energetic and physical longing, revelling in the production of tears and blood, instructing that his hands and feet should be 'killed' by being stamped and jumped on. Finally she pervertedly demands his lungs to sit on. Bodice watching knits commenting upon the irrational behaviour of her sister but then indulges in her own quiet means of depraved sexual violence. She first has the soldier beg for the life of the victim before coldly silencing his ears through an act of grotesque degeneracy:

> Bodice . . . We must shut him up inside himself (*She pokes the needles into Warrington's ears.*) I'll just jog these in and out a little. Doodee, doodee, doodee, doo.
> Fontanelle He can see my face but he can't hear me laugh!
> Bodice Fancy! Like staring into a silent storm.
> Fontanelle And now his eyes.
> Bodice No . . . I think not. p. 15

It is a scene of utmost sexual violence which engages the audience one way or another in the dramatic power of its movement. On the one hand there is a fascination at the horror of the deeds perpetuated which is almost pornographic involving audience

emotions with the action. Bond sets this up through the contrasting attitudes of the two women, the one hot in her violence, the other coldly calculating. On the other hand Bond simultaneously alienates the pornographic empathy through the choric use of the soldier who half way through comments 'What a pair!' and who at the end reflects:

It's all over. Walking offal! Don't blame me, I've got a job
t'do . . . p. 16

The alienation is increased through the deliberate feeding from the Shakespearean play: the cruelty of the daughters to Gloucester in particular being brought to mind by the decision to deafen Warrington and the overt refusal to blind him.

Bond's statement of violence is thereby dependent to some extent on the audience's residual knowledge of the Shakespearean play, a residual knowledge which is employed as an alienation device forming an intellectual appraisal of the situation through the contrast.[21] It is this device of audience alienation that operates throughout the play. Specific parallels are established between Bond's artifact and the Shakespearean in a frustrated and dislocated manner.[22] For example a common-place critical point about *King Lear* is that the blinding of Gloucester parallels and reflects Lear's inner blindness. In Bond, however, this interpretative point is placed both in and out of focus by the dramatist. Warrington is not blinded and Warrington in any case parallels not only Gloucester but Edmund. Lear, however, later is blinded in a clinical manner, the eyes being removed by 'a scientific device' – a Nazi-type experimental machine – and then preserved in 'a soothing solution of fomaldehyde crystals' (p. 63). Meanwhile Lear cries out in the extremity of his pain:

Aahhh! The sun! It hurts my eyes! p. 63

The dramatological effect is again complex. The 'soothing . . . formaldehyde' draws on the audience's knowledge of Shakespeare's flax and egg whites after Gloucester's blinding but is an absurd statement foregrounding the clinical obscenity of power structures which forces man, in this case the 'fourth prisoner', to create such a machine. It is the eyeless Lear not the eyes themselves that needs soothing. Yet in his blindness Lear cries out that it is

the sun which hurts his eyes. The contradiction of the cry capitalises on residual knowledge not merely of Gloucester and Lear being blind but now can see – a knowledge which in itself has archetypal significance not only in the Christian tradition as in the blinding of Saul/Paul, but beyond to Tiresias and Oedipus, the blind seers of classical myth, and forward to perhaps Oswald and Mrs Alving at the conclusion of Ibsen's *Ghosts*.[23] Yet the scene also works within its own right and within the internal dynamics of Bond's play itself. Throughout he maintains a semiological consistency in a sign system of physically violent images which through their progression state the resolution of the complexity of the play's issues. These include Lear's execution of the soldier in scene one, the torturing of Warrington, the murder of the boy, the rape of Cordelia amidst the screaming of the pigs, the abandonment of the wounded soldier, the execution of Fontanelle and her autopsy, the bayoneting of Bodice, the blinding of Lear, the withering of the ghost, the execution of Lear. Each image feeds off another in the dramatic mosaic of violence. Lear executes the soldier at the beginning of the play with a single shot because of the wall. He is similarly executed with a single shot when at the end of the drama he attempts to dig up the wall. Fontanelle longs to have Warrington's lungs removed so that she can sit on them but it is her body that is opened for autopsy, and it is within her body that Lear's hands fumble looking for the essence of her evil and from which they emerge covered with blood and viscera. The truth of such evil is not within the womb, within the beauty of creation. 'If I had known' Lear says 'this beauty and patience and care, how I would have loved her.' Rather evil is found within a social structure and mode of thought which causes men to commit violence upon one another.

It is in this that Bond's *Lear* differs significantly from Shakespear's *King Lear* as Alan Sinfield has perceptively demonstrated:

Shakespeare's and Bond's attitudes are dependent finally upon divergent views of human nature. When Shakespeare's Lear demands "Then let them anatomise Regan, see what breeds about her heart. Is there any cause in nature that make these hard hearts?" [3.6.74–7] there is no reply. It seems that we must refer the answer to the gods, who are not as systematically concerned for humanity as Lear once thought. The autopsy on Fontanelle in Bond's play leads Lear to appreciate the potential

beauty and goodness of humanity: "She sleeps inside like a lion and a lamb and a child. The things are so beautiful. I am astonished I have never seen anything so beautiful" [p. 59]. For Shakespeare the problem begins when authority is weakened. That is why there is no prior motivation for Lear and his daughters: established hierarchy guarantees order and no remoter source is in question, except perhaps the gods. Bond, however, shows that his characters have been socialised into paranoia and violence. Shakespeare's Lear spends most of the play discovering what the world is, essentially, like; Bond's Lear discovers that things do not have to be the way they are.[24]

In the Shakespearean tragedy there is a metaphysical transcendence brought through knowledge of the self and the human condition. For Tate and Johnson that metaphysical dimension could not be accepted because it was in contradistinction to their eighteenth-century sensibility and their neo-classical notion of tragedy. As Gāmini Salgādo points out they were of an age 'which had no tragic sense, only a superficial notion of tragic form'.[25] For Wilson Knight, Jan Kott and Peter Brook the recognition of that transcendence could be seen only in the context of a grotesque reality. In Brook's case this was manifested in the terms of the absurd, seeing man ridiculously devoid of the gods in whom he wishes to believe. For Bond, however, such metaphysical notions and generic debates (to what extent does tragedy encompass the grotesque?) seem fatuous. Within the mythical story of Lear is a debate about society corrupting itself through its organisation and philosophy. Bond's Cordelia is Shakespeare's Cordelia enjoying the power Tate's mentality may have given her. It is a power as equally corrupt as that of Lear at the beginning of the play. In Act 3 Lear after begging her to pull down the wall but receiving a refusal tells her 'Then nothing's changed! A revolution must at least reform!' (p. 84). In failing to see this Cordelia has become as Orwell's pigs in *Animal Farm* not the true revolutionary but the new oppressor. Lear in contrast has come to understand the pain of loss and darkness. The gradual severing of the ties with the ghost leads him to attack the wall which is the dominant symbol of oppression throughout the play. Bond's image is clear. Destroy the barrier of darkness in society and true freedom will be found and with it true justice which Bond defines in his Preface as 'allowing people to live in the way for which they evolved' (p. xii).

So it is that in Act 3 Lear tells the parable of the bird who stole the man's voice, of the man who caged the bird, of the king who whipped the man, of the bird who humiliated the King, of the king who tortured the bird and of the man who felt the bird's pain. The impetus for the story derives from King Lear's comfort to Cordelia in Shakespeare:

> Come, let's away to prison.
> We two alone will sing like birds i'th' cage;
> When thou dost ask me blessing, I'll kneel down
> And ask of thee forgiveness . . .

(5.3.8–11)

Bond's statement of reality however extends beyond two individuals asking for blessing or forgiveness, to the interaction of an entire society; a society where walls – of class and inequality – cannot be allowed to exist. His *Lear* therefore transcends not metaphysically but socially in his attempt to destroy the wall which mistakenly he originally erected. The social corruption is so deep, however, that it has become a mode of thought. Lear is ignored and finally shot. But in Lear's death as in Shakespeare's in *Bingo*, Bond makes at least the optimistic statement that through persistence the truth can be perceived, a truth that is which is appropriate to the twentieth rather than the seventeenth century.

4

Demythologising Shylock: Arnold Wesker, *The Merchant*; Charles Marowitz, *Variations on The Merchant of Venice*

In 1976/7 both Arnold Wesker and Charles Marowitz felt constrained to rewrite Shakespeare's *The Merchant of Venice*. The versions which they produced, Wesker's *The Merchant* and Marowitz's *Variations on The Merchant of Venice*, can be seen as two protests against Shakespeare's play as it is generally perceived. They felt independently that this Shakespearean drama of 1598 in its pervailing anti-semitism is intensely objectionable in the twentieth century. Marowitz wrote:

> It is difficult, almost impossible, to come to a play like *The Merchant of Venice*, whose central character is an orthodox Jew, without bringing to the experience all one has learned and read about the Jews in the past 2000 years; difficult to obliterate from the mind the last seventy-five years of Jewish history which includes European pogroms, the Hitler 'death camps', the rise of Jewish Nationalism and the Arab–Israeli conflicts. Of course, Shakespeare had no knowledge of any of these things and it is undeniable that none of these factors enter into *The Merchant of Venice* – and yet, can they be excluded from the consciousness of the spectator who attends the play? . . . Rather than indulge in those strenuous mental calisthenics which enable us to separate our contemporary consciousness from that of Shakespeare's, I prefer to join them up; to yoke them together despite the differences and seeming incompatabilities. What had always angered me about *Merchant* was that contemptible trial scene in which Shylock is progressively humiliated, stripped of all prop-

erty and dignity and sent packing from the courtroom a forced convert, a disreputable father, an unmasked villain.[1]

In this statement Marowitz neatly summarises the problems of Shakespeare's drama. It may be that the trial scene epitomises the tenor of the entire play which allows Christians not merely to triumph over Jew but to indulge in gross anti-semitic attitudes. Yet twentieth-century notions of the anti-semitic and contemporary attitudes towards Jews are a moral phenomenon entirely outside Shakespeare's sixteenth-century experience. Further modern impressions and expectations of *The Merchant of Venice* are based on the intertextual life of the play that has prevailed largely since the eighteenth century. The acting tradition of this play together with the history of holocaust has transformed audience expectations as they approach a performance of the work. In 1948 W. H. Auden wrote:

> Recent history has made it utterly impossible for the most unsophisticated and ignorant audience to ignore the historical reality of the Jews and think of them as fairy-story bogeys with huge noses and red wigs. An Elizabethan audience undoubtedly still could – very few of them had seen a Jew – and, if Shakespeare had so wished, he could have made Shylock grotesquely wicked like the *Jew of Malta*. The star actors who, from the eighteenth century onwards have chosen to play the role, have not done so out of a sense of moral duty in order to combat anti-Semitism, but because their theatrical instinct told them that the part, played seriously, not comically, offered them great possibilities.[2]

Auden's point, like that of Marowitz, is that Shakespeare's play cannot be seen outside our own historical period which necessarily implies that it cannot be divorced from the anti-semitism of the first half of this century. This statement has largely been proved true by protests about productions of the play since the war. The programme for John Barton's second production of the play for the RSC in 1981, for example, publishes a selection of letters and reviews objecting and counter-objecting to a play which some people find racially offensive.

Auden's second point, however, also echoed by Marowitz, relates to the problem of Shylock as a character with a complex stage evolution; a history which seems to imply that the modern

theatre's conception of Shylock is very different from the original design of Shakespeare and his actor, Richard Burbage.[3] This raises the difficulty of actors' influence over a dramatic score; an influence to which Arnold Wesker strongly objected on witnessing Laurence Olivier's acclaimed performance of Shylock in Jonathan Miller's 1971–3 Old Vic production. Wesker wrote:

> . . . in 1973, watching Laurence Olivier's oi-yoi-yoi portrayal of Shylock in Jonathan Miller's production at the National Theatre, I was struck by the play's irredeemable anti-semitism. It was not an intellectual evaluation but the immediate impact I actually experienced.
>
> Here was a play which, despite the poetic genius of its author – or who knows, perhaps because of it! – could emerge as nothing other than a confirmation of the Jew as bloodsucker. Worse, the so-called defence of Shylock – 'If you prick him doth he not bleed' – was so powerful that it dignified the anti-semitism. An audience, it seemed to me on that night, could come away with its prejudices about the Jew confirmed but held with an easy conscience because they thought they'd heard a noble plea for extenuating circumstances.[4]

What Wesker was objecting to here was a highly complicated set of stage signs dependent upon the text, the stage history, the production, the expectation of the audience and the presence of a great acting talent in Laurence Olivier.[5] All these elements interact to produce an effect which instead of confronting the audience with what may possibly have been the original issues of the play, reduced its scope to a concentration on the aspect of the tragic Jew. Olivier in coming to the role of Shylock developed the characterisation of the figure within the context of an acting tradition probably going back not to Richard Burbage in Shakespeare's company but to Charles Macklin in the eighteenth century.[6] Patrick Stewart has recorded that when he began rehearsals for John Barton's first production of the play for the RSC in 1978 one of the director's initial questions to him was 'How are you going to get off?'[7] Despite elsewhere Stewart affirming that Barton felt that the play 'had for too long belonged to Shylock'[8] the question betrays the historical stage boundaries that have encompassed the play. In 1741, on 14 February, the Drury Lane actor Charles Macklin

reinterpreted the role of Shylock for the stage. Until this date Shylock had certainly been portrayed by the actors Doggett at Drury Lane and then Griffin at Lincoln Inn's Field as a comic character in a style it has been conjectured, which had evolved from Burbage's portrayal.[9] Macklin's modern biographer William Appleton follows Toby Lelyveld's thinking that Burbage probably played the role 'comically, with red hair and a long nose, traditional attributes of the Jew' and continues to make the point that the presentation was possibly in the convention of the commedia dell' arte and in particular the comic figure of Pantaloon.[10] Macklin departed from this traditional acting style employed for the character and whilst he did not reject the comedy by making Shylock a sentimentally tragic figure he did foreground within it the serious villainy of the character. Edmund Kean followed playing the role in London from 1814.[11] Whereas Macklin had discarded Burbage's red wig for the role as the sign of the Jew replacing it with a red hat, Kean threw away the red hat altogether. His Shylock was to be no caricature. Rather he developed an inner characterisation for the figure which allowed for a tragic pathos. Through the nineteenth century the evolution of the character continued. Macready attempted to find an even greater psychological consistency in the character than Kean, believing in the character as a person with whom he had to gain an affinity.[12] In America, Edwin Booth dropped the last act concluding the play with Shylock's exit from court[13] – an interpretation which became something of a tradition particularly in the United States.

But it was Henry Irving — who first played the role on 1 November 1879 and then subsequently over a thousand times throughout his career – who cemented the foundation for the twentieth-century's interpretation of the character and the play. Although Irving actually restored the last act of the play,[14] his interpretation foregrounded Shylock as a figure demanding emphathetic response from the audience. The whole production as Alan Hughes has recorded owed much to Ellen Terry's portrayal of a Portia who was culpable in trapping Shylock, making not merely Shylock but all the principal characters into tragic figures who failed to understand themselves.[15] From Burbage to Irving the play had been transformed from a commedia dell'arte type of entertainment to a drama of naturalistic intensity. As Bernard Shaw was ruefully to note of Irving's portrayal:

There was no question then of a bad Shylock or a good Shylock: he was simply not Shylock at all; and when his own creation came into conflict with Shakespeare's as it did quite openly in the Trial Scene, he simply played in flat contradiction of the lines, and positively acted Shakespeare off the stage.[16]

It was with this tradition behind the role largely sustained throughout the twentieth century that Olivier had to contend in his performance, as have other major Shylocks of recent years – Peter O'Toole, Eric Porter, Emrys James, Warren Mitchell, Patrick Stewart, David Suchet, Antony Sher. In each case the decision has been to play within the tragic dimension of the part.[17] Thus the drama that Wesker and Marowitz objected to in the mid-1970s was not the original dramatic concept of the work but the play as it has evolved in its intertextual life and now linked to the sensitive issue of anti-semitism in Western culture. In the face of this both in their separate ways attempt to demythologise the Shylock tradition and in so doing to alter audience opinion concerning the moral boundaries of the Shylock story as it is generally perceived.

In doing this both are within a tradition of contemporary dramatists who like Edward Bond with *Bingo* and *Lear* attempt to demythologise the icons of British history and culture.[18] Trevor Griffiths' attempted correction of the Scott of the Antarctic story in the television series, *The Last Place on Earth*; Michael Hastings' play concerning T. S. Eliot, *Tom and Viv* are further examples as is Howard Brenton's *The Churchill Play* in which the figure of Winston Churchill and his values as portrayed by establishment politics, are debunked through a play within a play structure set in a British internment camp in 1984.

In his *Variations on the 'The Merchant of Venice'* Marowitz attempts to contemporise the Shylock story within post-war history. He sets the play, therefore, within the Palestine of the 1940s. Marowitz's view of this period is that the British mandate in Palestine rather than relieving the Jewish problem actually fostered an anti-semitism. In his introduction to the play he writes:

Clement Attlee's Middle East policy . . . severely restricted immigration to Jerusalem, thereby forcing hundreds of thousands of escaping Jews to return to Europe and the concentration-camps that awaited them. These policies were (quite unfairly) personified by Ernest Bevin, the Foreign Secretary of the time.

By identifying Antonio with Bevin and the lethal policies of the Attlee government and lining up Shylock with the nationalist forces . . . one created a completely different balance between the social forces in the play.[19]

One of Marowitz's principal objections to Shakespeare's play is that Antonio is portrayed as the good man, which necessarily means that Shylock is cast as the bad man. Thus he translates the context of the play preceding its action with the bombing of the King David Hotel in Jerusalem 22 July 1946. Revolutionary struggle is the means by which the moral boundaries of his drama, therefore, have to be judged but he juxtaposes this modernity with an Elizabethan design which, though constantly reminiscent of the Shakespearean play, also draws on the Marlovian verse of *The Jew of Malta* (1589/90). The plight of the Jews is established from the start where Shylock as a revolutionary is found grieving over a dead body and calling for revenge. The tableaux which includes Tubal, Jessica and Chus gives a motivation for the actions of the play. They are within a struggle against Christian forces of oppression. This allows Marowitz to explain certain actions that occur within the Shakespearean play from a non-Christian viewpoint. Jessica's elopement for example in Shakespeare is portrayed within a Christian context. Although it can be strongly argued that the Elizabethan dramatist's viewpoint allows criticism of Jessica's apostasy within for example the profligacy of selling a ring for a monkey or within the category of dubious lovers invoked in the great speech opening Act V '. . .In such a night as this. . .', it has to be conceded that such criticism is not foregrounded. In the general context of the drama her conduct receives Christian encouragement and approval. Marowitz consequently makes Jessica a strong revolutionary for the Jewish cause. She is instructed to 'entertain' Lorenzo as part of the plan against the Imperialist forces. Her reluctance to do this allows an opportunity for Shylock to give a statement of his moral position:

> It's no sin to deceive a Christian
> For they themselves hold it a principle,
> Faith is not to be held with heretics,
> But all are heretics that are not Jews.
> This follows well and therefore fear it not.

Jessica's sacrifice in having to associate herself with the Christian demonstrates the cold determination necessary for revolution:

> First be thou void of these affections:
> Compassion, love, vain hope and heartless fear.
> Be mov'd at nothing, see thou pity none,
> But to thyself smile when the Christians moan.

> p. 230

Marowitz is invoking the thoughts of Marlowe's Machiavellian villain Barabas,[20] but is placing them within a recognisable social context. The female revolutionary is a part of modern experience, and hypocritical sexuality by male or female for the ulterior purpose of political or revolutionary policy is commonplace within the armoury of spy stories whether real or fictitious.

Shylock makes the point, however, that deceit is part of a Christian way of life – Marlowe makes a similar point in *Tamburlaine*[21] – and Marowitz shows this to be correct by Bassanio's wooing of Portia. The trial of the caskets is presented as a charade in which the will is cheated through disguise. Bassanio first tries the golden casket dressed as Morocco and then tries the silver casket disguised as Arragon. Having failed to win in either case he has no problem in his own person in choosing the lead casket and winning the lady. Similarly Jessica finds that when alone with Lorenzo's friend Gratiano, he has no qualm about making advances to her, Marowitz transposing Lorenzo's humourous lines to Launcelot in Shakespeare's play (3.5.23–4) into an angry rather than frivolous statement made to Gratiano:

> Lorenzo (*Angry*) I shall grow jealous of you shortly,
> Gratiano if you thus get my wife into corners.

> p. 255

The moral values of the Christians are thereby reduced by Marowitz to pretension and hypocrisy, thus giving credence to the revolutionary activity of the Jews. Marowitz's central objection to Shakespeare's play as we have seen, is the trial scene and it is this that becomes the apex of his *Variations*. Having already employed the dressing up motif within the Bassanio episode Marowitz

measuredly refrains from dressing Portia as a learned lawyer. His focus is elsewhere. The Christians will not be defeated by wills, codiciles or laws and in court their racialist sense of values needs no disguise, it is enshrined within the law itself. Thus Balthazar, not Portia disguised, leads Shylock through the complexities of the situation. The Shakespearean scene, however, is still invoked. He gives the 'quality of mercy' speech and insists on the value of the law when Shylock refuses Bassanio's cheque to 'twice the sum'. Finally he traps Shylock with the blood and weight argument and the subsequent statement of the Venetian law concerning aliens seeking the life of any citizen. Shylock is thereby defeated not by a disguised woman but by the establishment itself. It is this that Marowitz is able to foreground, by the simple strategy of following the Shakespearean scene without the disguised Portia but with Balthazar speaking of the Venetian laws in a court dominated by the British group and the British Union Jack. Marowitz consequently alienates the audience from the progress of the Shakespearean scene, from which he is blatantly feeding. The audience recognises the Shakespearean play but reacts against it through the change of personnel and context. British justice having dominated, Shylock is defeated but instead of leaving the court in humiliation Marowitz has him turn contemptuously on the pompous Duke to give his first statement of revolution with lines from *The Jew of Malta* (1.2.110–15):

> Who hateth me but for my happiness?
> Or who is honour'd now but for his wealth?
> Rather had I a Jew be hated thus
> Than pitied in a Christian poverty
> For I can see no fruits in all your faith
> But malice, falsehood and excessive pride.

p. 281

Rather reminiscent of Brenton's *The Churchill Play* (1974) the revolution can now take place. The explosion is heard, the Union Jack falls, Shylock's compatriots enter and Jessica leaves Lorenzo to rejoin her father. Shylock's second statement of revolution is predictable and again feeds off the audience's knowledge of the Shakespearean template:

I am a Jew. Hath not a Jew eyes? hath not a Jew hands, organs, dimensions, senses, affections, passions? fed with the same food, hurt with the same weapons, subject to the same diseases, healed by the same means, warmed and cooled by the same winter and summer, as a Christian is? if you prick us do we not bleed? if you tickle us do we not laugh? if you poison us, do we not die? and if you wrong us, shall we not revenge? if we are not like you in the rest, we will resemble you in that. . . . The villainy you have taught me I will execute, and it shall go hard but I will better the instruction. p. 282

Marowitz gives a focus for an understanding of the Jewish situation, rather than a sentimental sympathising for the tragic figure of an actor's imagination. He attempts thereby to break the cultural traditions surrounding the play and confront the audience with the plight of the Jew battling against a moral code which naturally discriminates against the race in the context of its own hypocrisy. The difficulty with his *Variations* is that there is a danger in the sometimes laborious manner in which he switches the Shakespearean scenes about and imposes the Marlovian speeches. Perhaps he attempts too much in drawing on Shakespeare and Marlowe and setting the play in the 1940s. Although this does provide a mode of alienation for the audience it may also lead to confusion or to charges of naivety. Nevertheless it is a provocative challenge to the cultural assumptions implicit in our reception of Shakespeare's play.

Arnold Wesker's *The Merchant* is probably more successful than the Marowitz *Variations* in that it is less exaggerated.[22] Once again it is the ubiquity of Christian law, reflecting a cultural dominance that is at the heart of the play. Unlike Marowitz, Wesker historizes the action of the play within renaissance Italy. Unlike Shakespeare's play, however, Wesker's drama draws an accurate historical picture of Jewish existence in the Venetian Ghetto Nuovo, where the windows faced inwards on themselves rather than outwards to the Christians – the outer ones being blocked up – and where the Jews, discriminated against by the Venetians, were locked up at night and opened up in the morning.

Rather than set the play in Christian Venice where Shylock is naturally the outsider, Wesker places the first part of the drama within the Ghetto. Like Marowitz he too sees the need to break down the polarity of good Antonio, bad Shylock. Shylock is

presented as a cultured man, at home with his books. Antonio is his friend, a Christian visiting him in the Ghetto and helping to catalogue his illegal library. From the opening, therefore, Wesker shifts the boundaries of the play. Antonio is the outsider in the Jewish Ghetto, which in turn is an outsider's community within Venice. Further he negates the possibility of Shylock maliciously wishing to kill Antonio, by making them friends. Finally he gives Shylock the dignity of being a learned spokesman for the oppressed community.

In the opening scene both Shylock and Antonio as they catalogue the books, which have to be kept hidden because of prohibitive Venetian laws, regret the nature of a society that neglects culture in terms of a capitalistic concentration on the acquisition of money. The two men become drunk together and Antonio is thereby forced to stay the night in the Ghetto, which for a Christian is illegal. This allows Wesker to sketch his picture of a society which controls its affairs through oppressive laws but ones which, he is later to demonstrate, have to be followed. Dramatically it allows him also to bring Bassanio, Antonio's godson, into the Ghetto on the following day in search of his godfather. Thus the request for the loan to finance the Belmont expedition, is made on Jewish territory. In this way Wesker is able to present the problem of prejudice in relation to the law and to capitalism. Bassanio in need is prepared to enter Shylock's home in the Ghetto. Yet he is clearly from a different culture which considers itself superior. He looks at Shylock as if he were a creature from an alien world, rather than a human being. 'And that is a Jew?', he asks Antonio, who reprimands, '*He* is a Jew' (p. 17). It is a rebuke which Bassanio later recalls with astonishment when, back on safe territory, he can converse with his Christian friends. Throughout he finds it difficult to refer to Shylock as anything but 'The Jew'.

In contrast to this portrayal and to the Shakespearean text Shylock constantly attempts to offer friendship to the Christians. Unlike in the Shakespearean play for example he encourages Christian and Jew to eat together and to associate with one another. It is the Christian, Bassanio who is amazed and shocked at the fraternity between Shylock and Antonio. He says to Lorenzo:

> You should have heard them, discussing Venice as though the city cared for their voice, existed for their judgement! p. 26

To Christian youth this is the world 'turned upside down'.

Prejudice must not be diluted nor the status quo affected. Wesker thereby foregrounds prejudice rather than usury as the concern of the play that is to interact with the Venetian law, and he adds to this the complexity of friendship. Antonio approaches Shylock for the money as a friend not as a money lender. Shylock in terms of friendship wishes to lend money without the surety that the law demands. The question becomes one of cold law against the humanity of friendship. Antonio cannot allow Shylock to depart from the law, since for an oppressed minority the law however prejudiced is its only protection. If Shylock suspends the law for friendship then the law cannot be guaranteed to protect his rights in other matters. It is a point that Robert Bolt makes in a rather different context in *A Man for All Seasons*. In that play More asks Roper if he would break down the law to catch the devil. When Roper replies that he would, More rebukes him by asking him where he would find his protection once all the laws were down and the devil turned upon him. Antonio's point in Wesker's drama is similar; for the minority race the law must be applied for the sake of minority itself.

The danger of the law turning against the minority is reinforced by the dramatist early iin the play through the arrival of Solomon Usque and Rebecca da Mendes from Lisbon where they report the law has turned against their nation, viciously executing them:

Usque	Fifty people burnt at the stake.
Rebecca	Old women, young men, relatives, friends.
Usque	Marian Fernandes, a cousin from Lisbon.
Rebecca	Maria Diez, my old aunt from Guarda.
Usque	Sebastian Rodrigo Pinto, a friend from Lamego.
Rebecca	Diego Della Rogna, his wife Isabella Nones, their four daughters and two sons.
Usque	An entire family burnt.
Rebecca	Facing each other.

$$\text{Silence} \qquad \text{pp. 12–13}$$

This is the grotesque context, highlighted by Wesker with the listing of the names, the statement of their being an entire family and the culmination of the story with the information that they had to witness one another being burnt to death, in which Antonio insists on the legal bond whilst Shylock naively looks towards the bond of his own integrity within his moral law:

Antonio Be sensible! The law of Venice is a jealous one, no
man may bend it. The city's reputation *rests* on respect
for its laws.

Shylock Sensible! Sensible! I follow my heart, *my* laws. What
could be more sensible? The Deuteronic Code says
'Thou shalt not lend upon usury to thy brother. Unto
a foreigner thou mayest lend upon usury, but unto
thy brother not.' Your papacy, however, turns your
laws against us. But for once, Antonio, let us not quite
bend the law but interpret it as men, neither Christian
nor Jew. I love you, therefore, you are my brother.
And since you are my brother, my laws say I may not
lend upon usury to you, but must uphold you. Take
the ducats. p. 24

Shylock has an idealism above the social strictures of the com-
munity. Love, ironically the essential quality of the Christian code,
is the attribute which Shylock possesses par excellence for his
friend. But Antonio demands a pragmatism based on reciprocity
of friendship but one bound by the knowledge of the Jewish
predicament:

Antonio I understand. And it brings me closer to you than
ever. But the deeper I feel our friendship the more
compelled I feel to press my point, and protect you.
You are a Jew, Shylock. Not only is your race a
minority, it is despised. Your existence here in Venice,
your pleasures, your very freedom to be sardonic or
bitter is a privilege, not a right. Your life, the lives of
your people depend upon contract and *your* respect
for the laws behind contract, just as your contract with
the city councillors *they* must respect. Therefore you,
of all people, have need of that respect for the law.
The law, Shylock, the law! For you, and your people,
the bond-in-law must be honoured. p. 25

It is in these terms that the bond of flesh becomes a challenge to
the law, 'a nonsense bond' which rebounds on Shylock and
Antonio. Ironically it is because of Antonio's argument concerning
the protective nature of the law that Shylock is forced to require
his pound of flesh when his friend fails to honour his commitment:

Shylock	They'll let us drop the bond.
Antonio	We cannot, must not.
Shylock	You understand?
Antonio	I understand.
Shylock	I'm frightened that you don't.
Antonio	I do.
Shylock	I will not bend the law.
Antonio	I understand.
Shylock	I must not set a precedent.
Antonio	I know.
Shylock	*You* said. *You* taught.
Antonio	Shylock, Shylock! I'm not afraid.
Shylock	Oh friend! What have I done to you? p. 62

The problematic issue has become the interaction of the law with their friendship. Shylock cannot even state his reasons for the bond since proclamation would negate the protection which he requires for his own people.

As with the Marowitz version there is no need in the trial scene for disguises. Portia and Nerissa however do conduct Antonio's defence in their own right as women. The prevailing prejudice of the Christians is made clear by Lorenzo's loquacious and conceited damning of Shylock, not he professes because he is a Jew but because he is a usurer. This denial of anti-semitism together with the charge of usury which the audience knows to be totally false confirms the picture of Lorenzo's racism which has been prepared for earlier through his dialogue with Bassanio. The 'Hath not a Jew eyes?' speech is spoken by him, not Shylock, and becomes in the smoothness and hypocrisy of its delivery from his lips a testimony to the shallow morality of the Venetian culture. Enraged Shylock shouts out at the court a defence of his humanity, so grossly patronised by Lorenzo's speech:

No, no, NO! I will not have it. (*Outraged but controlled.*) I do not want apologies for my humanity. Plead for me no special pleas. I will not have my humanity mocked and apologized for. If I am unexceptionally like any man then I need no exceptional portraiture. I merit no special pleas, no special cautions, no special gratitudes. My humanity is my right, not your bestowed and gracious privilege. pp. 76–7

Through friendship in opposition to prejudicial law Wesker has established the individual's humanity as the undeniable right of existence. It is a humanity that will not be patronised but it is a humanity which can be constantly persecuted by dominant moralities and cultures. Portia's revelation of the loophole in the law is received with relief and joy – a bond of friendship can perhaps triumph over bias and discrimination. Such thinking, Wesker states, is naive. The law strips Shylock of his books, the symbols of his life and essence as a man. The oppressive culture is confirmed in its philistinism and inhumanity but is consistent with Wesker's bleak portrayal. Shylock acquieses. What else can he do? The law still must be upheld or the prejudicial conditions under which his people survive would be exacerbated.

For Wesker the conclusion of the play cannot be found in Marowitz's revolutionary acts nor can it be decorated by a fifth act which affirms the harmony of Christian marriage, as occurs in traditional readings of Shakespeare's play. Rather Wesker concludes with the bitterness of discontinuity. Jessica rejects Lorenzo and Portia determines that Bassanio will know his place in her home. Wesker's *Merchant* is no fairytale, no commedia dell'arte experiment nor is it a sentimentalised tragedy. Rather it is a statement of the discord that evolves when men of positive values are persecuted merely because they exist in or near a society of prejudice and ignorance.

Wesker's is a challenging play. It is lamentable that as I write, it still has not received a London production. In its own right *The Merchant* must stand alongside his acclaimed *Trilogy*,[23] as one of his finest dramatic achievements. In its contrast to the traditions surrounding *The Merchant of Venice*, it, like Marowitz's *Variations*, helps to expose the bourgeois expectations that productions of Shakespeare's play may have unwittingly nurtured. Of Shakespeare's play itself however, it tells us very little and neither it nor the *Variations* give any real guide as to how the modern theatre might find a mode of production which equates to the original Shakespearean event. The simple answer may be as some have suggested, that the play should no longer be performed. This, however, is to cut the Gordian knot. Shakespeare's play involves racial issues. Issues and prejudice, however, are different matters. It may be that the modern audience brings to the play notions about prejudice that are not contained for one reason or another, within its original concept. Historically we cannot assume that

the nature of Elizabethan prejudice is synonymous with our understanding of the term. It certainly was not. One of the most recent directors of the play, John Barton, fell into the trap of evaluating and apologising for the drama through his insistence that the Christians in the work are racist but that Shakespeare is non-committal.[24] Ralph Berry has gone further:

> I assume that Shakespeare's intention was to build into the text a strategy for confronting the audience with its own assumptions and wishes. 'Here is a murderous Jewish usurer, defeated by Christian legal skill. Are you happy about it?'[25]

In other words Berry sees the play as a continual challenge to prejudices both Elizabethan and modern. He insists, therefore:

> It is not a play rendered obsolete by history. And it gives evidence of its vitality by its capacity to offend . . . I . . . prefer to acquiesce in the logic of the text, and say: the disturbed reaction is the correct one. We recognize the play through its attack upon us. The grand object of *The Merchant of Venice* is to create feelings of unease, disturbance, insecurity, perhaps guilt, revulsion, repugnance – in a word, and to simplify, discomfort.[26]

Did the comic caricature of Burbage's Shylock do this? Perhaps the Shakespearean text in juxtaposing a humanity of character with a comically grotesque symbol of Christian evil, offended his audience in its own laughter. If we accept such a reading of the play then modern productions need to throw out the intertextual tradition of the Shylock performance. Instead of humanising the character through naturalistic consistency we should perhaps give no excuses but merely portray the character as an evil caricature and comic victim of Christian fun. In doing so we would not pamper to bourgeois feelings of guilt, to which Wesker objects, but offend those feelings by presenting the uncomfortable truth of the prejudicial mind. The difficulty is whether as an audience we are ready for such an interpretation or whether we would see it as merely an eccentric reaction to the cultural myth, which could still contain it. The timing is crucial but the necessity is clear. Rather than deconstructing *The Merchant of Venice* only to reconstruct it in a sincere but necessarily reductive manner of Marowitz or Wesker we may need to demythologize Shylock and allow Shakespeare's

blatant image to stand in the context of the Elizabethan's possible conception of the play. Theatrical cosiness and pandering to conscience would be dissipated in the offensive image of the Shakespearean original. Having done that, however, a new tradition would probably begin to evolve which in itself, would require in time to be demythologized. For the present what we have is a misleading acting tradition for the play, a nervous sensitivity prevailing from our knowledge of history and with Marowitz and Wesker two brave attempts to bring to mind the problems that surround this highly popular Shakespearean work and to correct some of the false assumptions that we may have about its issues.

5

Frustrating Dramatic Structure: Samuel Beckett, *Waiting for Godot* and *Endgame*

John Peter reviewing Howard Davies' production of *Troilus and Cressida* at the Royal Shakespeare Theatre in 1985 dismissively refers to 'the modish view which compares *King Lear* to *Waiting for Godot* because both have two desolate old men in a desolate countryside' (*The Sunday Times*, 30 June 1985). Of all modern drama Beckett's work has probably been bandied about more than any one else's in parallels being drawn with Shakespeare's work. John Fletcher and John Spurling have traced the first statements of comparison to Roy Walker writing in *The Twentieth Century*, December 1958,[1] but the popular or 'modish' conception of the idea derives from the 1960s with Jan Kott's essay *King Lear, or Endgame* which was influential on Peter Brook's famous RSC production at Stratford (1962) and subsequently in London, with Paul Scofield as the King. Kott's essay emphasised the grotesque element in Shakespeare's play in conflict with the tragic:

> The world of tragedy and the world of grotesque have a similar structure. Grotesque takes over the themes of tragedy and poses the same fundamental questions. Only its answers are different. This dispute about the tragic and grotesque interpretation of human fate reflects the everlasting conflict of two philosophies and two ways of thinking. . . . Between tragedy and grotesque there is the same conflict for or against such notions as eschatology, belief in the absolute, hope for the ultimate solution of the contradiction between moral order and everyday practice. Tragedy is the theatre of priests, grotesque is the theatre of clowns.[2]

Kott's thesis is to show that what occurs in Shakespeare's play is

the movement of Lear through 'the school of clown's philosophy'. The Fool teaches Lear in a language 'of our modern grotesque. The same grotesque that exposes the absurdity of apparent reality and of the absolute by means of a great and universal *reductio ad absurdum'* (p. 133). In modern theatre the exponents of grotesque were the absurdist dramatists of the 1950s including Beckett, Genet and Ionesco. Brook's production of the play emphasised the relationship between fool and priest in an incomprehensible world which testified only to the pointlessness of sanity in an absurd existence. Gāmini Salgādo writes of Alec McGowan's Fool in the production:

. . . this was a circus clown in the world of Beckett's Vladimir and Estragon: a 'bitter fool' indeed whose humour constantly showed the scars inflicted by a cruel and absurd world. . . . Suffering and the incapacity to comprehend that alone seemed to be all that existed in this world, pitilessly illuminated in every corner for our inspection. The rare moments in the performance when Lear seemed to evoke the audience's sympathy rather than its spell-bound fascination came almost entirely when King and Fool came together, as in Scofield's delivery of 'O fool, I shall go mad.'[3]

The Beckettian parallels were strong and have often been discussed. But all this occurred a quarter of a century ago and one might have thought that discussion on the subject might well have become exhausted. Yet in 1985 Peter still feels it relevant to dismiss the comparison between *King Lear* and *Godot*, whilst Alan Sinfield from a different standpoint complains in *Political Shakespeare* (1986) that for Adrian Noble's 1982 production of *King Lear* the director 'actually invoked Jan Kott'.[4] Certainly the influence of Beckett on modern theatre has been maintained since the fifties. In recent years a number of Beckettian productions of classic plays have taken place, one of the most notable being Christopher Fettes's production of Marlowe's *Dr Faustus* in 1980 with Beckett's original Krapp, Patrick Magee, taking the role of Mephistophiles and with Valdes and Cornelius being portrayed in the manner of *Endgame's* Clov and Hamm.[5] In the 1985/6 RSC season Howard Davies' production of *Troilus and Cressida*, despite not drawing direct comparisons with Beckett, could not help being reminiscent of another so called absurdist play, Jean Genet's *The Balcony*.

What is it that makes the parallels between Shakespearean plays and the work of Beckett so tempting and enduring for critics and producers alike? Possibly, as Sinfield suggests, it is a matter of political naivety on the part of the liberal humanist directors and critics that make up our theatrical establishment. Another view is the one posed by John Northam who has indicated that it is something concerned with the 'structure and meaning' of a Beckett play in comparison with a Shakespearean that forces us into comparisons:

> The collocation of two plays so dissimilar as *The Tempest* and *Waiting for Godot* may well appear an exercise in misplaced ingenuity. It cannot be justified by the indubitable evidence of Beckett's awareness of Shakespeare's play as he wrote his own (the near-quotation from Act 1 scene 2 in Lucky's speech) still less by the merely suggestive evidence that Caliban's character may be reflected in Gogo's (his coarse physicality, his greed, his flashes of poetry, his reluctant waking from a dream, his readiness to worship a man for his possessions), that Beckett's strategy of polarities (Gogo/Didi, Pozzo/Lucky) may owe something to Shakespear's (Ariel/Caliban), or that Pozzo's reflections on the sky in Act 1 may be intended as a remote and reductive echo of 'our revels now are ended'. I hope merely to show how comparison based on different considerations has helped me clarify for myself the structure and meaning of a modern play which, while by its very nature it seems to refute such an analysis, deserves the same degree of attention as is paid to Shakespeare or Racine.[6]

Both views of course are subjective, related to different traditions of literary criticism. Ironically one of the most prominent of Beckett's critics, Ruby Cohn, notes in the face of all the parallels, that in 'Beckett's best-known play, the Shakespearean residue is small. . . . *Godot* is barely Shakespearean.'[7] The issue though is not to be found in verbal echoes but rather in the relationship of the structure and meaning of the Beckett play in relation to a Shakespearean. To discuss the plays in these terms, however, there is a need to consider what can be understood through the structure of a play, Shakespearean or Beckettian.

Shakespeare was primarily a craftsman, writing plays for a successful theatre company. Like so many artists before and since

Shakespeare discovered a formula by which his plays could operate. The skeleton of the plays, as Emrys Jones has demonstrated,[8] could in certain circumstances be applied to both a tragedy and a comedy. The formula provided Shakespeare with a dramatic structure which would be filled out through the plot. For the sake of simplicity we can see how this operates within Shakespearean romance comedy. In my view the basic structure appears to be:

(a) an opening statement(s) of a dilemma or an impossible resolution often but not always, associated with the threat of death;
(b) a search involved with the opening statement relating firstly to an individual or to a number of individuals attempting to find identity or self knowledge, and secondly to one or more couples attempting to discover some form of relationship;
(c) the requirement of the searchers to remove themselves from the society which formed the norm of the opening statement, that removal often being signified by geographical relocation or physical disguise or both;
(d) through the adventures under disguise or in the area of relocation a movement being made towards a resolution of the difficulties which is finally accomplished through an engineered recognition scene – Aristotelean *anagnorisis* – in which misunderstandings of identity are realised and the multiple marriage usually results.[9]

Through this structure Shakespeare develops his plot, produces his satire and makes social comment even on elements implicit in the structure, such as marriage or the nature of disguise in relation to the social norms that define identity. In *Twelfth Night* for example Orsino loves Olivia but she indulgently mourns her brother's death and refuses Orsino's advances. A girl, Viola, is shipwrecked, her twin brother – the twin being an aspect of her identity – lost at sea. She determines to serve the love stricken lord. The search for her identity now that the stability of her family and her twin have been lost and the search also for Orsino's and Olivia's self knowledge, involve Viola exacerbating the discontinuity of her identity. She dresses up as a man, Cesario, to be accepted at either house.[10] Adventures, confusions and further misunderstandings acrue in that both Olivia and Orsino form attachments to Viola–Cesario. The adventures are concluded by the engineered recognition scene in which the lost twin brother, Sebastian, arrives and

recognises his sister. Multiple marriage is announced in which possibly as Catherine Belsey notes 'the heroine dwindles into a wife'[11] and in which the clown wryly comments on the dominant masculine viewpoint:

> But when I came, alas! to wive,
> With hey, ho, the wind and the rain,
> By swaggering could I never thrive,
> For the rain it raineth every day.

Twelfth Night, 5.1.383–6

Similarly in *As You Like It* there is initial discord in two households: Orlando's and the Duke's. This leads to a search for a new life and existence for Orlando, the Duke, Rosalind and Celia, the latter two having to disguise themselves as Ganymede and Aliena. All escape to the forest where the ramifications of the changes of identity are presented until Ganymede engineers through the agencies of Hymen, a recognition scene. This allows for the multiple marriage together with a return to the original geographical location in the city:

> Wedding is great Juno's crown;
> O blessed bond of board and bed!
> 'Tis Hymen peoples every town;
> High wedlock then be honoured.

As You Like It, 5.4.135–8

From the basic structure the actors, guided by Shakespeare – in *commedia dell' arte* the actors are their own guide, improvising the plot – produce the plot of the play. This has a resolution in accordance with the dominant ideologies of the Elizabethan period, such ideologies however being questioned in the progress of the dramas themselves as Belsey has again noted:

> . . . the plays are more than their endings, and the heroines become wives only after they have been shown to be something altogether more singular because more plural.[12]

The aesthetic unity of a play is accomplished through the harmoni-

ous interlocking of structure and plot which permits a variety of discourses within its progress, including those bringing into question assumptions concerning its own harmony or aesthetic unity. Fabian comments in *Twelfth Night*:

> If this were play'd upon a stage now, I would condemn it as an improbable fiction. 3.4.121–2

In some plays, as for example *Measure for Measure*, the discursive discourse is foregrounded to such an extent that it cannot be contained by the artificiality of the play's structure, leading critics later to term the play as problematic.[13] By the time of writing *The Tempest* – one of only two dramas by Shakespeare which accords with the Neo-classical formula of the three unities[14] – the dramatist was again containing discursive discourse within a harmonious plot. Within this play Shakespeare creates a controlling force for the dramatic structure in the character of Prospero. The magician placed in his geographical relocation, the island, at the moment of the play's inception, controls its plot to the point of *anagnorisis*; the recognition or awakening of the characters from their confusions. But the magician himself is an actor subject to the dream of the play:

> These our actors,
> As I foretold you, were all spirits, and
> Are melted into air, into thin air;
> And, like the baseless fabric of this vision,
> The cloud-capp'd towers, the gorgeous palaces,
> The solemn temples, the great globe itself,
> Yea, all which it inherit, shall dissolve,
> And, like this insubstantial pageant faded,
> Leave not a rack behind. We are such stuff
> As dreams are made on; and our little life
> Is rounded with a sleep.

The Tempest, 4.1.148–58

Prospero recognises his artificiality is subject to the construct of the play related to the world outside, the world that is of the audience's perception of reality. Within the constraint of the drama however Prospero is able to demonstrate a faith in a controlling

force beyond his experience of reality, a force which John Northam
terms Providence:

> His magic power . . . is given, not explained, and true Providence
> is something which is greater and more mysterious than he, since
> it has acted 'strangely' on his behalf. And though Providence may
> act in this way in the special circumstances of the play, it cannot
> be assumed to operate even with this degree of comprehensibility
> within the context of ordinary living; Prospero's magic powers
> are relinquished before the return to the world of social commit-
> ments. There man must live by his faith or lack of faith in
> Providence.[15]

It is 'faith or lack of faith in Providence' in relation to the structure
and setting of a play which informs the working of Beckett's drama
as much as it does Shakespeare's. The structure and settings of
the Elizabethan dramatist in demanding geographical relocation,
in for example *As You Like It* and *The Tempest* a movement from
the city to the country or to an island,[16] communicates statements
concerning the experiences of the characters in their attempts to
cope with the problem of existence. The re-establishment of the
original location implies some form of resolution. It is in this that
an affinity and a contrast can be found with Beckett's work. It can
be suggested that Beckett's settings approximate to the geographical
relocations found in such Shakespearean plays. In *Waiting for Godot*
Gogo and Didi are stranded in a lane with a solitary tree. Pozzo
and Lucky pass by and leave, come again and leave again. They
talk but there's no communication, except for some physical and
mainly animalistic reactions made to one another – the reaction to
shout when in pain, the instinct for revenge, for food and for
sexual enjoyment. Yet all these are seen to be bankrupt or
ridiculous. The only possible controlling agent is Godot from whom
they are separated. There is no Prospero on stage, no Ganymede
to introduce Hymen – just the two characters in the country lane.
Unable to exercise any control over anything they can do nothing
when Pozzo arrives or when Lucky refers to 'the divine Miranda'
recalling Miranda's own description of Ferdinand (*The Tempest*,
1.2.418). For neither in metaphysics or art is their to be any release
from the gabble of existence:

Given the existence as uttered forth in the public works of Puncher and Wattmann of a personal God quaquaquaqua with white beard quaquaquaqua outside time without extension who from the heights of divine apathia divine athambia divine aphasia loves us dearly with some exceptions for reasons unknown but time will tell and suffers like the divine Miranda with those who for reasons unknown but time will tell are plunged in torment plunged in fire whose flames if that continues and who can doubt it will fire the firmament that is to say will blast hell to heaven so blue still and calm so calm with a calm which even though intermittent is better than nothing . . .[17] pp. 42–3

For Beckett's characters 'time will tell' only of further time and of nothingness. For them Viola's faith in time's revalatory power, 'O Time, thou must untangle this, not I;/It is too hard a knot for me t' untie!' (*Twelfth Night*, 2.2.38–9) is an absurdity.

In *Krapp's Last Tape* Krapp is similarly isolated in his room, alone only with his memories, played out on the tape recorder. Prospero too has his memories of what he was, of how he came to the island, which he plays out to the inattentive Miranda (*The Tempest*, 1.2.23–169). His past however is to inform the present. Through his rememberance he is to find the impetus for action when time provides. Miranda may irritate him in her inattentiveness but she has a belief in his love and a compassion for his history. In the conclusion Prospero is able to move, to leave his island. Krapp however remains static. In *Happy Days* Winnie is buried up to her breasts in earth, unable to move, talking without communicating. By Act 2 she is buried to her neck. There is no escape from her island. She has become fused with it. She is the island. Her husband attempts to move round it, to make contact but despite all her talk she remains an island of earth, an island solitude.

The island – or rather peninsular – is the setting also of *Endgame*. There Clov and Hamm exist in a house, the last bastion of humanity. Blind Hamm is confined to a chair being served by the old stancher Clov but unable to do anything. Hamm, the ham-actor or maybe as Ruby Cohn suggests Hamlet[18] – warms up for his last soliloquy, Clov prepares for 'making an exit'[19] but the end is stasis:

Clov! (*Long pause*) No? Good (*He takes out the handkerchief.*) Since that's the way we're playing it . . . (*he unfolds handkerchief*) . . .

let's play it that way . . . (*he unfolds*) . . . and speak no more
about it . . . (*he finishes unfolding*) . . . speak no more. (*He holds
the handkerchief spread out before him.*) Old stancher! (*Pause*) You
. . . remain. (*Pause. He covers his face with handkerchief, lowers his
arms to armrests, remains motionless. Brief tableau.*)

CURTAIN *Endgame*, pp. 52–3

Art is as spurious a notion as God if we think that through it some
order making sense of existence can be perceived. Last exits are as
fictitious as the dramas themselves. They have no significance.
They are merely just another way of 'playing it'. In terms of the
dramatic structure what is absent from all these plays is the
recognition scene. There is no mechanical device to resolve the
confusion of the play, no curtain to be drawn back to reveal
Ferdinand and Miranda playing chess, finding an ordered con-
tinuity of existence through their relationship. In *Endgame* such
mechanisms of drama are banal:

Hamm More complications! . . . Not an underplot I trust.
 (*Clov moves ladder nearer window, gets up on it, turns
 telescope on the without.*)
Clov (*dismayed*). Looks like a small boy!
Hamm (*sarcastic*). A small . . . boy!
Clov I'll go and see. (*He gets down, drops the telescope, goes
 towards door, turns.*) I'll take the gaff.
 (*He looks for the gaff, sees it, picks it up, hastens towards
 door.*)
Hamm No!
 (*Clov halts*)
Clov No? A potential procreator?
Hamm If he exists he'll die there or he'll come here. And if he
 doesn't . . .
 (*Pause.*) *Endgame*, pp. 49–50

What we find in Beckett's drama is a statement within the structure
of the play that there can be no 'brave new world',[20] no means of
escape from the island, no return from the forest or country lane.
The feed off from Shakespeare, therefore, is largely found by
implication in the modern dramatist's revolutionary approach to
dramatic structure. The entirety of existence has become not the
release but the stasis of the geographical relocation found in the

Elizabethan's work. The land of banishment, escape or disguise whether Illyria, the Forest of Arden or Prospero's island has become the norm of Beckett's characters' perception of reality. There is no exit. Unlike Prospero, Vladimir cannot philosophise on the state of life as like a sleep since he cannot even decide whether he is asleep or not:

> Was I sleeping, whilst the others suffered? Am I sleeping now? Tomorrow, when I wake, or think I do, what shall I say of today? That with Estragon my friend, at this place, until the fall of night, I waited for Godot? That Pozzo passed, with his carrier, and that he spoke to us? Probably. But in all that what truth will there be? (*Estragon, having struggled with his boots in vain, is dozing off again. Vladimir stares at him.*) He'll know nothing. He'll tell me about the blows he received and I'll give him a carrot (*Pause*) Astride of a grave and a difficult birth. Down in the hole, lingeringly, the grave-digger puts on the forceps. We have time to grow old. The air is full of our cries. (*He listens.*) But habit is a great deadener. (*He looks again at Estragon*) At me too someone is looking, of me too someone is saying, He is sleeping, he knows nothing, let him sleep on. (*Pause.*) I can't go on! (*Pause*) What have I said? *Waiting for Godot*, pp. 90–1

Nevertheless in many of the plays Beckett is also explicit in deliberately drawing attention to the artifice of the drama itself and to the traditions of theatre from which he is feeding. The verbal echoes from Shakespeare foreground the intertextuality of the plays, appealing to the residual knowledge of the audience. In the passage above for example the image of the graveyard and the forceps is for the *cognescenti* reminiscent of the philosophising Hamlet holding Yorick's skull. The final phrases of the speech may also – as Ruby Cohn suggests – derive from Prospero's 'We are such stuff as dreams are made on . . .'[21] Certainly Lucky's speech as we have seen draws attention to *The Tempest* whilst in *Endgame* Hamm reports 'Our revels now are ended.' This echoing of the Shakespearean canon is not a matter of mere dramatic dexterity or critical ingenuity. It is related to the nature of the Beckettian dramatic statement. Through blindness Shakespeare's Gloucester finds sight, through barrenness, led part of the way by the Fool, King Lear finds contentment in the arms of Cordelia. Although Gloucester, Lear and Cordelia will die, they will do so with a

knowledge and perception of error, foolishness and mistake. But for Beckett blindness is final. The image in *Endgame* from first to last is of Hamm seated, blind. The image on the return of Pozzo in Act 2 of *Waiting for Godot* is of a blind man being led nowhere by the clown. There is no vision of an existence beyond the heath. The potential beauty and fullness of Prospero's island which is encompassed in the figures of Ariel and Caliban, is in the twentieth-century's metaphysical drama, ephemeral nonsense. There is only the crudity of the Caliban vision, unrelieved by the music, the 'Sounds, and sweet airs, that give delight and hurt not', (*The Tempest*, 3.2.131). There is only the weariness of an Aliena or an old Adam as they reach the forest – an exhaustion that has become permanent. Hamm tells the story of the madman:

> I once knew a madman who thought the end of the world had come. He was a painter – and engraver. I had a great fondness for him. I used to go and see him, in the asylum. I'd take him by the hand and drag him to the window. Look! There! All that rising corn! And there! Look! The sails of the herring fleet! All that loveliness! (*Pause.*) He'd snatch away his hand and go back to his corner. Appalled. All he had seen was ashes. (*Pause.*) He alone had been spared. (*Pause.*) Forgotten. (*Pause.*) It appears the case is . . . was not so . . . so unusual. *Endgame*, p. 32

All beauty has gone in the stasis, the endgame of existence. The play has lost its mechanism for a resolution. There can be no *anagnorisis* and, therefore, there is merely the chaos of the asides, the last soliloquies, the temporary exits and appearances, the echoes of Shakespearean models.[22]

John Northam argues that however bleak a picture is being painted, Beckett must have some kind of faith as is testified by the mere fact of him writing anything at all. The argument is one rehearsed in the famous debate between Kenneth Tynan and Eugene Ionesco in which the latter concedes that the very act of writing means a statement of a total incapacity to communicate is negated.[23] Beckett's plays paint the bleakest picture possible of man's impotence in the face of what he perceives to be an absurdity of existence and to do this he mocks the art form in which he engages and in which Shakespeare excelled. The reminiscenses from *The Tempest*, *Hamlet* or *King Lear*, the frustration of the so often finely woven structure of the Shakespearean play becomes

in Beckett a central dramatological emblem. Simultaneously he demonstrates both a faith and a lack of faith in the artistic form to explain, relieve or compensate for the monotony of existence. Nevertheless by writing Beckett still creates. He admits the existence of a 'potential procreator' in himself and it is here that we can resort to another modern artist in looking at the Beckettian metaphor. The American poet Wallace Stevens, like Shakespeare and Beckett, employs in his great poem of the twentieth-century *Sunday Morning*, the image of the island solitude:

> We live in an old chaos of the sun,
> Or old dependancy of day and night,
> Or island solitude, unsponsored, free,
> Of that wide water, inescapable.

The statement is one of desolation but it is one relieved by the expression in the art itself. If for Stevens God could not exist, chaos could still be averted by the beauty of the world itself:

> Deer walk upon our mountains, and the quail
> Whistle about us their spontaneous cries;
> Sweet berries ripen in the wilderness;
> And, in the isolation of the sky,
> At evening, casual flocks of pigeons make
> Ambiguous undulations as they sink,
> Downwards to darkness, on extended wings.[24]

Hamm's story of the man who from the window could see nothing but ashes, was of a lunatic. He was not unusual. Beckett gives a picture of the world of the madman, the fool, the clown but in doing that he affirms his right to create – even in the satire of his own artistic form. Shakespeare's clowns never reach Dover, never escape from Illyria whilst the melancholic Jacques can take only a monastic refuge. Beckett's characters remain with the Shakespearean clowns but he himself by writing of them accepts a glimmer of hope even in his denial of artistic order. Paradoxically he expresses within his pessimism, a faith and optimism which may not be as far as he intends from Shakespeare.

6

Modern Morality Plays: Eugene Ionesco, *Exit the King* and *Macbett*

M. C. Bradbrook writes of Eugene Ionesco's *Exit the King*:

> In *Exit the King*, Ionesco is refashioning the deposition of Richard II, as earlier playwrights refashioned Greek myth. This play of Shakespeare has long fascinated him, and from it he draws the ceremonious grandeur of deposition and death. Love and Necessity, the rival Queens, carry out the ritual of despoiling, which would be thoroughly in the vein of some late medieval writer. In this play Ionesco has reached a firm simplicity of outline, and a completely traditional theme.[1]

In its medieval vein the play resembles not only *Richard II* but *Everyman* and *Dr. Faustus*. In each case they are plays concerning the final moments of an individual's existence. Everyman sees all disappear from him. In the end he is left almost totally alone. Marlowe's Dr Faustus at the end of his play is entirely on his own dismissing his servants whilst he waits for the 'one bare hour' to pass. Richard II also loses everything until in Promfret Castle he is alone with his thoughts and the music of life beyond his prison walls:

> Music do I hear?
> Ha, ha! Keep time. How sour sweet music is
> When time is broke and no proportion kept!
> So is it in the music of men's lives.
> And here have I the daintiness of ear
> To check time in a disorder'd string:
> But for the concord of my state and time,
> Had not an ear to hear my true time broke.
> I wasted time, and now doth time waste me . . .
>
> *Richard II*, 5.5.41–9

Shakespeare employs music as means for Richard to contemplate the loss of time. It is time which proves the enemy of man. Throughout Ionesco's plays time is erratic: clocks whirl, bells chime in halves, time speeds:

Marguerite It's midday already
King It's not midday. Why yes, it is! It doesn't matter.
 For me, it's the morning. *Exit the King*, p. 23[2]

If there is one universal truth, it is the inability of man to stop the progress of time, the progress that is towards the inevitable moment of death. Marlowe's Dr Faustus impotently cries out in his dying hour:

> Stand still, you ever-moving spheres of heaven,
> That time may cease, and midnight never come;
> Fair nature's eye, rise, rise again, and make
> Perpetual day; or let this hour be but
> A year, a month, a week, a natural day,
> That Faustus may repent and save his soul.
>
> *Dr Faustus*, Sc xix, 136–42[3]

Faustus's cry is ridiculous, and will remain so whatever man does. Perhaps like Marlowe's Tamburlaine, one might embalm the body of the dead loved one and have it constantly carried with you in procession. It can be done but it will not make the loved one live again. Solutions are impossible. Whatever the action taken, time will continue. For Ionesco, King Berenger's court engages in a facile ceremony:

Guard (*announcing*) The ceremony is about to commence!
 (*General commotion. They all take up their positions, as if for some solemn ceremony. The King is seated on his throne, with Marie at his side.*)
King Let time turn back in its tracks.
Marie Let us be as we were twenty years ago.
King Let it be last week.
Marie Let it be yesterday evening. Turn back, time!
 Turn back! Time, stop!
Marguerite There is no more time. Time has melted in his
 hands. pp. 35–6

Marguerite's statement is the inverse of reality. It is not man than melts time, but time which decays man. Time is only flexible in its perception by the individual. As a measurement it is constant, as an experience it fluctuates. In *As You Like It* Rosalind instructs Orlando in the experimental nature of time. 'Time' she says 'travels in divers paces with divers persons' and she continues by giving comic examples of how 'it trots hard' for the young maid between the contract and solemnisation of marriage; how it 'ambles' with 'a priest that lacks Latin and a rich man that hath not the gout'; how it 'gallops' for a thief going to the gallows and how it 'stays' with 'lawyers in the vacation' (*As You Like It*, 3.2.290–312).[4] The problem as Shakespeare sees it throughout his works is in the attempt to reconcile the constantly ordered measurement of time, as symbolised for example in the prison scene in *Richard II* by the music heard from within the Castle, with individual experience, Richard wasted away in prison.[5] In *Exit the King* Berenger believes he has only just come to the throne. Marguerite informs him otherwise:

King	. . . What a joke, what a farce! I came into the world five minutes ago. I got married three minutes ago.
Marguerite	Two hundred and eighty-three years.
King	I came to the throne two-and-a-half minutes ago.
Marguerite	Two hundred and seventy-seven years and three months.
King	Never had time to say knife! Never had time to get to know life. pp. 44–5

The truth is not that time is the joker but that man subsumes his fear of death through an elaborate language of pretence. Richard II at Barkloughly meditates upon death and in so doing he conjures up an image of a character sitting in the court of his crown, waiting to kill him. The ideology of Shakespeare's view of Richard's kingship in relation to medieval iconography is enshrined within the language:

> . . . for within the hollow crown
> That round, the mortal temples of a king
> Keeps Death his court; and there the antic sits,

Scoffing his state and grinning at his pomp;
Allowing him a breath, a little scene,
To monarchize, be fear'd, and kill with looks;
Infusing him with self and vain conceit,
As if this flesh which walls about our life
Were brass impregnable; and, humour'd thus,
Comes at the last, and with a little pin
Bores through his castle wall, and farewell, king!

<div align="right">

Richard II, 3.2.160–70[6]

</div>

The language conjures the picture of the medieval dance of death,
coming to commoner or king alike. But there is also the distancing
of the self from the inevitability of death, through its very allegorisa-
tion as the antic. There is an heroic romanticism in Richard's speech
despite the macabre underpinning of the images he employs. In
the context of Shakespeare's play Richard resorts to fables of
religion and mythology to comfort himself. No power can touch
him because he has divine protection:

For every man that Bolingbroke hath press'd
To lift shrewd steel against our golden crown,
God for his Richard hath in heavenly pay
A glorious angel. Then, if angels fight,
Weak men must fall; for heaven still guards the right.

<div align="right">

Richard II, 3.2.58–62

</div>

Even following the hollow crown speech, Richard maintains at
Flint his comparisons of himself with Christ and with Judas. The
truth of the matter is that Richard as a construct in a play is Richard
Plantagenet a deposed king, awaiting the inevitability of death.
The heroic is a posture, the reality, as he must perceive it, resides
in the image in the mirror he contemplates during the deposition:

Give me that glass, and therein will I read.
No deeper wrinkles yet? . . .
 Was this face the face
That every day under his household roof
Did keep ten thousand men? Was this the face
That like the sun did make beholders wink?

> Is this the face which fac'd so many follies
> That was at last out-fac'd by Bolingbroke?
> A brittle glory shineth in this face;
> As brittle as the glory is the face.
> (*Dashes the glass against the ground*)
>
> *Richard II*, 4.1.276–7, 281–8

His kingship, his stories, his life have the fragility of the glass he breaks. Shakespeare presents the confusion of man's experience of time and the natural folly of 'wasting' time. Consequently it is the measured progress of the clock that underpins much of the Shakespearean play.

For Ionesco the need is to ridicule the very notion of heroic posturing. There can be no resort to Richard II's religious and cosmological images for this King. Instead they are anticipated and thereby negated by the farcical interchanges between the Doctor and Marguerite:

Doctor	. . . Mars and Saturn have collided.
Marguerite	As we expected.
Doctor	Both planets have exploded.
Marguerite	That's logical.
Doctor	The sun has lost between fifty and seventy-five per cent of its strength.
Marguerite	That's natural.
Doctor	Snow is falling on the North Pole of the sun. The Milky Way seems to be curdling. The comet is exhausted, feeling its age, winding its tail round itself and curling up like a dying dog. p. 19

If cosmological images are prevented from allowing Berenger to take refuge in a fiction, the same is true also with the images of nature. Richard II on reaching Barkloughly salutes the ground instructing nature to kill Bolingbroke (3.2.1f). It is a romantic nonsense. But it is one in which Richard can temporarily escape. For Berenger no such routes can be allowed:

Doctor	Yesterday evening it was spring. It left us two hours and thirty minutes ago. Now it's November. Outside our frontiers, the grass is shooting up, the

trees are turning green. All the cows are calving twice a day. Once in the morning and again in the afternoon about five, or a quarter past. Yet in our country, the brittle leaves are peeling off. The trees are sighing and dying. The earth is quaking rather more than usual.

Guard (*announcing*) The Royal Meteorological Institute calls attention to the bad weather conditions. pp. 19–20

The interjection of the Guard exacerbates the comedy to a point near despair. Nature and the universe give no optimism for the man facing death. To believe that they do so is to believe that one can see through a wall with a telescope.

Doctor If you look through this telescope, which can see through roofs and walls, you will notice a gap in the sky that used to house the Royal Constellation. In the annals of the universe, his Majesty has been entered as deceased. p. 36

The Doctor sees nothing. His statement of the magic of the telescope is fictitious but within that fiction is the mirrored truth that Berenger has to face, the inevitability of death. For Ionesco this universal truth is part of the evil he perceives within existence: an evil that resides in contradiction to the miracle of life. This he explains in the 1977 essay *Why do I write?*:

I could accept the enigma of existence, but not the mystery of evil. The fact that, evil is a law of life when human beings are not responsible for it makes it even harder to swallow. All we need is to cast our eyes around us or read the papers in order to know that good is unattainable. All we need is to look at one drop of water through a microscope in order to see how the cells, all those microscopic creatures ceaselessly fight and kill and devour one another. And what goes on in the microcosm is repeated right up the scale, at every dimension of the universe. Making war is the law of life. There is nothing but that. And though we know all about it, we have just stopped noticing.[7]

For Ionesco evil is all embracing and as such intimately related with death. His philosophy is akin to the idealism of Christianity and

indeed in this essay he affirms a belief in a Godhead. *Exit the King* focuses on questions inherent in Christian idealism and which have been staged before by dramatists within the Christian tradition. The central dilemma for example facing Faustus at the beginning of Marlowe's play is that he cannot reconcile the problem of death's relationship with evil:

> Jerome's Bible, Faustus, view it well.
> *Stipendium peccati mors est.* Ha! *Stipendium,* etc. The reward of sin
> is death: that's hard. *Si peccasse negamus, fallimur, et nulla est in*
> *nobis veritas.* If we say that we have no sin, we deceive ourselves,
> and there's no truth in us. Why, then, belike we must sin, and
> so consequently die.

> Ay, we must die an everlasting death.
> What doctrine call you this? *Che sarà, sarà:*
> What will be, shall be! Divinity, adieu!

> *Dr. Faustus,* scene I, 38–47

Rejecting Jerome's bible and cutting short the passage from St John's Epistle[8] Faustus's sin is one leading to utter despair. It is prompted by ambition and pride but as the play progresses its association with the inevitability of death becomes more and more prominent. In the conclusion ambition means nothing. Similarly the cursing of one's parents is absurd, since man is left alone with the prospect of his extinction:

> Curs'd be the parents that engender'd me!
> No, Faustus, curse thyself, curse Lucifer
> That hath depriv'd thee of the joys of heaven.

> *The clock striketh twelve*

> O, it strikes, it strikes! Now, body, turn to air,
> Or Lucifer will bear thee quick to hell!

> *Thunder and lightning*

O soul, be chang'd into little water drops,
And fall into the ocean, ne'er be found.

Enter Devils

My God, my God! Look not so fierce on me!

Scene xix, 180–7

Berenger too curses his parents (p. 44) as he wriggles for existence. It is Queen Marguerite, Necessity, that has to put him right, as in the medieval drama *Everyman*, knowledge shows the protagonist the truth of his mortality. It is not, however, death as such that is the problem for Berenger but as Richard Coe has pointed out it is the fear of death which haunts Ionesco's image.[9] Queen Marguerite's function is to educate Berenger through that fear and further to allow him to realise that his individuality is not the entirety of all existence. It is such a thought on behalf of Everyman, Faustus, Richard or Berenger which is the sin of their pride: the inability to accept their dignity, not as something greater than that of other men but as associated with that of other men. Everyman appeals to his goods and wealth; Faustus makes his pact to gain universal renown: Richard disinherits Hereford for his own ends. With Berenger it is his overt attempt to cheat time in order to continue his own existence which manifests 'his pride'. Marguerite merely informs him that however much he cheats the end still has to come:

King They promised me *I* could choose the time when I
 would die.
Marguerite That's because they thought you'd have chosen
 long ago. But you acquired a taste of authority.
 Now you must be made to choose. You got stuck
 in the mud of life. You felt warm and cosy. (*Sharply*)
 Now you're going to freeze. p. 37

Each of the plays shows the protagonist to act solely through selfishness and in each case the respective dramatists demonstrate the dissipation of power. Everyman's requests are refused; Faustus degenerates into a comic clown; Richard loses his crown, Berenger

his authority over anyone. Even love in the person of Marie is of no avail. She begs him to order her to kiss him. But when he does so she cannot move towards him (p. 33). Her love is as ineffectual as Aumerle's optimistic encouragement of Richard II at Barkloughy Castle (*Richard II*, 3.2.). Marguerite's influence is in contrast. She instructs him in a similar lesson to that which Bolingbroke teaches Richard when the deposed king smashes the mirror, philosophising on the 'truth' of his situation. Bolingbroke insists that Richard is still fictionalising the situation. It is not Richard's sorrow that has destroyed his face but

> The shadow of your sorrow hath destroy'd
> The shadow of your face.

Richard II, 4.1.292–3

Ironically at the end of *Richard II* and throughout *Henry IV*, Bolingbroke himself is seen to fictionalise his coming moment of death through the Jerusalem story. Such fictions have to be cut away. Berenger has to realise in Marguerite's words that 'his existence is not all existence' (p. 89). The fear of death is conquered by facing it. Ionesco's *Exit the King* presents a universal truth that even the twentieth century has to accept, man facing the inevitability of his demise. The play, however, is not pessimistic. The fear of death is conquered by Berenger with dignity. As the stage set gradually disappears in the final act Berenger is left by himself. For him there is not the prayer of Everyman, the scream of Faustus, or the heroic fight of Richard, but rather the quiet dignity of fading away into the mists. Ionesco's visual signs as throughout his work being as important as the verbal:

> *(The) disappearance of the windows, the doors and the walls, the King and the throne must be very marked, but happen slowly and gradually. The King sitting on his throne, should remain visible for a short time before fading into a kind of mist.*
> p. 93

Exit the King is a medieval play for a modern age. It presents the one reality that all mankind has to face. As such it is one of the most remarkable plays in the post-war era.

Macbett is a play with a different register from *Exit the King*. Rather than death as the focal point Ionesco is concerned with the

cyclic nature of an evil which cannot be destroyed. Besides Shakespeare's play there are a number of other influences on the work. Rosette Lamont notes in particular Ionesco's debt to Alfred Jarry's *Ubu Roi*[10] whilst the reviewer in the *Times Literary Supplement* (9 June 1972) puts forward the suggestion that the play is a satiric response by Ionesco to the Kenneth Tynan/Roman Polanski film of *Macbeth* (1971). Certainly evidence of both influences can be detected. The grasping obscene selfishness of Pere Ubu is reflected in a variety of characters, as are the jibes of Mere Ubu in the character of Lady Duncan. The horrific scenes of blood and gore found in the Polanski film from its opening shots on the sands of battle to its closing scenes in which the camera briefly sees through the eyes of the decapitated Macbeth, are conjured up by the exaggerations of Ionesco's play. Neither, however, is it merely a rewrite of *Ubu* nor just a satiric thrust at the late Kenneth Tynan with whom Ionesco had clashed on a number of occasions. *Macbett* is rather 'a making strange' of Shakespeare's play which simultaneously allows us to accept the Ionesco work in its own right and yet send us back with fresh eyes and sensitivity as Rosette Lamont has suggested, to 're-read' Shakespeare.[11]

Interviewed in *Le Figaro* in 1972 Ionesco commented upon the spelling of his title:

> I ended the name of my play, *Macbett*, with two t's, so that it wouldn't be confused with the play by Shakespeare, which I suspect many people know.[12]

It is a typical Ionesco joke. The question to be asked concerns not the spelling of the name but the nature of the adaptation and its relation to Shakespeare's play. Macbeth's view of existence in the conclusion of Shakespeare's play is one not dissimilar of course from the vision of dramatists such as Beckett and Ionesco:

> Tomorrow, and to-morrow, and to-morrow,
> Creeps in this petty pace from day to day
> To the last syllable of recorded time,
> And all our yesterdays have lighted fools
> The way to dusty deaths. Out, out, brief candle!
> Life's but a walking shadow, a poor player,
> That struts and frets his hour upon the stage,
> And then is heard no more; it is a tale

Told by an idiot, full of sound and fury,
Signifying nothing.

Macbeth, 5.5.19–28

Within the speech Shakespeare's Macbeth, like the absurd drama-
tists were later to do, states the vacuity of existence through the
metaphor of the actor: 'the walking shadow'. It is related possibly
to the shadow that Bolingbroke perceives in Richard's contempla-
tion of the mirror. Ionesco's ingenuity lies within the distorted
presentation of such 'shadows' and 'mirrors'. The importance of
the protagonist is reduced. There is no danger in the play of the
audience finding a psychological empathy with Macbett. Rather
Ionesco presents a central semiological statement created not by
one character but by a number of figures each reflecting one
another. Macbett is decentred as a protagonist, his image being
reflected in that of Banco and in turn in those of Glamiss and
Candor. This allows for a composite vision of evil at the centre of
the stage which is an amalgam of all the characters. Early in the
play one may be unsure whether it is the one actor, for example,
playing both Banco and Macbett: the two not appearing on stage
together until the entrance of Archduke Duncan (pp. 26–7) when
farcically Banco's head appears and disappears from the wings.[13]
Such a technique alienates the audience from the dramatic persona
and begs comparisons between Ionesco's dramatic technique and
those advocated by Brecht and other politically committed drama-
tists.

There is an irony here in that Ionesco has always been seen at
variance with the political playwrights. Edward Bond has
constantly criticised the theatre of Beckett and Ionesco accusing
them of being 'trapped in the decadence of our time' and of having
'no rational view of the future or of anything else'.[14] Ionesco on
the other hand has similarly attacked Brecht and other left wing
dramatists referring to their work as a 'vulgarisation of ideology'[15]
and calling for the need to 'depoliticise theatre'[16] It is interesting,
therefore, to find an affinity at least between images drawn by
Bond and Ionesco. Yet both are concerned with the brutality and
degradation of war. Here for example is Bond in *Summer* (1982)
describing the brutality of Nazi butchery:

Now I will tell you about the end. When we had to go home.
By then the island was full of bodies. They had been sealed up
in caves and pushed down cracks. The soldiers said if the island
was a coat the pockets would bulge! The order came: exhume
the dead and throw them into the sea. We were angry. It would
seem as if we had something to hide. Our enemies were quick
to lie about us. We were not criminals. We'd done everything in
the open. According to laws of war. Harsh – but war is harsh.
Now we must open the graves. Dig the bodies out of the rocks.
It is an order. We stood guard while prisoners dug and carried.
Such stench. Can you imagine? For three days. The bodies were
thrown into the sea. But there is no tide. The bodies won't go
away. The sea will not take them. It is as if it was against us.
They floated round the island. Only a few were skeletons. Sand
had preserved the skin of the rest. They drifted on the surface
or just below it. Some of them held hands – that's how they
died.[17]

Bond's interest is to revolt through the depiction of the bestiality
of war. Yet it is a similar interest found also in Ionesco's *Macbett* in
which Macbett and then Banco summon up the images of modern
war from the cannon fodder of the Somme to the napalm of
Vietnam:

The blade of my sword is all red with blood. I've killed dozens
and dozens of them with my bare hands. Twelve dozen officers
and men who never did me any harm. I've had hundreds and
hundreds of others executed by firing squad. Thousands of
others were roasted alive when I set fire to the forests where
they'd run for safety. Tens of thousands of men, women, and
children suffocated to death in cellars, buried under the rubble
of their houses which I'd blown up. Hundreds of thousands
were drowned in the Channel in desperate attempts to escape.
Millions died of fear or committed suicide. Ten million others
died of anger, apoplexy, or a broken heart. There's not enough
ground to bury them all. The bloated bodies of the dead have
sucked up all the water from the lakes in which they throw
themselves. There's no more water. Not even enough vultures
to do the job. pp. 14–15

Macbett's speech is immediately repeated to the last detail by

Banco, the repetition naturally exacerbating the picture described.[18] Ionesco here is far from running away from the realities of recent history. Just as his play *Rhinoceros* (1959) conjured up the tyrannies of both Hitler and Stalin so *Macbett* by its references to modern warfare contemporises elements of the Macbeth story. Rosette Lamont in proclaiming Ionesco 'a serious political thinker' writes:

> The French dramatist has read Shakespeare's play with the twentieth-century apprehension of the ruthless mendacity of our leaders, and then shifted in revealing ways episodes and characters in order to bring out in his "pretense" the deceitful reality of those who, claiming to serve history, serve their own ends.[19]

The difference of course lies within the diagnosis and prescription of the two dramatists. Bond's commitment to Marxism is totally at variance with Ionesco's humanism and metaphysical interests.[20] Thus Ionesco's approach to *Macbett* is different in kind and intent from Bond's to *King Lear*. Whereas Bond as we have seen contradicts the Shakespearean design of laying his foundation for an optimistic socialist society, Ionesco transforms Shakespeare's play of evil tyranny into a metaphysical farce in which the humour reveals the universal evils constantly present within existence. Ionesco refuses to allow any stability in the pictures he presents. A mass guillotining is performed whilst the Archduke takes tea. Simultaneously Lady Duncan flirts with the bemused Macbett. Later the Archduke ironically appears as an Edward the Confessor figure healing the sick. The scene is artificial. It accelerates rapidly to near chaos before culminating in the murder of Duncan. Evil allows for neither consistency nor permanence. Macbett appears, therefore, to be no more a tyrant than Duncan had been. Banco reflects him in desire and ambition but his plans are overheard and Macbett gets in first to kill him:

> I heard every word, the traitor! So that's all the thanks I get for promising to make him chamberlain. . . . Who are they trying to fool, me or Banco? . . . It's all a sinister plot. Well we'll soon see about that. . . . Let's destroy his issue at fountain head – that is, Banco himself. p. 82

Ionesco seizes too on Shakespeare's conception of the illusions

that evil creates: *Macbeth*'s witches are androgynous, the protagonist hallucinates about the appearance of a dagger and sees a ghost at the banquet scene. In *Macbett* Ionesco questions what the ghosts and illusions are. Is the picture hanging on the walls of the banqueting hall, Macbett asks, one of Duncan or Banco or Macbett or is it nothing at all? Is experience merely illusion, a shadow of a presence which cannot be grasped?

There is no Lady Macbett as such in the play. Her dramatic function is found in Lady Duncan who seduced Macbett and who later shows herself to be the metamorphosis of the First Witch. In the guillotining scene and earlier in her attitude towards the soldier whose throat she longs to cut (p. 23) Lady Duncan clearly displays the characteristics of Mere Ubu but she might also remind us of Bond's Bodice and Fontanelle. In her metamorphosis Ionesco presents a parodied medieval fable in which the old witch is transformed into the beautiful wife.[21] The romanticism of a medieval tale however is absent: the witch becomes a striptease artist displaying her sexuality as Lady Duncan for Macbett in a scene which culminates in the general rolling at her feet as the lights fade allowing only 'Lady Duncan's glistening body' to be seen. This is not a travesty of the Shakespearean play. It is rather a refocussing upon the elements of evil found within its progress. Lady Macbeth's 'unsex me here' speech (*Macbeth*, 1.4.37–51) with its dedication to the spirits of the night is charged throughout with a latent sexuality. But within that form of lustful decadence Macbeth and his Queen can find no stability. One of the most ironic lines in Shakespeare's play comes when the Queen tells Macbeth he lacks 'the season of all natures, sleep' (*Macbeth*, 3.4.141). The statement passes between a couple who have murdered sleep itself. There can be no rest for either of them. Macbeth resorts more and more through the play to the illusion of the witches and Lady Macbeth after the banquet scene never appears on stage again in his presence. As the witches' grasp becomes stronger the audience perceives their illusory nature. In *Macbett* the audience itself is further tricked. The Witch turns into Lady Duncan who becomes Lady Macbett but once Macbett is in power, Lady Macbett metamorphoses back into the Witch in a horrific scene of degradation:

As indicated in the text, she puts on her smelly old dress, her apron covered in vomit, her dirty gray [sic] hair, takes out her teeth, shows

the plate to audience, puts on her pointed nose etc. pp. 85-6

It is here that Ionesco uses his theatrical maturity and ingenuity. He is able to trick the audience into certain beliefs only to frustrate and surprise them by his twists of fancy. In this he approximates the paradoxes of *Macbeth* without repeating them and yet involves the 'wise' audience in them. The witches are ephemeral and changeable. Their evil is to be found in many shapes and the audience is forced like Macbett from one belief to another: each belief affecting its judgement of the proceedings. Banco claims that the evil resides within the witches themselves; that they spurred him on (p. 81). But Banco reflects Duncan and Macbett and Glamiss and Candor as the First Witch reflects Lady Duncan and Lady Macbett in the one person. Evil is ephemeral. It cannot be pinned down or eradicated, Ionesco believes, by any philosophy.[22] The focus of evil is the battles, murders, executions, butchery. The 'gallons of blood' that 'spurts from . . . throats in fountains' (p. 15, repeated p. 17).

Within this dramatic scenario or rather imposed upon it Ionesco presents two characters in alienation roles. The first is the Lemonade Seller. He is reminiscent possibly of a Brechtian character, but perhaps more so of Thersites in *Troilus and Cressida*: Shakespeare's anti-heroic cynical chorus and bitter commentator on the proceedings of war and sex that is the degeneration of Greek civilisation. The Lemonade Seller, makes his money from being as unscrupulous as war itself. His Lemonade like Thersites's tongue will mock everyone. There is no truth in what he says about his drink just as there is no virtue in the blood of battle. Thus his lies are juxtaposed with the brutality of the second soldier just as in *Troilus and Cressida* Thersites' curses set the context for the brutal death of Hector, cut down unarmed by Achilles' Myrmidons:[23]

| Lemonade Seller | Lemonade. Cool and refreshing. Lemonade, for soldiers. Good for the heart. Good for the shakes. The willies. The heebeejeebees. . . . Lemonade, lemonade. Good for stiff necks, colds, gout, measles, small pox. |
| Second Soldier | I killed as many 'em as I could. Mashed 'em up something horrible. They yelled and the blood spurted. What a do! It aint always as larky as that. Give me a drink. pp. 12, 13 |

In contrast to the Lemonade Seller is the Butterfly Catcher attempting in the midst of battle and tyranny to find and capture part of Ionesco's miracle of life so tainted and destroyed by inherent evils. He can merely cross the stage as an absurd figure rushing about on a worthless errand. Ionesco's image is clear. It is one questioning whether anyone can escape the evils of existence; evils symbolised even by the Butterfly Catcher who if he succeeded in his job would still be guilty of killing an innocent creature. In Ionesco's pessimistic philosophy there is no escape from the evil, since even its antidotes involve destruction. He writes:

> When I stroll through a peaceful meadow it never occurs to me that all those plants are struggling for their share of living space; nor that the roots of those magnificent trees, as they spread deeper through the ground, cause pain, bring tragedy and death. Equally, every step I take is a killer. Then I tell myself that the beauty of the world is a delusion.[24]

Both Berenger and Macbett are finally isolated in the face of their own evil. It is a meeting which culminates in death. Their deaths, however, do not eradicate evil in a moment of catharsis as in a classical tragedy. The death of Macbett implies only his replacement by yet another figure. Macol the new king using Malcolm's speech to Macduff (*Macbeth*, 4.2.57f) takes over the kingdom with voluptuousness and tyranny. Malcolm's words in *Macbeth* are a fiction, a story to test Macduff's loyalty but Macol's speech in Ionesco is in earnest. The shadow world of deceit is the world of politics. Nothing good can be caught. The Butterfly Catcher crosses the stage, looking, searching oblivious to his absurdity.

Ionesco's perception provides no answers. He believes that no philosophy has been able to conquer evil and that no philosophy ever will. Such pessimism is naturally antagonistic to dramatists such as Bond and to the cultural materialists' view of Shakespeare. Ionesco believes that universal truths do exist. Consequently for him Shakespeare's plays are not confined by their historical period. Unlike Bond therefore Ionesco can agree with Jonson that 'Shakespeare is not of an age, but for all time.' His *Macbett*, though having an integrity in itself testifies to the bleak picture of life 'signifying nothing' which is painted by Shakespeare's protagonist. Ionesco demands us to receive the picture afresh as a universal

statement of evil. In this he defamiliarises the trappings of Shakespeare's drama allowing us to re-familiarise ourselves with what he considers to be the metaphysical truths of the play.

7

The Jacobean Pinter: *The Homecoming*

Harold Pinter's *The Homecoming* is a different kind of play from the majority of those I have been discussing in that it does not directly feed off a Shakespearean original. It has however been compared with a number of Shakespearean dramas especially *Hamlet, King Lear* and *Troilus and Cressida* and been seen to have an affinity with *Oedipus*. I have noted elsewhere its relationship with such Jacobean plays as *The Revenger's Tragedy* and *The Changeling*.[1] In itself it has proved a controversial work since its first appearance. Reviewing the 1965 production Harold Hobson characterised the problem as being one in which theatrical effectiveness was seen as no compensation for moral vacuity. In terming it Harold Pinter's 'cleverest play' he wrote:

> . . . It is so clever, in fact so misleadingly clever, that at a superficial glance it seems to be not clever enough. This is an appearance only, but is one for which Mr Pinter will suffer in the estimation of audiences, who will perceive an aesthetic defect that does not exist, in the place of a moral vacuum that does. . . . I am troubled by the complete absence from the play of any moral comment whatsoever. To make such a comment does not necessitate an author's being conventional or religious; it does necessitate, however, his having made up his mind about life, his having come to some decision. . . . We have no idea what Mr Pinter thinks of Ruth or Teddy or what value their existence has. They have no relation to life outside themselves. They live; their universe lives: but not the universe.[2]

These objections have been taken further by Simon Trussler who in an assault on the play decries it as morally offensive and even pornographic:

. . . *The Homecoming* is, in short, a modishly intellectualised melodrama, its violence modulated by its vagueness, its emotional stereotyping disguised by carefully planted oddities of juxtaposition and expression. To suspend disbelief in this play is to call a temporary halt to one's humanity. *The Homecoming* is his only work by which I have felt myself actually soiled and diminished. If a work is pornographic because it toys with the most easily manipulated human emotions – those of sex and (more especially) violence – without pausing to relate cause and effect, then *The Homecoming* can even be said to fall into such a category.[3]

In opposition to such criticism stands Martin Esslin who not looking for a didacticism in the play states its mimetic quality, explaining the drama's 'realism' in terms of wish fulfilment:

It is my conviction that *The Homecoming*, while being a poetic image of a basic human situation, can also stand up to the most meticulous examination as a piece of realistic theatre, and that, indeed, its achievement is the perfect fusion of extreme realism with the quality of an archetypal dream image of wish fulfilment.[4]

In differing ways Hobson, Trussler and Esslin present us with critical problems. Does a play necessarily have to present a didactic line? If not how does the playwright avoid charges of gratuitousness in its violence and sexuality? What does Esslin mean by his phrase 'realistic theatre' and how does that enhance the play in its fusion with archetypical dream images?

Early in his career Pinter stated his suspicion of didactic theatre:

If I were to state any moral precept it might be: Beware of the writer who puts forward his concern for you to embrace, who leaves you in no doubt as to his worthiness, his usefulness, his altruism, who declares that his heart is in the right place, and ensures that it can be seen, a pulsating mass where his characters ought to be. What is presented, so much of the time, as a body of active and positive thought, is in fact a body lost in a prison of empty definition and cliche.[5]

Although recently, in a prefatory interview to his play *One for the Road*, he has modified his view slightly and with that play written

a didactic piece, his work generally has been of a different order
and intent than that of committed political writers such as Edward
Bond. Five years after writing *The Homecoming* he was stating his
desire not to be categorised according to left or right politics, or
any moral stance whatsoever. Thus in 1970 he said:

> I am concerned with making general statements. I am not
> interested in theatre used simply as a means of self-expression
> on the part of people engaged in it. I find in so much group
> theatre, under the sweat and assault and noise, nothing but
> valueless generalizations, naive and quite untruthful. I can sum
> up none of my plays. I can describe none of them, except to say:
> That is what happened. That is what they say. That is what they
> did.[6]

Similarly in the following year he responded to a question by
asking others:

> Evil people. What the hell does that mean? Or bad people. And
> who are you then if you say that, and what are you?[7]

His view was that his plays have to work on their own terms
within the world that they create. To ask for a moral stance he
believed was to demand something which he could not provide
since an overt didacticism would relieve the plays of that element
of discomfiture which is written into them. That Simon Trussler
felt himself 'diminished' by *The Homecoming*, that Harold Hobson
detected a moral vacuum is perhaps all that Pinter wished to
achieve. His avowed aim at this time was not to provide answers
but to present questions based on the characters and situations
created. It is in this theatrical rather than didactic aim that his early
plays have to be considered. It is in this too that he states in 'A
Note on Shakespeare' his admiration for the Elizabethan:

> In attempting to approach Shakespeare's work in its entirety,
> you are called upon to grapple with a perspective in which the
> horizon alternately collapses and reforms behind you; in which
> the mind's participation is subject to an intense diversity of
> atmospheric. . . . One discovers a long corridor of postures; fluid
> and hardened at the quick; gross and godlike; putrescent and
> copulative; raddled; attentive; crippled and gargantuan;

crumbling with the dropsy; heavy with elephantiasis; broody with government; severe; fanatical; paralytic; voluptuous; impassive; muscle-bound; lissome; virginal; unwashed; bewildered, humpbacked, icy and statuesque. All are contained in the wound which Shakespeare does not attempt to sew up or re-shape, whose pain he does not attempt to eradicate. He amputates, deadens, aggravates at will, within the limits of a particular piece, but he will not pronounce judgement or cure. Such comment as there is, is so variously split up between characters, and so contradictory in itself, that no central point of opinion or inclining can be determined.[8]

Pinter's consideration of Shakespeare demonstrates that point of view in the plays is multifarious. It is not to be ascribed to one dominant character or situation. Rather Shakespeare builds a mosaic of complementary and contradictory discourses within the plays, without stating his own position. All that is presented is what Pinter metaphysically calls 'the wound'. We do not know for example what Shakespeare's attitude was towards 'honour'. We do have Shakespeare's construct, Falstaff talking of it:

Well, . . . honour pricks me on. Yea, but how if honour prick me off when I come on? How then? Can honour set to a leg? No. Or am arm? No. Or take away the grief of a wound? No. Honour hath no skill in surgery, then? No. What is honour? A word. What is in that word? Honour. What is that honour? Air. A trim reckoning! Who hath it? He that died o'Wednesday. Doth he feel it? No. Doth he hear it? No. 'Tis insensible, then? Yea, to the dead. But will it not live with the living? No. Why? Detraction will not suffer it. Therefore I'll none of it. Honour is a mere scutcheon. And so ends my catechism.

Henry IV Pt I, 5.1.130–40

Honour is an insensible word, only made sensible in the context of other words, signs or codes. Against Falstaff's use of the word is the knightly tradition of chivalry, off which Falstaff is antithetically feeding. In the context of the play he later stabs the cold corpse of Hotspur. The action is in keeping with his value system but it is at variance with that signified by the Hotspur–Hal confrontation. The Shakespearean mosaic allows each sign to complement and feed off another, including the audience know-

ledge of courtly codes. Shakespeare theatrically presents both concord and discord between the discourses presented. Thus Falstaff's 'death' (Pt 1 Act 5 scene 4) allows Hal to summarise and accept with contentment the fat man's style of living. This can be done because Falstaff no longer provides a threat to the dominant moral code of the court. He is no longer a temptation to Hal:

> Poor Jack, farewell!
> I could have better spar'd a better man.
> O, I should have a heavy miss of thee,
> If I were much in love with vanity!
> Death hath not struck so fat a deer to-day,
> Though many dearer, in this bloody fray.

Henry IV Pt 1, 5.4.103–9

The speech is shown to be sententious by the immediate 'resurrection' of Falstaff with which it is juxtaposed. The fat knight can equally moralise about the necessity of a counterfeit lie:

Counterfeit? I lie, I am no counterfeit; to die is to be a counterfeit; for he is but the counterfeit of a man who hath not the life of a man; but to counterfeit dying, when a man thereby liveth, is to be no counterfeit, but the true and perfect image of life indeed.

Henry IV Pt 1, 5.4.116–22

Shakespeare by appealing to the multiconscious apprehension of the audience can simultaneously establish Hal as credibly moving towards the responsibility of office and yet reduce his significance in providing an alternative comic philosophy to the political intensity of chivalric, revolutionary or establishment codes. Such contradictions in the dramatic sign system runs through into *Henry IV Part Two* in which Hal is forced by his responsibilities to reject Falstaff and into *Henry V* in which he has to comply with the execution of Bardolph. Although each act is a testimony in the context of the King's party to establishment values, each also reduces the protagonist by allowing the existence of an alternative world divorced from the coterie of the court yet suffering by its confrontation with the court's values. The Falstaff tavern characters are not constructs therefore to idealise a king shining as the sun breaking from behind clouds – an idealisation which Hal

constructs – but rather they signify an alternative value system in contrast to the dominant ideology.

Similarly in a play such as *Troilus and Cressida* Shakespeare presents a number of contradictory discourses juxtaposed one with another. All are brought together in the final act which is placed in the context of the action of battle. Here a conflict of attitudes is presented from Thersites's commentary which employs a sexual imagery in his description of the fighting –

> The cuckold and the cuckold-maker are at it. Now, bull! now, dog!' 'Loo, Paris, 'loo! Now my double-horn'd Spartan! 'loo, Paris, 'loo! The bull has the game. Ware horns, ho!
>
> *Troilus and Cressida*, 5.7.9–12

– to the heroism of Hector, whose code of honour allows him ridiculously to divest himself of his armour whilst still on the field of battle –

> Now is my day's work done; I'll take good breath;
> Rest, sword; thou hast thy fill of blood and death!
>
> *Troilus and Cressida*, 5.8.3–4

– and finally to the pragmatic Achilles who seeing Hector unarmed has him hacked down:

> Strike, fellows, strike; this is the man I seek.
> So, Ilion, fall thou next! Come, Troy, sink down;
> Here lies thy heart, thy sinews, and thy bone.
> On, Myrmidons, and cry you all amain
> 'Achilles hath the mighty Hector slain'.
>
> *Troilus and Cressida*, 5.8.10–14

Each image counterbalances another within the mosaic of the play. The characters are fictional constructs presenting discordant signs to the audience which perceives patterns dependent on dramatic juxtapositions. Authorial moral intention is not foregrounded as dogmatism. Rather the writer creates a structure and plot which allows for a variety of views and experiences.

In the mid-twentieth century Antonin Artaud in calling for a

break from stereotypical drama compared the function of theatre
with that of dreams:

> If theatre is as bloody and as inhuman as dreams, the reason for
> this is that it perpetuates the metaphysical notions in some
> Fables in a present day, tangible manner, whose atrocity and
> energy are enough to prove their origins and intentions in
> fundamental first principles rather than to reveal and unforget-
> tably tie down the idea of continual conflict within us, where
> life is continually lacerated, where everything in creation rises
> up and attacks our condition as created beings.[9]

It is a similar sentiment which informs Pinter's view of Shakespeare
and by which much of his own drama can be comprehended. To
fix the audience's reception by the proposition of the dramatist's
favoured didactic line is seen as an impertinence. Pinter believes
that Shakespeare avoids doing this. The majority of Pinter's plays
are not vehicles for overt political or social didacticism but are
rather patterns held up for audience response.

Martin Esslin has drawn comparisons between *The Homecoming*
and *Oedipus* or *King Lear* because each deals with 'the desolation
of old age and the sons' desire for the sexual conquest of the
mother'.[10] The play works as a present day fable drawing on
archetypal patterns. Its force is within its presentation of sexual
struggle. The final words of the play are spoken by Max. They are
both an order and a plea: 'Kiss me' (p. 82).[11] In the context of the
society depicted by the preceding action the words have lost their
meaning. Max's authority has dissipated. Ruth continues 'to touch
Joey's head' and 'Lenny stands, watching'. Pinter concludes his
play with a tableau which encapsulates all that has gone before.
The bully is insecure and the pimp impotent. Both have apparent
rule, both have apparent power but the essence of their status is
constantly seen beneath their postures. There is found impotence
and fallibility:

> You understand what I mean? Listen, I've got a funny idea she'll
> do the dirty on us, you want to bet? She'll use us, she'll make
> use of us, I can tell you! I can smell it! you want to bet? p. 81

Max's language expresses only his inner insecurity by redefining
statements concerning Ruth. 'She'll do the dirty on us' is precisely

the reason why she was to stay. She was to do the 'dirty' through prostitution, through sexual gratification. His 'funny idea' however is no longer one whereby through her 'dirty' work she'll entertain him sexually but rather 'dirty him' in rejecting him. You can 'bet' on that, you can even 'smell' it. The animalistic smell is not one of sexual attraction but of rejection by the dominant female. Through the play Pinter plays out sexual power games in which male and female manoeuvre for the dominant role. It is an ancient theme, Clytemnestra and Orestes, Jocasta and Oedipus, Gertrude, Ophelia and Hamlet. In the *Oresteia* of Aeschylus and Sophocles' *Oedipus* the competition is between mother and son. In the latter social and sexual evil is expressed through Oedipus's physical relationship with his mother. The enjoyment of sexual power is undermined by the reality that is the knowledge of the relationship. Oedipal sexuality is not fertile but stagnant, involved in death:

> Enough!
> All, all, shall be fulfilled. . . Oh, on these eyes
> Shed light no more, ye everlasting skies
> That know my sin! I have sinned in birth and breath
> I have sinned with woman. I have sinned with Death.[12]

In *Hamlet* the inordinate sexuality of the mother in marrying the uncle is similarly related to death and to power. Oedipus' sexuality implies that his power is wasted in the land. Hamlet's objection to his Mother's incest relates to the comparison of the two Kings – her husband and her brother-in-law. The effect of the incestuous dexterity is that 'It is not, nor it cannot come to good'. Yet Hamlet's sexual confusion is not taken out on his Mother but on Ophelia. The Mother is whore and the son will mock the purity of all feminity as personified by Ophelia:

Hamlet	Lady, shall I lie in your lap?
Ophelia	No, my lord.
Hamlet	I mean, my head upon your lap?
Ophelia	Ay, my lord.
Hamlet	Do you think I meant country matters?
Ophelia	I think nothing, my lord.
Hamlet	That's fair thought to lie between maids' legs.
Ophelia	What is, my lord?
Hamlet	Nothing.

Hamlet, 3.2.108–16

The sexual puns on 'no thing' and 'country matters' are crude banter, manifestations of the tired, immature or perverted mind, however wronged. In action Hamlet is as impotent with Ophelia as he is in his attempted revenge over Claudius. The potential aggressor is the victim of his own weakness.

In Pinter's *The Homecoming* Lenny confronts Ruth over a glass of water:

> Lenny Just give me the glass.
> Ruth No.
> *(Pause)*
> Lenny I'll take it, then.
> Ruth If you take the glass . . . I'll take you.
> *(Pause)*
> Lenny How about me taking the glass without you taking me?
> Ruth Why don't I just take you?
> *(Pause)*
> Lenny You're joking. p. 34

In this often quoted exchange from the play Ruth turns Lenny's posture of masculine power back on to him. Lenny had previously attempted a demonstration of his masculine potency by the narration of two comic stories. The first deals with the prostitute who had been 'searching' for him and when finding him made a 'proposal' that 'wasn't entirely out of order'; a proposal to which 'in the normal course of events' he would have subscribed. The story is to reflect on his masculine superiority. The prostitute had to find *him* out. It was *Lenny* who was standing beneath the arch, alone. If *he* had wished he could have shown *his* sexual potency but he did not because the woman was not fit for it. She was 'falling apart with the pox'. The sexual disease was with the female. So instead of taking her sexually up against the wall he claimed his masculinity by violence. He claims that he beat her up:

> . . . and there she was up against the wall-well just sliding down the wall, following the blow I'd given her.

If he had wanted to of course, the story goes, he could have killed her but instead:

I just gave her another belt in the nose and a couple of turns of
the boot and sort of left it at that. p. 31

Pinter invests Lenny with an attitude whereby the character
in proclaiming his sexual dominance constantly and comically
undermines his authority even within his own stories. He was as
the prostitute. The approach had to be made to him. He was
unable to respond in that he could neither take sexual advantage
of the woman nor could he kill her. Instead he allowed himself a
'tease', a beating up. He could not as the play later puts it
concerning Joey, 'go the whole hog' (p. 68).

The second story tells of him helping the old lady with the
mangle. It concludes:

> . . . after a few minutes I said to her, now look here, why don't
> you stuff this iron mangle up your arse? Anyway, I said, they're
> out of date, you want to get a spin drier. I had a good mind to
> give her a workover there and then, but as I was feeling jubilant
> with the snow-clearing I just gave her a short-arm jab to the
> belly and jumped on a bus outside. Excuse me shall I take this
> ashtray out of your way.
>
> p. 33

The pretended male potency is again expressed in terms of the
violence of the story. The posture is exaggerated by the juxtaposi-
tion of the violence with the final sentence of supposed courtesy
to Ruth – the enquiry about the ashtray. Lenny's subtext relates
Ruth both to the old lady and the prostitute. The courteous request
points to the fact that he had originally wished to oblige both
ladies. In the end he 'clumped' them. The stories are thereby an
assault. He sexually threatens Ruth through their sub-text:

> I mean, I am very sensitive to atmosphere, but I tend to get
> desensitized, if you know what I mean, when people make
> unreasonable demands on me. p. 32

The 'unreasonable demands' are anything in a relationship how-
ever brief which does not accord with Lenny's posturing. But it is
within the pretence, in the bravado and violence of the stories that
his impotence lies – an impotence which Ruth can easily expose.
Firstly she responds to his attempts to show his strength by
patronising him:

Lenny	And now perhaps I'll relieve you of your glass.
Ruth	I haven't quite finished.
Lenny	You've consumed quite enough, in my opinion.
Ruth	No, I haven't.
Lenny	Quite sufficient, in my own opinion.
Ruth	Not in mine, Leonard.

<div align="right">p. 33</div>

The humiliation comes in extending his name from the familiar to the formal as a parent would do in disciplining a child. Lenny responds to Ruth by trying to keep up his act but in doing so he reveals that Ruth has hit her target:

> Don't call me that, please. . . . That's the name my mother gave me.

The key word is 'please'. It both accepts the changing situation as Ruth begins to move into a position of superiority whilst retaining the semblance of civility that he has been employed throughout his stories. The exchange about the glass is the power struggle in which Ruth demonstrates Lenny's inability for sexual action. The first stage won, Pinter can allow her to go on the offensive:

Ruth	Have a sip. Go on. Have a sip from my glass.
	(*He is still.*)
	Sit on my lap. Take a long cool sip.
	(*She pats her lap. Pause.*
	She stands, moves to him with the glass.)
	Put your head back and open your mouth.
Lenny	Take that glass away from me.
Ruth	Lie on the floor. Go on. I'll pour it down your throat.
Lenny	What are you doing, making me some kind of proposal?

<div align="right">p. 34</div>

Lenny's fantasy is over. Ruth has broken it by showing the essence of the situation. Take the glass, take the drink, sip it, sit on my lap, lie on the floor. If you are so strong take me. Faced with such a situation all Lenny can say in effect is, What's going on? What are you doing? Ruth laughs at him. She has turned the sexual power tables.

What we find throughout the play as in so much Elizabethan

drama, are various postures being undermined by their juxtaposi-
tioning with other postures. In Middleton and Rowley's *The
Changeling* (1623) for example Beatrice-Joanna in engaging the
disfigured De Flores to kill her fiancé Piracquo so that she can
marry her new love Alonso, believes that she will thereby remove
two hated men with the one act. The murder done she is faced
with the opposite reality. De Flores has sexual power over her but
as the play advances however she falls totally in love with the
murderer. In John Marston's *Antonio and Mellida* (1599) the defeated
Duke Andrugio can one moment philosophise contentedly on his
new state as lord not of men but of nature, happy amongst her
gifts but then suddenly rages into a fit on the mention of his lost
dukedom and authority. Such contradictory images abound. In
Henry IV Parts I & II Falstaff can be lamented and yet dismissed
whilst Hal can appear as both hero and anti-hero within the same
set of plays. With Pinter's *The Homecoming* the settings of course
are different. We are not in the court but in the London suburbs
yet the contradictory pictures remain. Teddy the respectable doctor
of philosophy is accused of bringing a whore into the house. The
whore is his wife. The house has not had a 'whore' in it since the
mother died (p. 42) but the mother was 'poor Jessie' a woman
whose 'image was so dear any other woman would have . . .
tarnished it' (p. 75). Yet 'MacGregor had Jessie in the back of
(Sam's) cab' (p. 78). As Sam collapses in the revelation Teddy
comments 'I was going to ask him to drive me to London Airport'
(p. 79). Ruth accused of being a whore, defended as being a wife
and mother is employed at the end of the play as a whore but no
one knows if she understands what is being asked of her. Max
believes he is all powerful but as the bully he is challenged in the
essence of his potency.

Pinter's boundaries in *The Homecoming* are drawn by the animalis-
tic needs of the community – the desire for food, violence, sex,
aggression and power. It is a world of purulent physicality
expressed even in a concern with one's own conception. As such
it again finds comparisons with the Jacobean drama. In *The
Revenger's Tragedy* (1606) for example we find Spurio the bastard
ruminating on the process of his own beginnings:

> Faith, if the truth were known, I was begot
> After some gluttonous dinner, some stirring dish
> Was my first father, when deep healths went round,

And ladies' cheeks were painted red with wine,
Their tongues as short and nimble as their heels,
Uttering words sweet and thick; and when they rose,
Were merrily dispos'd to fall again –
In such a whisp'ring and withdrawing hour,
When base male-bawds kept sentinel at stair-head,
Was I stol'n softly. . . .[13]

Although the language and the idiom are different an affinity can be discerned between the Bastard's aggression here and that displayed by Lenny in *The Homecoming* as he challenges his father, winding him up with recourse to a similarly perverted imagination:

I'll tell you what, Dad, since you're in the mood for a bit of a . . . chat, I'll ask you a question. It's a question I've been meaning to ask you for some time. That night . . . you know . . . the night you got me . . . that night with Mum, what was it like? Eh? When I was just a glint in your eye. What was it like? What was the background to it? I mean, I want to know the real facts about my background. I mean, for instance, is it a fact that you had me in mind all the time, or is it a fact that I was the last thing you had in mind? p. 36

In Spurio and Lenny we find the same morbid, antagonism in their thought processes which helps define the panoramas of their respective plays. Nothing is permanent, nothing sacred. Teddy acquiesces in the loss of his wife to the household and then even mocks the boxer, Joey, for his inability to find sexual satisfaction with her. She has teased him. Comically Joey feebly excuses his sexual failing: 'Sometimes . . . you can be happy . . . and not go the whole hog. Now and again . . . you can be happy . . . without going any hog' (p. 68). Teddy will leave and return to the States, to his respectable job and his children. Ruth will stay in her new flat, earning her keep. Yet as he is about to depart a moment of intimacy is expressed Ruth referring to him as the play's first director Peter Hall suggests, by his 'familiar' name:

Eddie
Teddy turns
Pause
Don't become a stranger. p. 80

It can be seen as a plea for something positive in a negative world, but as such in itself it is as impotently ridiculous as Hamlet's cry over the dead Ophelia:

> I lov'd Ophelia: forty thousand brothers
> Could not, with all their quantity of love,
> Make up my sum.

Hamlet, 5.1.263–5

So what? These are fine words after the event but the fact remains in the world of the fiction that Ophelia is dead. Whatever the familiarity Teddy still leaves. The door is closed.

There is no direct parallel between *The Homecoming* and Classical, Shakespearean and Jacobean drama but in the landscape drawn there are correlations, within the juxtapositioning of attitudes and the panorama of sexual and violent decadence. Pinter's world is devoid of a cathartic resolution. There is no explanation for Sam's collapse. There is no Laertes to revenge the death of Polonius; no Fortinbras to restore rule; no ghost to instruct a Hamlet figure in the decadence of the court. Indeed there is not even a protagonist. There is merely the decadence itself related to a twentieth-century coven in the East End of London. If the play diminishes its audience it does so as *Troilus and Cressida* diminishes by presenting the stark picture of the degeneration of a civilisation. It is not concerned with academic notions of catharsis but with a portrayal, engaging a variety of images each playing off one other, of a civilisation decadent in its sexuality and its struggles for power. It is here that Pinter's play finds an affinity with the Classical, Shakespearean and Jacobean models and challenges the audience to a response. In *The Homecoming* Pinter pulls no punches by giving no answers. The moral vacuity is the expression of the play and he leaves it to the audience to accept or reject its validity as a statement of twentieth-century relationships and society.

8
Theatrical Discontinuity: Charles Marowitz, *The Shrew, An Othello, Collage Hamlet*

Charles Marowitz would not claim to be a dramatist. He is first and foremost a director and secondly a dramatic critic. In the relationship of the two he sees an affinity:

> A director, strictly speaking, is a critic both of the playwright's work and the actor's. His job, like the drama critic's is to sift perceptions and act upon insights. The director, you may say, is of necessity a constructive critic whereas the drama critic feels no such imperative. But to the extent that drama criticism has any real value, it rebounds off the specifics of performance – which is precisely what directing does.[1]

As a director–critic Marowitz can serve as a bridge between our discussions so far concerning the adaptation; reworking and re-evaluation of Shakespeare by modern dramatists as such and the concluding chapter which is concerned with the performance of Shakespeare in our subsidised national theatres. Marowitz, however, can be seen as another kind of bridge. The dramatic scores that we have been discussing have fallen into two broad categories. Beckett and Ionesco in writing a metaphysical drama are within a tradition of modern theatricality going back to the work of Alfred Jarry at the turn of the century. As such they have some affinity at least with the apocalyptic theory of Artaud. In direct opposition to their theatre is the work of Bond and Wesker. Bond not only attacks what he sees as decadence in their drama but also goes to some pains to distinguish his part, particularly his use of violence, from Artaud's manifestoes for a Theatre of Cruelty. His aim is a political revaluation of the place of Shakespeare in the

context of his own socialist philosophy. As such his theatrical purpose as we saw earlier is related to that of the other major dramatist–theorist of the mid-century, Bertolt Brecht.

Marowitz has long been admitted to being a disciple of Artaud. He has an admiration for the theorist that has led to articles and a play on Artaud's life in the lunatic asylum at Rodez, where he was committed in 1937, and to work with Peter Brook on the RSC *King Lear* of 1962; on their famous production of Peter Weiss's *The Marat/Sade*, 1964, and the accompanying Theatre of Cruelty season. But Marowitz is also a political thinker and although in some of his work as for example his version of *Macbeth*, 1969, he creates an Artaudian phantasmagoria, his series of Shakespearean re-creations which evolved over a number of years from the Theatre of Cruelty season, constantly concern themselves with political and social problems.[2] Peter Brook's experimentations were not confined to Artaudian ideas. Throughout his work he appears to have been aiming towards a synthesis of various dramatic theories and traditions.[3] The same is true also of Marowitz to the point where it would become artificial and futile to try and delineate one influence from another. Through a synthesis which has involved the ideas of both Artaud and Brecht as well as those of other writers and directors such as Brook and Jerzy Grotowski, Marowitz's style of direction has evolved. The basis of his theory is what he terms dramatic syntax. He explains:

> In grammar, syntax is what makes possible the construction of sentences: it is that arrangement or order which defines subjects, predicates and other kinds of agreed relationships in the formulation of language. In our terms, syntax is very much the same. It assembles the subjects and predicates of the agreed action (i.e. the play) so that comprehensible relationships can be created between them. In the theatre, unlike grammar, there are innumerable ways of interpreting the agreed action (the play) and so the making of syntax depends very largely on how individual directors and actors see the material before them . . .[4]

He continues by drawing a parallel between the syntactical construction of a drama and changes found within music:

> . . . the change of syntax, like a change in key-signature, can radically alter the way a dramatic vocabulary is expressed; and

these changes can sometimes be as drastic as a piece of music performed in a major or a minor key, with a twelve-tone scale or entirely by electronic means.[5]

In dramatic terms this change in syntax can become as radical as a translation from one language to another. With the Marowitz-Shakespeare[6] the director–new-dramatist, Marowitz, adapts Shakespeare's plays for the late twentieth century. He never claims that what he is presenting is Shakespeare. Rather it is the Marowitz-Shakespeare or what we may call his translation of the original. He describes it in slightly different terms by asking himself a series of radical questions such as,

> Is it possible to express one's view of *Hamlet* without the crutch of narrative?
> Is it not true that all of us know Hamlet, even those of us who have never read the play or seen it performed? Isn't there some smear of Hamlet somewhere in our collective unconscious which makes him familiar?
> Can a play which is very well known be reconstructed and redistributed so as to make a new work of art? If *Hamlet* were a precious old vase which shattered into a thousand pieces, could one glue the pieces all together into a completely new shape and still retain the spirit of the original?[7]

For Marowitz the questions are rhetorical demanding an affirmative response. His Shakespeare is one which must react against the well-worn formulas and cliches of theatre and scholarship representing the myths which Shakespeare himself culled and refashioned for his theatre. Where the academic Shakespearean industry has gone wrong has been in seeing Shakespeare as an end in himself. The myths can live on and be presented in radically new, exciting and appropriate ways:

> The answer is not to apply unlimited scholarship to track down the sources of the play wherever in history or pre-history they may be hiding, but to accept that an old story is rooted in mysteries that never really disappear and which have to be re-jigged in order to translate effectively into the present. A cut-up version of *Hamlet*, one may contend, has nothing to do with the play Shakespeare wrote, even if it does utilize his words and

many of his ideas. But one can just as readily ask to what extent Shakespeare can be counted the author of a play which is compounded of ancient group-myths and cultural *bubumeinshes* as well as being obviously culled from two or three verifiable, non-Shakespearean sources. I do not say this to belittle Shakespeare's achievement, but surely the graduations are endless.[8]

His main concern is to free Shakespeare from the shackles of narrative although it has to be said from the start that in reading Marowitz's versions and his thoughts about them it is often apparent that ironically he has actually derived his interpretation from his own narrative reading of the plays. For example in an almost Bradleyan fashion he contends in his introduction to his *Collage Hamlet* that Ophelia must have had sex with Hamlet before the play began.[9] Such a statement or idea might of course help a Stanislavskian actress to find inner resources and motivations for her performance but is not explicit in the text. Rather it extends the narrative of the play beyond the Shakespearean confines. Maybe Marowitz is hoist by his own interpretative petard. Possibly he is a victim of the critical trends which he condemns.[10] Nevertheless this does not negate the main thrust of his attack which is not on Shakespeare but on the straitjackets which envelope his work. The principal one of these in the legitimate theatre and in mainstream critical and educational traditions relates to tragedy and inevitably to Aristotelean formula. Marowitz sees this as stupefying and divorced from contemporary, popular art forms in film, television and novels which work on criteria other than strict chronology. He attempts, therefore, to break up narrative allowing his plays to work through collage and pattern. We have already seen how he attempts to do this in *Variations on The Merchant of Venice*. He is, however, suspicious of his approach as applied to comedy. In the *Variations* or his *Measure for Measure* he stresses the social implications underlying these Shakespearean plays attempting to draw corollaries with contemporary society. The result is that although these are two of his most successful adaptations any real comic aspect of the drama is lost in its moral propositions.[11] The same is true also with *The Shrew*, 1973 which can be seen not only in contrast to Shakespeare's play but also to the way that other directors have attempted to contemporise it.

Shakespeare's *The Taming of the Shrew* has become a controversial play in an age increasingly sensitive to the inequality in man's

treatment of the sexes. Rather than the robust, expensively-clad Elizabeth Taylor kneeling to Petruchio in the final scene of Zeffirelli's film version of 1966, theatrical attempts in the 1970s were made by directors such as Jan Sergeant in Newcastle (1975) and Michael Bogdanov in Stratford (1978) to cut across the received line of the play and portray Katherine as the victim of male dominance mentally battered into her final submission. Marowitz's version, which has undergone a considerable time of experimentation, however, differs from these sack cloth and ashes productions. His perception of the syntax is concerned with the declining nature of male–female relationships as formalised in marriage. Juxtaposed therefore with the Petruchio/Kate story in his version is a modern dialogue between a Boy and a Girl, played by the actor of Hortensio and actress of Bianca. Over a number of scenes their relationship is built up. In the first of them, (pp. 145–51) the Boy makes the initial moves, the Girl making it difficult for him. Eventually he kisses her but as she responds he demands more. She breaks away:

She (*Holding him slightly off. Quietly*) Do you expect sex as a matter of course?

He (*Surprised*) Were we talking about sex?

She Weren't you?

He (*Admitting it*) I suppose I was.

She Do you?

He As a matter of course. No. Of course not. It never is a matter of course.

She It isn't with me. I thought it would be fairer to let you know. p. 149[12]

Sex has to be a part of the relationship not dominated by either partner. The Girl gives as good as she has received. Following this interchange she 'kisses him hard', taking control showing her own individuality. But it is precisely that individuality which Kate in the main plot must lose by her marriage to Petruchio. As the Boy/Girl scene closes, Kate is seen:

. . . *standing motionless like a doll, wearing a simple white shift; eyes straight ahead; a vague sense of being the victim of some grim unwanted social ceremony.* p. 151

Petruchio's appearance is mocking. Marowitz extends the charac-

ter's fantastical dressing up in Shakespeare's play to drag. As a male in woman's clothes he demonstrates the usurpation of the sex through male dominance. Hortensio, the actor of the Boy in the previous scene, expresses mock arrogance. The interaction of the two plots is thereby stressed. Masculine humour evolves from attitudes of dominance within relationships and from the male orientated, expected expressions of decorum. Elizabethan and modern man come together in Hortensio's reaction to Petruchio:

See not your bride in these unreverent clothes. p. 153

His words are as mocking as the clothes Petruchio wears. Petruchio strips off his feminine attire stating the truth of the relationship:

> She is my goods, my chattels; she is my house,
> My household stuff, my field, my barn,
> My horse, my ox, my ass, my anything,
> And here she stands. Touch her whoever dare,
> I'll bring mine action on the proudest he
> That stops my way to Padua.

 p. 155

All look on in a general acquiescence of Petruchio's values and even Bianca, the actress of the Girl, though showing a certain distaste for her father's support of the marriage, concludes the scene by a comment of secret pleasure to Hortensio, 'That being mad herself (Kate) is madly mated'. Whatever reservations may exist, the value of male-dominated matches is approved. An immediate contrast however is found in the next scene as Hortensio and Bianca appear as the Boy and Girl hotly disputing the social propriety of their relationship – whether they should formally be engaged. He demonstrates a jealousy of her. She replies that their relationship should not be ruled by

. . . that grotty old background exerting its traditional pull . . .
She's mine. I'm hers.' Public, neon-lit togetherness. p. 157

But when finally she does acquiesce to admit their engagement, he immediately breaks away from her in confusion.

Marowitz thereby takes the social pressure and appearance of a relationship as signified through the dominant bullying of Petruchio in Shakespeare's play and applies it to the commonly accepted social conformity of relationships as expressed by 'an engagement' or 'marriage'. Both imply 'Property of . . .', categorising feelings of jealousy and love as if such labels were to eliminate confusion. Marowitz's point is to show that the reverse may be true. Legalistic, capitalistic labelling can destroy rather than cement a relationship. To 'tame' Kate by marriage can be enough to destroy her. The bullying follows from the social conventions determining relationships according to male orientated capitalistic rules prevelent to the present and accepted by both sexes. Thus true relationships are broken down into the stereotypical patterns which were exaggerated by Shakespeare in the Petruchio–Kate relationship:

Petruchio	Good Lord, how bright and goodly shines the moon!
Katherina	The moon? The sun! It is not moonlight now.
Petruchio	I say it is the moon that shines so bright.
Katherina	I know it is the sun that shines so bright.
Petruchio	Now by my mother's son, and that's my self,
	It shall be moon, or star, or what I list,
	Or ere I journey to your father's house.
	Go on fetch our horses back again.
	Evermore cross'd and cross'd; nothing but cross'd!
	. . .
Katherina	Forward, I pray, since we have come so far,
	And be it moon, or sun, or what you please;
	And if you please to call it a rush-candle,
	Henceforth I vow it shall be so for me.

(*The Taming of the Shrew*, 4.5.2–10, 11–15)

The Shakespearean scene, used in truncated form by Marowitz (p. 174) is emblematic of the consensus in married relationships which is falsely determined by the social convention itself. The Boy/Girl relationship breaks down its failure to maintain an equality of passion and mutual respect for individual identity:

He Let's not play The Sorry Game because you know I always wind up sorrier than you.

She (*Utterly reasonable*) I don't want to play any game.
 (*Checks watch*) I have to make an early start tomorrow.
 (*He scoffs to himself, remembering when he heard that line before.*)
He (*Hungry*) Stay tonight.
She (*Not wanting to be cruel*) No, not tonight.
He (*Sorry he weakened*) I'm not going to beg, dammit.
She I don't expect you to. (*Pause. Cigarette out.*)
 I'd better go.
He (*Tries to stop her with a move*) Look . . .
 (*She stops, fully composed, looks.*)
He (*After a pause; no more moves to play*) You better go.
 (*She kisses him lightly, meaninglessly on the cheek, and moves off.*)
He (*When she's gone*) I'll call you.
 (*Fade out*) pp. 169–70

The exchange is controlled by a veneer of respect but its falsity and
hypocrisy is perceived. The Boy and Girl despite the breakdown of
their relationship, the meaningless kisses, will marry. Before that
scene, however, Marowitz is to produce Petruchio committing the
most obscene and violent of crimes against his wife. The stage
directions describe it in full:

> *Kate is backed over to the table and then thrown down over it. Her
> servants and Baptista hold her wrists to keep her secure. Petruchio
> looms up behind her and whips up her skirts ready to do buggery. As
> he inserts, an ear-piercing, electronic whistle rises to a crescendo pitch.
> Kate's mouth is wild and open, and it appears as if the impossible sound
> is issuing from her lungs.* p. 178

Where is the reality, the honesty in a relationship? Revoltingly
degraded and diminished by the violence shared with the audience
through the confusion of lights and shrill noises, Kate eventually
is forced frantically to proclaim her loyalty to her husband. As she
does so the Boy and Girl appear at their wedding ceremony,
smiling in the mutual negation of identity and the breakdown of
their initial relationship. The juxtaposing of scenes throughout the
play coalesces in this final image signifying the Marowitz concern
at the futility implicit in the social organisation of emotions. It
signifies further a pessimism on his behalf in his belief that
relationships cannot endure. His dramatic syntax here produced a

different play from the common interpretations of the Shakespearean comedy, but it capitalises on the implicit logic of the Shakespearean. Petruchio's violence is exacerbated to the point of its logical outcome in rape and buggery but it is juxtaposed with a picture of a quiet, felicitous, union of smiles and respectability. That is the result of the Petruchio's taming of the shrew, but Marowitz questions what lies behind any wedding photograph? What exactly is the nature of male–female relationships? Can they actually endure the course of time whilst preserving both a sense of individual identity and mutual respect? These are serious questions and for him they are ones unable to be contained by the comic genre. In adapting the Shakespearean play his modern sensibility forces him to abandon its comedy. That fact however tells us as much about Shakespeare and the freedom of his sensibility as it does about Marowitz. Perhaps this is one reason why when beginning his adaptations Marowitz felt the tragedies to be more applicable to his methodology. Although with the Shakespearean tragedies as we shall see he usurps the tragic genre through satire.

In *An Othello* Marowitz explores the problem concerned with the black man in a white society. From the Shakespearean play he again asks himself questions which rather than being a part of the narrative logically flow from it:

> What is this black general doing at the head of a white army fighting Turks who, if not actually black, are certainly closer to his own race than his Venetian masters? Why is he the only black in the play? Are we to assume he is some kind of splendid oddity in an otherwise white society? That no racial tension exists in the state in spite of miscegenation, senatorial bigotry and wars waged against non-whites? These are not historically based speculations but a series of false hypotheses created by a desire to stretch old material into new shapes for no other reason than to see them hang differently. Pure perversion.[13]

Pure perversion or not, and we might ask whether 'perversion' can ever be 'pure', Marowitz is on shaky grounds if he attempts to justify his adaptation in historical terms. As Leslie Fiedler has noted miscegenation as such is not a major factor in Shakespeare's play as historically the concept had not been defined in the early seventeenth century:

. . . it would be a mistake to think of *Othello* as trading on the kind of horror at the mating of a black male and a white female commonly felt by, say, American audiences of the late nineteenth and early twentieth centuries. *Othello* may, indeed, end with precisely the scene of erotic black-white murder which has haunted the American mind all the way from *The Klansman* to *Native Son* but its tonalities are different, since the whole notion of miscegenation had not yet been invented. The seeds are there, perhaps even the first sprouts, but only when fostered by 'scientific' anthropology can the miscegenation-madness attain full growth.[14]

Marowitz's arguments may only apply from his contemporary point of view. Nevertheless from his vantage point certainly the seeds of racism are present in Iago's world view, as in the imagery of the black ram tupping the white ewe and the beast with two backs and also in the attitude of Brabantio. Marowitz is concerned to go beyond the sexual image in *An Othello* to present a critique of dominant, capitalist, white culture in the contemporary world. He bases his version of Shakespeare's play therefore on the writings of black activists, particularly Malcolm X. He states that from Malcolm X he learnt of the difference between the house Negro and the field Negro on the American plantations. The house Negro was accepted into the house of the white master to the extent that he would defend that home against all assault. He was integral to it, accepted into it and fiercely loyal. In contrast the field Negro was a black slave labouring on the land, eating not the droppings from the white man's table but the offal fit only for animals. The problem for black revolution therefore was not a simple matter of black rising against white but of the field Negroes convincing the house Negroes of their need to be freed from subjugation, and to understand the nature of the discontent brewing in the fields. The problem is not one long since dead in history. It continues into the twentieth century where the white man's domination continues to some extent by means of patronising certain blacks in order to gain their acquiescence in the status quo. Marowitz's play was written at a time not only of black freedom movements in the USA and UK but rapid changes in Southern Africa, with in particular Zimbabwe winning the right to affirm its identity and with the racial ferment beginning to brew within South Africa.

Shakespeare's apparent narrative polarities are complicated by

Marowitz in that he portrays his Iago as a black man. His difference from Othello is that the general's attitude is reminiscent of the house Negro mentality whilst Iago's can be equated with that of the field Negro. Iago consequently has his own view of Othello's courting of Desdemona with his stories of adventures:

> All that shit about 'hair-breath 'scapes' and 'Anthropophagi' and even how they chained your black ass, and how you was hip enough to leave all those cotton-pickin' coons behind you cause you knew where all that gravy lay, and it weren't in the cotton fields or the hold of slave ships. . . . No, you bet your sweet little ass, it weren't. It was in Mr Charlie's army, ey black-boy? With all that lick'n polish, and two pairs of suits, and plenty of fried chicken, and chitlin's once a week; and brown-nosin' it up the ranks and steppin' on your kinky-haired brethren to do it . . . p. 265

Both are victims of white supremacy. Othello is useful as the white man's instrument of preservation defending the Venetians against the Turk, but no sooner is the Turk defeated than Othello is recalled by the Duke who explains to Cassio,

> We don't want a bloody coon General trottin' around these islands with a white pussy in tow, and subvertin' the authority of our rule. p. 286

The play's sexuality is integrated with this attitude. Black man, white woman becomes an emblem of fantasy and frustration. As the play opens black hands appear from the darkness to embrace the breasts of the white woman. But for Othello the white woman though desired is a symbol of his vulnerability. During his epileptic fit in the second scene, he witnesses Desdemona enjoying the favours of the white camp in a 'gang bang' which implicates her not only sexually but racially in his downfall. She is part of the conspiracy against him. The episode takes place on a large strawberry spotted handkerchief that floats down from above. As the white woman she too enjoys her sexual fantasies. In a later scene she turns to the audience and asks how many have not wished to do as she has done, to enjoy the force of the black man:

Wouldn't you have, if you'd had the chance? Not just big, and
not just black, but holy and black, strong and black, elegant and
black. . . . Wouldn't you have, if you'd had the chance? If his
arms had lifted you, like a baby into a waiting cradle, and his
mouth had eaten away the hunger of a thousand poached
summers; days filled with dry flirtations and rough-and-loveless
goodnight kisses. Wouldn't you have? If one night, the dream
had sprinted out from under your sheets and stood rock-solid
by the foot of the bed saying: Let's! And the hell with everything
else! Wouldn't you have?
Wouldn't you?

Overhearing Iago cynically comments:

O ain't we the noblest little ole savages you ever clapped eyes
on? I do declare, we are! pp. 292–3

As the field Negro Iago has little to do to destroy his Othello. He
can almost stand aside to watch him destroy himself through his
infatuation with the white woman:

Who me? A double-dealin' son-of-a-bitch? Shit, man, that's the
kettle callin' the pot black. . . . Why don't he have a heart-to-
heart with his l'il white pussy. Put it to her. 'You been messin'
round with one of my horny little roosters?' . . . But do he say
that? No man, he ready to chop her into little pieces without so
much as a howd'ye-do. Oooh-ooh, he achin' to whip her ass so
bad, I think I just wastin' my time plantin' little black seeds.

 p. 288

Throughout Marowitz involves the audience in a consideration of
the issues. To what extent is the black/white sexual relationship
based on ignorance, fear, submission, domination? To what extent
are each of us involved in these questions, yet subverting them in
our subconscious? Brabantio as a Jew for example (p. 295) turns to
the audience and asks how many would want their daughter to
marry a black man! The mixture of idioms here and elsewhere is
designed to complicate further the racial point but possibly, as
Almansi holds, overdoes it to the detriment of the play.[15] As the
drama progresses Marowitz uses even more techniques to force
his point. He changes the register, drawing the attention of the

audience more and more to the fact that they are watching a play. The boundaries of the drama are deliberately confused in a metadramatic exercise. Thus the actors begin to divorce themselves from their parts turning on Iago and attempting to throw him out of the drama. The actor of Othello becomes distracted only half concentrating on his role-play. The actress playing Desdemona becomes scared. It is the actor of Othello who kills her. In this way Marowitz prevents the audience relaxing into an enjoyment of a clear cut narrative line. Rather their sensibilities are deliberately disordered in the chaotic movement in and out of character. The Duke and Lodovico cut Othello's throat. Iago takes the body away and Desdemona rises from her bed. Her murder was another Othello fantasy. Whitey has succeeded yet again.

Critical reviews of *An Othello* have varied. Harold Hobson wrote of it as 'a terrible play and a powerful, its not the least impressive feature being its demonstration that it is the liberals whom the blacks most relentlessly hate' (*The Sunday Times*, 11 June, 1972). *Plays and Players* (August 1972) provided two views in contradiction. Jenny Sheridan complaining that –

> Black Power and jealousy do not mix, simply because the opposing positions, once established within the *Othello* context, cannot develop in any meaningful way.

– concluded that this was still a white man's view of the black problem which of necessity distorts. She compared the play with the reality of the Angela Davis civil rights trial and found its message wanting:

> . . . in the week when the Angela Davis trial told us more about the problem than can any amount of *Othellos*, this gloss on Shakespeare, contemporary America and Europe – nay the world – seemed all the more misguided and meaningless.

Alex Stuart, however, disagreed seeing the themes of the play summed up in words spoken by the Duke;

> Do you reckon a black man is the equal to a white man . . .
> Can a black man be as white as a white man is? pp. 283–4

For Stuart, Marowitz was successful in alienating Othello from

audience empathy. No longer tragic, Othello 'no longer deserves our sympathy'. What is perhaps as important is that despite the disagreements both critics can be seen to have been provoked into thought about the issues Marowitz raises in the play, although writing in 1982 Guido Almansi thought it exposed its weakness in the fact that he believed it had prematurely aged.[16]

In Marowitz's most famous collage, *Hamlet*, the syntax is found with a critique of liberal political attitudes. For this director Shakespeare's *Hamlet* is far from being what many traditional approaches to the character can make him: the romantic hero wrestling against insuperable odds and concerned with the very morality of action in his tragic attempt to put universal order to rights. Rather Marowitz considers him the pathetic liberal taking refuge in fine words rather than displaying the courage of action. His soliloquies, his procrastination are an excuse and an escape from the truth of action, not a facing up to it. This is a factor at least in the Shakespearean play but one often lost in its intertextual traditions. Marowitz writes of the relation, therefore, between the 'traditional Hamlet' and what he sees as weaknesses in contemporary society:

> I attempted to delineate a criticism of the type of person Hamlet was and, by inference, to indict the values he represented; values which (i.e. misdirected moral concern, intellectual analyses as action-substitute, etc.) were, in my view disreputable in our society and which derived much of their respectability and approval from traditional works such as Shakespeare's *Hamlet*.[17]

Marowitz's answer is to expose Hamlet as a farcical figure and by so doing to reveal the danger of such characters in the contemporary world:

> In short, by assaulting the character of Hamlet, one was deriding the supreme prototype of the conscience-stricken but paralysed liberal: one of the most lethal and obnoxious characters in modern times.[18]

The *Collage Hamlet* debunks the character of the protagonist through a series of contrasts. Shakespeare's play foregrounds a number of comparisons: Claudius/King Hamlet, Laertes/Hamlet, Gertrude/Ophelia, Hamlet/Fortinbras, with the protagonist often

relating the comparison to his own situation. It is within this latter element that actors can establish an empathy between the audience and the protagonist. Principally through the soliloquies they appeal directly to the spectators in an emotional attempt to gain sympathy. Marowitz reduces Hamlet implicating the soliloquies in the figure's ridicule. Thus he opens the Collage with Fortinbras as the pragmatic, professional soldier, speaking with an authority that will lead directly to action (p. 29):

> Go, Captain, from me greet the Danish King.
> Tell him that by this licence Fortinbras
> Craves the conveyance of the promis'd march
> Over his kingdom.

The passage from 4.4.1f of Shakespeare's play is counterpoised by Hamlet's questioning of who Fortinbras is and the immediate enunciation of the first lines of the soliloquy 'How all occasions do inform against me'. This is delivered downstage whilst Fortinbras is 'standing strongly behind him'. The visual sign is clear, as the lights gradually fade on Fortinbras, Hamlet is exposed as the ineffectual thinker, Fortinbras the man of action. It is a comparison to be pursued throughout the play. Sophistry has replaced realism. Later, for example, following a schoolroom scene in which the Queen absurdly ridiculing the iambic pentameter, teaches her students Laertes, Ophelia, Clown and Hamlet, the moral precepts of Polonius (*Hamlet* 1.3.58f) Fortinbras holds Hamlet back to teach him a true lesson (p. 41):

Fortinbras Come, come and sit you down,
 You shall not budge till I set you up a glass
 Where you may see the inmost part of you.

He begins a comparison of the King and Ghost breaking up Hamlet's first soliloquy (*Hamlet*, 1.2.129f) and juxtaposing with it further lines from the play mouthed by the Ghost, the Queen and the King. As the scene continues however Gertrude and Claudius make love in front of Hamlet. He fails to see what is happening. The lesson is ignored. Ridiculously he turns to the audience uttering the same type of philosophical platitudes ridiculed through the schoolroom scene, 'I have of late but – wherefore I know not – lost all my mirth . . . (p. 42, *Hamlet* 2.2.295f). As he concludes the

speech both Ghost and Fortinbras leave the stage in disgust. The moralising Hamlet cannot perceive the facts before his eyes. He is a waffler.

Similarly the character of Hamlet is denigrated in comparison with Laertes. Again early in the play, Laertes establishes a strength of purpose. He enters to confront the King:

> Laertes (*Suddenly*) Where is my father?
> King Dead.
> Laertes I'll not be juggled with.
> To hell allegiance; vow to the blackest devil.

Hamlet looks on at the hotly direct son of a murdered father and tries '*weakly . . . to match Laertes passion*':

> Yea, from the table of my memory
> I'll wipe away all trivial fond records . . .
> p. 33

Hamlet is thereby established as a pathetic figure. His language is childishly naive. He plays a child's game of fist over with fist with the clown. He brandishes a toy sword and then finds himself instructed in his passion by the clown, who as a theatre director with an inadequate actor in his rehearsals despairingly consults the script for 'speak the speech, I pray you' (p. 43). But this Hamlet can learn no pragmatic lines. If the reality of the King making love to the Queen cannot touch him neither can a similar reality mediated through art. He sits and watches a flicker-film in which the King makes love to Ophelia but he says and does nothing. He is the impotent politician–prince, looking on without seeing, talking without acting and thereby guilty of complicity in evil. In a telling scene (p. 47) the King and Queen force Hamlet to pour poison into his father's ear. The Marowitz point is simple but effective. Hamlet's bourgeois liberal philosophy is as responsible for the murder of the King as anything else. Under such circumstances even the play must begin to grind to a halt. Hamlet falters in his words, to be prompted by the Clown:

> Clown (*As prompter*) A father kill'd . . . a mother stain'd . . .
> Hamlet (*Dully*) A father kill'd . . . a mother stain'd . . .
> Clown (*Decides to prompt from another part of the speech*) Bestial
> oblivion . . .

Hamlet (*Revved up again*) Now whether it be
 Bestial oblivion or some craven scruple
 Of thinking too precisely on the event,

 (*Clown breathes sigh of relief and departs, thankful he's got
 the show on the road again.*) p. 47

But such prompting only leads Hamlet resembling Beckett's Lucky, to string together dislocated passages from the drama. He resorts to catch phrases and to playing at swordsman with a toy:

Hamlet The body is with the King, but the King is not with the body.
 The King is a thing –
Guildenstern A thing, my Lord?
Hamlet . . . of shreds and patches. Did you think I meant country matters.
 Another hit, what say you? (*Running Laertes through*)
Laertes (*Dropping his sword*)
 A touch, a touch, I do confess. p. 53

Tried by the court for the death of Polonius, Hamlet is even forced by Fortinbras to take refuge in a place of insanity and is thereby sentenced to be confined. Throughout therefore it is Fortinbras who attempts to galvanise Hamlet into action but he always fails. All that Hamlet can promise to do is 'observe his (Claudius') looks . . . tempt him to the quick'. As Fortinbras leaves him yet again in disgust (p. 65) Marowitz involves the audience in his distaste for the protagonist. Hamlet addresses them with his excuses:

 Had *he* the motive and cue for passion
 That I have, he would drown the stage with tears
 . . .

 p. 65

For this Hamlet it is not tears but general ridicule that is deserved. The protagonist stands centre stage in the final scene propped up on his toy sword, weakly mouthing his catch phrases: 'To be or not to be that is the question', 'The play's the thing wherein I'll catch the conscience of the King', whilst the characters surrounding him laugh and mock him. His desperate attempt to kill them with

his toy produces only further hilarity. Hamlet the liberal is a farcical figure, his weapon infantile, his language cliched.

Through these plays Marowitz works against the narrative lines so often slavishly followed in empathetic productions of classic drama. He juxtaposes elements of Shakespeare with others out of sequence adding occasionally his own interpolations. As such he attempts to find the essence of the Shakespearean play beyond its iambic pentameters. In this he is searching for the mythic qualities and appropriateness of the plays. But further he attempts to translate the myth to the modern audience by the use of his chosen dramatic syntax. The Marowitz-Shakespeare is thereby one directly concerned with contemporary social and political relevances. This may imply that his work will go quickly out of date. Such a judgement however is conditioned rightly or wrongly by the implicit liberal notion that 'good' plays, like those of Shakespeare, are timeless in their appropriateness and universality. Yet what Marowitz helps to do is to question some of the assumptions behind the attitudes which can be employed to condemn him and perhaps more significantly which misread Shakespeare through the 'reverence' of tradition. Marowitz at least has helped to problematise Shakespeare at a time when the dramatist's work has been in danger of being dominated and misrepresented by the cliches of a bourgeois culture.

9
Postscript: The Modernised Bard

The plays I have been considering feed off Shakespeare. Some serve as critiques of his drama reacting against the reverence surrounding his 'sacred texts'; some play off Shakespeare helping us to new insights about him and his work; others find within the Shakespearean dramatic formula new modes of expression pertinent to the modern world. All of them are plays in their own right. Yet most can also be accused of 'modernising Shakespeare'. In recent times that aim has become one of some controversy. Should Shakespeare be contemporised? A headline in *The Chicago Tribune* on 10 July 1986 proclaims 'Britons a bit put off by modernized Bard'.[1] The article beneath drawing on British reviews of the RSC 1986 seasons at the Barbican and Stratford records some critics' distaste for a *Troilus and Cressida* set in the Crimean War, *The Merry Wives of Windsor* set in the 1950s and a *Romeo and Juliet* which 'features roller skates and an Alfa Romeo car'.

The charge can be made that to modernise Shakespeare is necessarily to divorce him from his historical context. Academic suspicion since the 1960s has consequently been levelled both at the Royal Shakespeare Company and the National Theatre company for their contemporary style productions and further at the dramatists who have made new plays from old: Bond, Marowitz, Wesker, Stoppard. Alan Sinfield, for example, in challenging the political conservatism of subsidised theatres has stated that re-creations of Shakespeare can only be partially successful:

> It is the cultural, and therefore political authority of Shakespeare which must be challenged – and especially the assumption that because human nature is always the same the plays can be presented as direct sources of wisdom. One way of doing this is to take aspects of the plays and reconstitute them explicitly so that they become other values. Brecht in *Coriolanus*, Edward Bond in *Lear* (1971), Arnold Wesker in *The Merchant* (1976), Tom

121

Stoppard in *Rosencrantz and Guildenstern are Dead* (1966) and
Charles Marowitz in a series of adaptations have appropriated
aspects of the plays for a different politics (not always a progres-
sive politics). Even here, it is possible that the new play will still,
by its self-conscious irreverence, point back towards Shakespeare
as the profound and inclusive originator in whose margins we
can doodle only parasitic follies.[2]

Sinfield continues by feeding off an idea proposed by Michael
Billington to treat Shakespeare 'as a historical phenomenon, impli-
cated in values which are not ours but which can in production be
made to reveal themselves' (p. 179). The call is not to contemporise
Shakespeare as Jan Kott proposed but to historise him within his
own time and culture. As one reviewer of Dollimore and Sinfield's
book has noted, however, their view of history may not be
recognised by the majority of historians as synonymous with what
they would term 'history'.[3] As they themselves happily admit,
their approach is ideologically committed to 'the transformaton of
a social order which exploits people on grounds of race, gender
and class'.[4] In this, their historical location of Shakespeare is
ironically as much 'in danger' of contemporising Shakespeare in
terms of cultural materialism as Peter Hall's, Peter Brook's, Trevor
Nunn's or Jan Kott's is in terms of 'liberal humanism'. The
admission of what they are doing does not negate such implications.

If jazzed up versions of the plays offend sensibilities concerning
the sanctity of the Shakespearean text that in itself may draw
attention to the problem of cultural values. It is impossible to
recreate the Elizabethan stage. Michael Reardon, the architect of
the Swan Theatre in Stratford, quite rightly did not attempt to re-
model the Globe or the Fortune theatres, rather he designed an
auditorium – within the constraints of an existing building – in
which Elizabethan plays could be performed. That the Swan
Theatre in some ways resembles what we know of the Elizabethan
theatres is all to the good but it remains a modern twentieth-
century auditorium designed to stage our perceptions of sixteenth-
century plays. Equally we cannot re-create the manner of an
Elizabethan 'production' for the major reason that we as actors or
audiences are not Elizabethans. Our values, our condition of life,
our period of history is different. The inheritance of the London
Elizabethan theatres is not to be found therefore in the archaeolog-
ical re-creations of the second Globe theatre on Bankside. Such a

preoccupation has value in terms of historical research but that is a matter to be sponsored by theatre museums, historical societies and academic institutions. It is not the forum for the living continuum of the Globe, the Fortune or the Swan. This is to be found, for better or worse, in the living theatre at the National, the Barbican, the Royal Court and so on.

If the Elizabethan drama retains a contemporary value, it does so because it is comprehensible for the modern audience: an audience which changes from decade to decade, from year to year, from month to month. Jan Kott did not invent 'Shakespeare Our Contemporary'. Shakespeare's plays have always been translated for the age that has produced and received them. As we have noted earlier the sensibility of Nahum Tate and Samuel Johnson could not endure the violent ending of *King Lear*. Conversely Peter Brook's vision of the twentieth century could not allow even for the vestiges of human kindness found in the same play. Some critics would hold that in either case the result is to diminish Shakespeare's drama. Harriett Hawkins, for example, in a cogent argument against a trend to contemporise Shakespeare in the modern criticism and theatre notes concerning Brook's *King Lear*:

> To shift the balance, by turning the Quarto's sympathetic servants into sadists, is to crack one side of the mirror that Shakespeare here holds up to human nature, showing 'virtue her own feature', as well as showing vice its own image, and – in effect — to make its reflection of human nature seem less authentic (albeit currently more fashionable) than it originally was. The same points could be made about Nahum Tate's adaptation, which spared Cordelia to make the play conform to eighteenth-century theories about poetic and providential justice. By excising the dramatic evidence against them, both Tate and Brook have, in turn, forced Shakespeare's tragedy to conform with, and thus to confirm, the unrealistically idealistic, and just as unrealistically cynical, generalizations about human experience and behaviour that its action and characterization would otherwise appear to have challenged.[5]

Drama, however, is not static. It is not written primarily for the study. As argued in Chapter 1 its nature constantly changes and did so even in Shakespeare's day. The lines concerning the flax and egg whites do not appear in the Folio edition of the play.

(Mischievously one might speculate whether they were omitted because they had been cut out in Jacobean theatrical practice.) Hawkins's argument at their omission from Brook's production is related to the theatrical philosophy underpinning the director's decision. As Ann Thompson has noted the cut was made not on textual grounds (which for the academic is permissable) but in order to further the director's personal interpretation of the play.[6] Whilst the academic usually looks towards textual authenticity and the historical context, the practitioner invokes his/her necessary collaborative involvement in the creation of a live performance for a contemporary audience.

One of the greatest evils of the modern era came with the Nazi concentration camps and the holocaust. In April 1945 John Gielgud and Peggy Ashcroft appeared in George Rylands's production of *The Duchess of Malfi* at The Haymarket at a time when the cruelties of John Webster's play of 1614 had to be seen in relation to the public's discovery of the persecution of the Jews and the Nazi treatment of the prisoners of war. The editorial comment in the *Evening Standard* for the 19 April 1945 reads:

> The rotten planking that masked the German cesspit is being ripped away and the people of the world recoil in horror from its stench and infamies. None could have believed that the reality would transcend in beastliness the report. That the terrible stories that have reached us could understate the fact. Human dignity is a precarious possession at the best of times. To debase it is an offence against life itself. It is one for which mankind even if prompted by the mere impulse of self preservation can offer no forgiveness.

In the same edition the *Evening Standard*'s theatre critic reviewing Rylands's production which had opened the night before, comments:

> The torture and brutal murder of 'The Duchess of Malfi' by her brothers is almost topical in its sadism. . . . Last night's revival stress(es) the grim nature of a story which almost gloats over the futility of mankind.

The difficulty in discussing and producing Shakespeare is how to correlate the Elizabethan values with those of our own time. Jan

Kott can perhaps be too easily dismissed. He instructively writes
of the problem:

> An ideal *Hamlet* would be one most true to Shakespeare, and
> most modern at the same time. Is this possible? I do not know.
> But we can only appraise any Shakespearean production by
> asking how much there is of Shakespeare in it, and how much
> of us.
>
> What I have in mind is not a forced topicality, a *Hamlet* that
> would be set in a cellar of young existentialists. *Hamlet* has been
> performed, for that matter, in evening dress and in circus tights;
> in medieval armour and Renaissance costume. Costumes do not
> matter. What matters is that through Shakespeare's text we
> ought to get at our modern experience, anxiety and sensibility.[7]

The importance here is that Shakespeare is seen simultaneously
within the context of his own time and that of the society producing
or reading him, Kott's discussion of *King Lear*, in the context of a
post-war realisation of the absurd vacuity of existence as expressed
in the work of Beckett, was appropriate to the audiences of the
1960s. Brook it can be argued reacted as a modern director both to
the Elizabethan play and to contemporary sensibility, not in an
escapist manner but in an attempt to make the drama challenging
for his particular modern audience. In the 1980s for various social,
political and cultural reasons the same production may or may not
be appropriate. To what extent have the conditions of life, of
theatre and of criticism changed?

A large slice of the critical problem lies within the timelessness
or not of Shakespeare's plays. As we have seen the cultural
materialist offshoots from and/or evaluation of Shakespeare deny
his universality whereas the metaphysical dramatists allow for
what Kott refers to as the 'timeless' element in the work. Modern
production in the subsidised theatres still tends to favour the
universal often in attempts to find an appropriate contemporary
mileu for a particular work. John Barton a director at Stratford
since the early 1960s, stated in 1984:

> Shakespeare is timeless in the sense that he anatomises and
> understands what is in men and women in any age, and what
> he is to say is always true and real. It is this element that is truly
> contemporary and which the wise actor or director will try to
> bring out.[8]

In the main stream of Shakespearean production the universal aspects of the play can be related to specific social problems, although the reasons why or how this occurs may not be immediately perceptible. The audience plays as great a part as the actors in contemporising issues. Its members bring their own sense of existence and experience to a performance which at times of national stress for example, may result in a collective interpretation of the stage action. The review of the 1945 *The Duchess of Malfi* is common in relating productions of classic plays to contemporary experience. Ian McKellen records the perceptions of a Czechoslovakian audience witnessing the Prospect Theatre Company's production of *Richard II* soon after Dubček had been deposed and the Soviet influence firmly imposed. McKellen played the role of the King:

> When I came to the speech where Richard II returns from Ireland to discover that his nation has been overrun by cousin Bolingbroke, and he kneels down on the earth and asks the stones and the nettles and the insects to help him in his helpless state against the armies who had invaded his land, I could hear something I had never heard before, nor since, which was the whole audience apparently weeping . . . the audiences were crying for themselves. They recognized in Richard II their own predicament . . . when their neighbours and as it were their cousins had invaded their land, and all they had were sticks and stones to throw at the tanks.
>
> I would never have talked about the play in those terms. We hadn't seen it as directly relevant to any modern political situation. . . .[9]

A traditional historical and political placing of *Richard II* often notes the controversy of the 1601 performance on the eve of the Essex rebellion (7 February) and the governmental ban imposed on the deposition scene. But for McKellen's company the play was working not in an Elizabethan but a twentieth-century mid-European political climate. An interpretation was not being forced onto the play and its audience. It was being taken from it by the spectators. Even if McKellen and his director and fellow actors had not discussed the drama in terms of a contemporary political relevance, they had still chosen *Richard II* as a 400-year old play that would still prove effective for one reason or another, in the

contemporary theatre. Not all plays will do so. Dramatic scores go in and out of fashion as society's demands change.

As I write it has recently been announced that Trevor Nunn is stepping down as chief executive of the RSC. It is perhaps apposite, therefore, to reflect, in the conclusion of this book on the way modern production since Nunn took over the reigns of the premier Shakespearean company in the UK, has in itself translated and fed off Shakespearean texts. In his first season as artistic director Nunn wrote:

> It is fanciful to imagine that all Shakespeare's plays are relevant and meaningful to a contemporary audience all the time. Shakespeare's humanism dominates, the plays will always be accessible, they don't require a specific political or religious climate in which to function, but our sense of humanist values, our moral sense, changes almost imperceptibly from age to age, from generation to generation (as of course Shakespeare's values changed), so that a neglected area of the canon can suddenly become sharply relevant. At a time of cynicism, hope is sentimental, at a time of hope, cynicism amounts to immorality.[10]

Nunn's period in charge at the RSC parallels a period in which many of the plays discussed in this book were written. It was a time of social unheaval. The angry young man attitude of the 1950s and early 1960s reacting against the values of the war generation and typified in John Osborne's *Look Back in Anger* (1956) gave way in 1968 to a dynamic in thought and attitude which flared up into student conflict in Paris, Berkeley and Britain. The drama of Osborne was replaced by that of the more radical dramatists Bond, Brenton, Griffiths. But their plays remained outside the main stream repertory. Trevor Nunn took over the RSC from Peter Hall who subsequently took charge of the National Theatre. The climate was new and Western politics and society somewhat confused. The permissive 1960s were closing, the debacle of the Americans in Vietnam festering and Watergate was yet to appear. Nunn's challenge at the RSC was to build on the Hall-Brook era of the 1960s and yet make the plays challenging for the 1970s and early 1980s. He expressed his manifesto:

> The drama has always performed a double function, of interpreting society to its audience but challenging that society at the

same time. . . . Our world has endured two global wars, the invention of a weapon capable of destroying all life, and consequently a period of cynicism as profound as Shakespeare's cynicism in *Troilus and Cressida* and *Hamlet*. But Shakespeare saw that total pessimism becomes a kind of optimism; the enactment of tragedy testifies to the belief that life endures.[11]

The statement characterised the thinking behind RSC performances through the next decade. The cynicism of the 1960s was to give way to a new optimism which in production often reduced the problematics implicit in the Shakespearean text. Nunn's famous 1966 production of Tourneur's *The Revenger's Tragedy* (1607) has often been regarded as an indication of what the Nunn regime would accomplish. Sally Beauman records:

In terms of acting, design and staging it marked a significant break with what had become, by 1966, the accepted RSC approach. None of the 'Hall-marks' of RSC work that a critic like Tynan had remarked upon as early as 1962 applied to this piece of work. The Brechtian neo-realism of John Bury sets, for instance; the carefully broken-down costumes and props customary in RSC productions at Stratford; the measured, rational, somewhat down beat style of speaking verse which the RSC had pioneered – all these were absent.[12]

In their place was a simplicity of style, a *danse macabre* played out in monochrome, with plenty of visual emblems from skull masks to gymnasium horses. Although the production was different it was essentially a hybrid transformation of a Jacobean mannerist play full of irony and ambiguity, into a linear work relying for its theatrical effect upon extraneous staging material which replaced rather than complemented the original design.[13] It can be argued that Nunn was not responsible for the editing of the text of *The Revenger's Tragedy* into a linear score, that he had this imposed upon him by John Barton, but the fact remains that the play was bastardised in production, though in its remoteness, unfamiliarity and in the freshness of Nunn's general style it caused a lasting critical stir. The productions that were to be mounted at Stratford during the seventies could often be challenged in their simplification of the problematics of the Shakespearean dramatic design. Block-busters as had been seen previously under the Hall era with

John Barton's adaptation, *The Wars of the Roses*, were periodically to rear their heads in terms of Nunn's 1972 Roman season showing the decline of classic civilisation and Terry Hands' 1975 productions of the *Henry V* and *Henry VI* plays which were played in the style not of Barton's super power politics but of the inevitably ridiculous individual futility of political manoeuvering and bullying. In each case the directors, though producing comprehensible and theatrically effective work, were imposing a linear development on the Shakespearean texts which was artificial.

Similarly in comedy the RSC seemed to discover in the critics Barber and Northrop Frye the notion of festive comedy. Nunn's famous musical production of *The Winter's Tale*, 1969, which drew parallels with *Hair* was to be followed by a lively song and dance *The Comedy of Errors*, 1976, and an operatic *As You Like It*, 1977. John Barton aimed for the melancholic effect in the festive comedy in his renowned production of *Twelfth Night* in 1969–72. By 1976 he was translating the festive element to the British Raj in India in a production of *Much Ado About Nothing* which owed not a little to the then current television sit-com *It Ain't Half Hot Mum*. Meanwhile Terry Hands rivalled Nunn in the spectacle of festive comedy using brilliant lighting techniques for the forest revelations of his *As You Like It* in 1980. Although during this period some productions ran counter to this trend, including Peter Brook's renowned *A Midsummer Night's Dream*, 1970–73, Keith Hack's underrated *Measure for Measure*, 1974, and to a lesser extent Michael Bogdanov's *The Taming of the Shrew*, 1978, the main line of development in comedy was towards a spectacular Shakespeare, an escapist rather than a challenging drama.

Whilst dramatists such as Bond and Wesker were re-writing Shakespeare to make the myths challenge contemporary society, the RSC certainly in its main house productions, seemed to be operating largely within a framework which commonly ironed out the intellectual ambiguity and problematics to be found within his drama. One important reason for this was probably related to the need to maintain and increase box office receipts. The economics of theatre are a constant headache and directors have to work under particular financial constraints which necessarily have an effect on the decisions concerning repertory. A way of combatting the problem was to stage experimental, intimate and low budget Shakespearean, Elizabethan and contemporary drama at the RSC's studio theatre, The Other Place founded in 1973 by Nunn and

Buzz Goodbody. It can be contended that the RSC's best work through the 1970s and early 1980s took place in this auditorium including of the Shakespearean plays Buzz Goodbody's *Hamlet*, 1975, with Ben Kingsley; Trevor Nunn's *Macbeth*, 1976, with Ian McKellen and Judi Dench; Ron Daniels' *Pericles*, 1979, with Peter McEnery, and his *Timon of Athens*, 1980, with Richard Pasco; and Adrian Noble's *Antony and Cleopatra*, 1982 with Michael Gambon and Helen Mirren.

It is, however, dangerous to oversimplify in a survey such as this which is necessarily reductive. Of course within the various productions at the Royal Shakespeare Theatre there were challenging elements but the tenor of the main house productions in the 1970s seems in retrospect one that only partially fulfilled Nunn's manifesto. It probably reflected of course the mainly bourgeois society of its audience, drifting more and more in the inert acceptance of a middle-brow political thought encapsulated eventually by Thatcher and Reagan. In such a society a tamed Shakespeare and its attendant processed culture is the reflection of the dominant ideology, whilst experiment in confrontation necessarily takes place before smaller audiences. But even the notion of an experimental studio theatre under the auspices of the Royal Shakespeare Company is indicative of an establishment dominance squeezing out radical thought. Queuing in the rain outside the tin hut of Stratford's The Other Place to see a challenging low-budget Shakespearean production or a play by Howard Brenton or Edward Bond may legitimise radical theatre, reducing the intellectual confrontations by providing a particularly trendy locale in which to work. If you got wet queuing to get in, you would expect to be assaulted by the play once inside. It all becomes part of the event and can be compartmentalised easily into the life of the theatregoing public. Arnold Wesker's objections concerning Olivier's portrayal of Shylock, as a pandering to conscience, takes on a wider significance. It is a pity that if the RSC and the NT are to produce the radical theatre of Bond, Wesker, Brenton and Griffiths that they can rarely do so in their main auditoria.[14] Thankfully the NT to some extent has periodically done so with for example Howard Brenton's *The Romans in Britain* (1980). The furore that ensued could be expected and is in a sense a testimony to the truth of the NT policy on that occasion.

Conversely Peter Hall and Trevor Nunn's complaints under the Thatcher regime of a drop in arts council subsidy naturally throws

a shadow over their own artistic policy. Who defines the freedom of artistic licence – the artists or those who provide the subsidy? The immediate cry of bourgeois revenge over *The Romans in Britain* production was a demand for a withdrawal of public subsidy. What effect such a public outcry has on the artistic integrity of directors, actors and performances naturally varies according to circumstances. The dangers, however, are clear. Similarly we must perhaps question at least the sense of self-satisfaction shown by the RSC on being awarded the Queen's Award for Exports in 1986. Has Shakespeare become so processed that a primary consideration is the 'mass production' of his plays for the tourist market place? If so is there a danger that this consideration might effect the kind of production mounted more than a genuine artistic appraisal of the plays themselves?

An element of spectacle and escapism in RSC productions has continued into the 1980s. Bill Alexander's acclaimed production of *Richard III* (1984–5) with Antony Sher as the protagonist became a cult performance, the interest of which, it can be argued, relied more on Sher's versatility in acting style and the concentration on the creation of a Richard far from the Olivier stereotype, than on developing the issues of the play. The production, though stunning in Sher's vituosity was uneven, neglecting the importance of character interaction. It focussed too strongly on the protagonist and thereby lost a consistency in the second half of the drama when the startling effect of the actor's athleticism had dissipated. Bosworth field was set to the background of an elaborately designed cathedral interior that had served well in the first half but which lost its force as the ghosts appeared from the crypt through the tombs of knights or kings. The RSC's elaboration of design and spectacle had almost become an end in itself. Similarly Trevor Nunn and John Caird's production of *Nicholas Nickleby* though theatrically effective in production style and set, and though scripted by the radical dramatist David Edgar, author of *Destiny*, appeared certainly in its 1986 revival at the Theatre Royal Newcastle as an escapist drama. Rather than confronting its audience with the realities of the causes and conditions of poverty the production proved to be in danger of appeasing middle-class consciences. The false romantic sentimentality of the evils of Victorian Britain was presented rather than the harshness that was its reality. Perhaps the production rightly reflected the attitudes of Mrs Thatcher's Britain and her desire to return to the nineteenth-century values.

What it did not reflect or challenge was the cold fact of such policies in the North East of England and elsewhere, in the mid-1980s, where unemployment was rife at around 33 per cent. This was processed drama, escapist 'culture'.[15] In this context Alan Sinfield is surely right in attacking RSC values and production techniques. A false consciousness concerning the relevance of Shakespeare is in danger of reducing the dramatist's work to that of the musical. Trevor Nunn's success in the West End with the escapism of Lloyd-Webber extravaganzas must be indicative of something. His final RSC production, 1986, as executive director, is of Thomas Heywood's *The Fair Maid of the West* (Parts I and II first published 1630/31; Nunn's version edits the two parts into a single performance). It is a joyous romp, entertaining, professional, highly theatrical and escapist.

Of the 1980s directors at Stratford a number stand out in their attempts to steer at least a slightly different course from that of Trevor Nunn or indeed the new chief executive, Terry Hands. Ron Daniels' production of *A Midsummer Night's Dream*, 1981, was in direct opposition to Peter Brooks's version ten years earlier. It allowed the play an Edwardian setting to express within its comedy a vivacity of life tolerated by an upper class where relations were in themselves somewhat strained and stiff. Theseus and Hippolyta were presented as living a cynical drawing room existence and although a romanticism was present Daniels did attempt throughout to stress that this was a theatrical construct which the audience was watching. He drew a parallel between the inadequacies of the mechanical theatricals and his own attempts to produce a play, by having one of his flats elevated back to front. It was a rather artifical device, intellectually incestuous perhaps, but it showed a desire at least of breaking away from total illusion which is in keeping with the tenor of Shakespeare's play.

Adrian Noble's production of *The Comedy of Errors*, 1983, and *As You Like It*, 1985, similarly challenged audience expectations by confronting them with an expressionistic style of theatre which included blue- or white-faced clowns. In a horrific dream sequence in *As You Like It* Celia was hunted to death by foresters. This forest of Arden was no place of escapism or sentimental festive comedy but rather a place of some terror and confusion as well as comedy. Although the hunting of Celia was a clear example of a director imposing extraneous material onto the Shakespearean text it simultaneously helped to reveal certain elements of the drama

which the recent intertextual tradition of productions had lost in a concentration on the festive. Noble uses the semiotic device of the mirror to a great extent as was seen in this *As You Like It* and also his *Measure for Measure*, 1983. Characters passed through a mirror on the set as they moved from one realm of perceived reality to another. We as an audience were thereby reminded of many of the Renaissance artists', including Shakespeare's, insistence that we are seeing in the theatre merely a reflection of planes of reality. Noble places the metaphor as a tangible visual sign in his productions to good effect.

Howard Davies's production of *Henry VIII*, 1983, was heavily dependent on Brechtian techniques, breaking up the action and representing scenes by highly artificial 'cut out' pictures of homes, pillars and halls being tracked on to the stage as background to the play. As Henry, Richard Griffiths, deliberately played against the Shakespearean lines refusing an easy acceptance of the metre by actually contradicting, for example, the tenor of the prologue by the flippancy of its delivery. Whether such devices confronted the audience, challenging them to engage with the debate of Shakespeare's play is debateable. Rather than actors taking part in procession for example, the grandeur of London was represented by tailors' dummies finely arrayed. This was interesting epic rather than mimetic theatre and as such may have challenged some of our Shakespearean assumptions but the vehicle in being a less well-known play in the Shakespearean canon was probably the wrong one to choose for such experimentation. A similar approach, however, taken by him the previous year to *Macbeth*, 1982, was, as Harrett Hawkins has demonstrated, an utterly boring travesty.[16]

Davies's *Troilus and Cressida*, 1985, was one of the productions criticised by the popular press as an example of the RSC modernising the bard. This production, in my view, was challenging in finding a vehicle for a demanding play, which made the Shakespearean vision of the Trojan War comprehensible and acutely appropriate. Pandarus (Clive Merrison), for example, was not stereotyped as the lightweight pandar with a dirty imagination but rather was given an extrovert's flippancy which was clearly seen to be an escapist attitude on his part; a means of coping with his own inadequacies and despair in the face of war. As Cressida was led off to the Greek camp, he pathetically entered rushing across a balcony above the action and down the staircase. He was carrying her suitcase hurriedly packed, clothes jutting from its lid.

He was confronted with nothing but Cressida's absence. He was too late. She was gone. He sat down a broken and a lonely man; his condition determined by the perpetrators of the war. Similarly Alun Armstrong's conception of Thersites as a lazy scrounging but victimised Geordie was perceptive. His was a reasonable way by which a character of his station could survive in a war conducted by an upper class. His degeneration and cynicism reflected the degradation of the war itself and of its victims, particularly Cressida (Juliet Stevenson). Thersites in his way proved to be no more despicable than Agamemnon, Ulysses or Achilles in their demands for the sexual favour of Cressida. To survive, all that Cressida herself could do was to kiss Ulysses with a repulsive, lascivious, violence which proved to be her protection. Her adultery was a matter of absolute necessity. She matched Thersites in the need for self-preservation. Like Pandarus both were victims of the repugnancy of war. This was one of the most challenging and poignant Shakespearean productions of recent years.

The difficulty, however, with challenging productions is that following their success, their radical style becomes formalised. Michael Bogdanov's *The Taming of the Shrew*, 1978, challenged audience expectation by having a 'traditional Shakespearean set-ting' for the play destroyed by the drunken Petruchio in the opening scene. By 1986 and Bogdanov's *Romeo and Juliet* his peculiarly radical approach to Shakespearean drama had become part of the expectation. As I sat in the RST awaiting the performance to begin the man next to me reading his programme saw the director's name. He turned to his companion and said 'Oh it's Bogdanov directing. We know what to expect.' He was right. We witnessed a highly modernised version of the play with roller skates, chain fights and the Alpha Romeo car. More importantly we saw a decentring of Romeo and Juliet as emotionally tragic figures. By the end of the play they were golden statues irrelevantly unveiled by the leader of the capitalist town. They were soon to be forgotten in Verona's market place. The trouble with Bogdanov's production was not merely that it ran against Shakespeare's play but that in attempting to challenge the audience it fell into a trap of Bogdanov's own making. There was nothing really unexpected. The production conformed to the Bogdanov style instead of attempting to reveal the Shakespearean play. The director of *The Romans in Britain* even in his radicalism had ironically become part of the establishment. Bogdanov has subsequently left the RSC and

with Michael Pennington (and sponsorship from the Arts Council and the Allied Irish Bank) has founded the English Shakespeare Company. It is too early to say whether this company will produce a challenging Shakespeare. Its first productions of *Henry IV Parts I & II* and *Henry V*, reveal a dedication to contemporise Shakespeare from the text outwards, rather than impose a trendy interpretation on it. Through a considered but radical mixture of historical styles Bogdanov establishes a patterned image of the horrors of war which flow from the Shakespearean text. As might be expected the productions have already found themselves criticised by purists. I found them fresh energetic and challenging.

It would be as wrong to conclude that Shakespeare at Stratford through the 1970s was all spectacle, as it would be incorrect to infer that the 1980s have brought a totally fresh approach. Similarly as previously noted it would be fallacious to ignore the achievement at The Other Place of most of the Shakespearean productions. Trevor Nunn's intimate and intense *Macbeth* 1976 for example intelligently found a means to communicate the drama to the contemporary audience. In it Nunn imaginatively fused a medieval conception of horror and evil with modern sensitivity to the psychological destruction of the ambitious. By eradicating kingly pomp, dressing the characters in stark black (in the case of Duncan, white) and by concentrating on the intensity of the language within a circular set comprising merely of orange boxes for seats, Nunn unleashed the power of the play and fulfilled one of his initial aims in taking over at the RSC of finding an appropriate chamber setting for Shakespeare. It was an aim he stated to David Addenbrooke in 1974 explaining his need to find a way of complementing the Shakespearean text with visual signs:

. . . . [the chamber setting] has to work within the scale of the individual actor – to make his words, thoughts, fantasies and language seem important . . . what he wears, what he sits on, possessions directly connected with him, are the next important point. The middle and far distances are not important . . . we want the stage to represent earth, (as for Elizabethans) and underneath the stage hell, the unknown, the darkly occult. Above it is a canopy, a roof fretted with golden fire, the-gods, Apollo.[17]

His 1976 *Macbeth* – it was his third attempt at the play – proved

that modern sensibility could accept such medieval and Elizabethan simplicity, harmonised with the complexity of the psychological motivation and the intensity of the language and action found in the Shakespearean play. The close proximity of John Napier's setting, matched the intensity of the verse. Nunn produced in 1976 a modernised Shakespeare without frills, a Shakespeare who spoke for himself. But Nunn consistently failed to be able to translate such a vision to his main auditorium. Even this *Macbeth* was diminished when transferred by popular demand to the Royal Shakespeare Theatre. The production proved to be both his triumph and his failure.

The plays we have considered in this book cannot be a substitute for the Shakespearean drama. They are plays which have an integrity of their own but a number of them have been brought about because of a malaise in the way modern society approaches Shakespeare. The Elizabethan dramatist has been in danger of becoming no more than an educational maitrix, a recreational spectacle or a tourist attraction. His plays were designed to entertain but in that they challenged and revealed aspects of his society. We are not yet so divorced, despite our technological revolutions, from his age to ignore his artifacts, nor confident enough in our own sensibilities, perceptions and philosophies to create plays which consistently match his intellectual perception and vigour. But some of the most significant drama of the last forty years has either consciously or unconsciously fed from his models and our reception of them. The modern dramatists from different ontological positions have attempted to defamiliarise Shakespeare. Hopefully their efforts in turn may help directors, actors and teachers to reform some of their ideas and approaches. But to do that implies a change in attitude also in audiences and the demands we make on the established theatre. This book has aimed to help introduce the reader to some of the problems implicit in the familiar Shakespeare, to some of the difficulties encountered with modern drama and to some of the patterns used by the modern dramatists to defamiliarise his work. It cannot, however, be a substitute for seeing the plays in performance. It is only there that their success or not can be tested.

Notes and References

CHAPTER 1: INTRODUCTION: RE-INTERPRETING SHAKESPEARE

1. Stanley Wells, *Literature and Drama, with special Reference to Shakespeare and his Contemporaries* (London, 1970) pp. 108–9. For a recent critique of play-text looked at 'as novel', 'as play' or 'as poem' see Terence Hawkes, *That Shakespeherian Rag: essays on a critical process* (London, 1986) pp. 73–91. Another interesting discussion is that of Erving Goffman, 'The Theatrical Frame', *Frame Analysis* (Harmondsworth, 1975) pp. 124–55.
2. Adolphe Appia, *Music and the Art of Theatre*, trans. Robert W. Corrigan and Mary Douglas Dirks, ed. B. Hewitt (Coral Gables, Florida 1962) p. 10.
3. See David L. Hirst, *Edward Bond* (London and Basingstoke, 1985) p. 132.
4. William Shakespeare, *The Tragicall Historie of Hamlet Prince of Denmarke 1603*, in *Elizabethan and Jacobean Quartos* edited by G. B. Harrison (Edinburgh, 1966) p. 28. (Reproduced from the Bodley Head Quartos published between 1922 and 1926, London). See The New Penguin *Hamlet* edited by T. J. B. Spencer, introduction Anne Barton (Harmondsworth, 1980).
5. Op. cit., pp. 37–8. Notice also the differences in this speech as printed in two modern editions: the Penguin here and Professor Alexander's text for Collins as quoted in Chapter 2.
6. A survey of Shakespearean production is found in George C. D. Odell, *Shakespeare from Betterton to Irving*, 2 vols, 1920 (Dover edition, New York, 1966).
7. From George Granville, Lord Lansdowne, *The Jew of Venice* extracted in *Shakespeare. The Critical Heritage*, vol. 2, 1693–1733, ed. Brian Vickers (London, 1974) p. 152.
8. *Nineteenth Century Shakespeare Burlesques*, selected by Stanley Wells, (London, 1978) vol. IV, p. 57.
9 See Thomas R. Whittaker, *Tom Stoppard* (London and Basingstoke, 1983) pp. 48f; Tim Brassell, *Tom Stoppard: an Assessment* (London and Basingstoke, 1985) pp. 36f.
10. A. C. Sprague, *Shakespearean Players and Performances* (1953 Greenwood edn, New York, 1969) pp. 113–14 drawing on contemporary theatre reviews in *The Theatre*, 1 December 1879, and *Saturday Review*, 8 November 1879.
11. See Chapter 4.

12. Keir Elam, *The Semiotics of Theatre and Drama* (London and New York, 1980) p. 93.
13. Antonin Artaud, *The Theatre and Its Double*, trans Victor Corti (London, 1970) p. 60.
14. Ronald Hayman, *Artaud and After* (Oxford, 1977) p. 160.
15. Artaud, pp. 55, 58.
16. From John Willett, *The Theatre of Bertolt Brecht* (rev. pbk edn, London, 1977) pp. 120–1.
17. For a discussion of Brecht's reading of Shakespeare see Margot Heinemann 'How Brecht read Shakespeare' in *Political Shakespeare New Essays in Cultural Materialism*, edited by Jonathan Dollimore and Alan Sinfield (Manchester, 1985) pp. 202-30. It has been suggested that John Osborne's adaptation of *Coriolanus, A Place Calling Itself Rome* (London, 1973) may have been written in reply to Brecht's adaptation. Osborne's secretary, however, has denied that this is so. See Ruby Cohn, *Modern Shakespeare Offshoots* (Princeton, 1976) p. 22. Ruby Cohn's book is the best available survey of Shakespearean 'offshoots' and 'adaptations'. In kindly reading through my typescript Arnold Hinchliffe notes in a letter to me 'I'm sorry there is no place for Osborne's version of *Coriolanus* which – I think – has never been produced anywhere. It does require a tank and a helicopter but what's a National Theatre for? It is an interesting adaptation and Coriolanus (or a view of him) suits Osborne well.' I agree but I am afraid space has not allowed its inclusion.
18. Bertolt Brecht, *A Short Organum for the Theatre* in John Willett, trans & ed., *Brecht on Theatre* (London 1965) pp. 182–3.
19. Adaptations and offshoots abound this century from Jarry's *Ubu Roi* to work by C. P. Taylor, Howard Brenton, Snoo Wilson and others. Friedrich Dürrenmatt in particular has written two major adaptations, *Konig Johann* (1968), *Titus Andronicus* (1970). For a checklist of many of these plays see Cohn, 1976, pp. 411–16.
20. Tom Stoppard, 'Is It True What They Say About Shakespeare?' *International Shakespeare Association Occasional Paper No 2* (Oxford, 1982) p. 13.
21. Guido Almansi, 'The Thumb-Screwers and the Tongue-Twisters: on Shakespearean Avators', *Poetics Today*, vol. 3, no. 3 (Summer 1982) pp. 87–100 divides the adapters into two camps: 'the thumb-screwers . . . tend to reestablish a Shakespeare who is more Elizabethan than the Elizabethan age could allow, a truculent and schizophrenic Shakespeare whose language is in chaotic upheaval and whose characters rant and rage' and the 'tongue-twisters' who 'are much less violent and severe, and insist on the element of "theatre within the theatre", already present in Shakespeare himself but emphasised and played upon by the new masters of dramatic acrobatics'. In the former category Almansi includes Bond, Ionesco, Dürrenmatt, Testori, in the latter, Stoppard, Marowitz, Manganelli. His categorisations can perhaps be challenged. Bond would not relish being compared with Ionesco for example, or vice versa. I am grateful to Guido Almansi for sending me an off print of this article.

22. John Marston, Preface to *The Fawn* (1604).

CHAPTER 2: PARASITIC COMEDY

1. Tom Stoppard interviewed by Ronald Hayman in Ronald Hayman, *Tom Stoppard* (London, 1977) p. 7.
2. Tim Brassell, pp. 66–7. Brassell narrows the influence even further to Eliot's lines from *Prufrock*:

> No! I am not Prince Hamlet nor was meant to be:
> Am an attendant lord, one that will do
> To swell a progress, start a scene or two,
> Advise the prince, no doubt an easy tool.
>
> T. S. Eliot, *Collected Poems*, 1909–62, p. 17

Thomas R. Whitaker, pp. 37–67 sees the drama in the context of Beckett's plays, and makes reference also to James Saunders, *Next Time I'll Sing to You* (not regarded as a major influence by Brassell). He also suggests a parallel with Sartre's *No Exit* (sometimes called *In Camera*, sometimes *Vicious Circle*, originally titled *Huis Clos*). Both Brassell and Whitaker acknowledge W. S. Gilbert's burlesque *Rosencrantz and Guildenstern: a Tragic Episode, in Three Tableux* (1891) as a previous playlet placing the same two characters at its centre. This playlet can be found in Stanley Wells, *Shakespeare Burlesques – Vol IV* (London, 1978), also in *Plays by W. S. Gilbert*, ed. George Rowell (Cambridge, 1982). Jim Hunter, *Tom Stoppard's Plays* (London, 1982) p. 137, comments: 'The title of Stoppard's play is important. A single dismissive line from the end of *Hamlet*, it hangs over the modern play like a memento mori. . . . One fundamental difference between *Rosencrantz* and Beckett's *Waiting for Godot* is indicated by their titles: in one play, the protagonists dead from the start, in the other, always waiting'. C. W. E. Bigsby *Tom Stoppard* (Harlow, Essex, 1976) p. 10 sees in the play an attempt 'to combine the brittle wit of Oscar Wilde with the mordant humour of Samuel Beckett'. He also finds echoes of Edward Albee's *Tiny Alice* and *Zoo Story*, Harold Pinter's *The Birthday Party* and John Osborne's *The Entertainer*. Bigsby's is a brief but telling study in which he states: 'Niebur's comment that laughter is a king of no man's land between faith and despair is clearly applicable to *Rosencrantz and Guildenstern are Dead*. For Rosencrantz and Guildenstern themselves, humour is a means of preserving sanity; for Stoppard it is a natural product of disjunction – of the gulf between cause and effect, aspiration and fulfilment, word and meaning, which is the root alike of all pain, absurdity and laughter, and a clue to the relativity of truth, itself a subject to which Stoppard has repeatedly returned' (pp. 15–16).
3. Arnold Hinchliffe, *British Theatre 1950/70* (Oxford, 1974) pp. 141–2.
4. In Giles Gordon, 'Tom Stoppard', *Transatlantic Review*, 29, 1968 quoted Brassell p. 38.

5. Tom Stoppard, *Rosencrantz and Guildenstern are Dead* (London, 1968) pp. 7–8. All quotations are from this edition which is based on Stoppard's revisions. The ending of the play was changed and a few other alterations were made from the first to the second performance. These have been detailed by Tim Brassell, *Tom Stoppard: an Assessment*, who also reproduces the original ending of the play, pp. 270–1.

6. For a discussion of the war of the theatres, see the seminal work of Alfred Harbage, *Shakespeare and the Rival Traditions* (1952; repr. Ontario, 1970). Some of Harbage's ideas have been challenged in recent years by in particular Ann Jennalie Cook, *The Privileged Playgoers of Shakespeare's London 1576–1642* (Princeton, 1981). See also Andrew Gurr, *Playgoing in Shakespeare's London* (Cambridge, 1987).

7. *Meyerhold on Theatre*, trans and ed. with a critical commentary by Edward Braun (London, 1969) p. 30.

8 See Chapter 8 below. Some would argue of course that the Marowitz Shakespeare is similarly out of date it reacts against certain historical readings of the play. I would contend, however, that Marowitz rather than acquiescing to a particular liberal line shows a foresight in his opposition which allows some of his experiments to retain their force through the inherent positivism of his interpretation. Stoppard's interpretation though amusing is negative.

9. See Chapter 9 below.

CHAPTER 3: A DIVERGENT VIEW OF HUMAN NATURE

1. Quotations from *The Fool* are from Edward Bond *The Fool and We Come to the River* (London, 1976).

2. Bond, Introduction, *The Fool and We Come to the River*, p. xiii writes, '. . . we must learn how to look, and teaching about art is as important as creating it. The S.S. Commandant didn't read Goethe, he admired himself reading Goethe'.

3. The image of the caged bird is also employed in *Lear*.

4. Introduction, *The Fool and We Come to the River*, p. xiii.

5. Arnold Hinchliffe, *Volpone: Text and Performance* (London and Basingstoke, 1985) p. 9.

6. Edward Bond quoted by Malcolm Hay and Philip Roberts, *Bond: a Study of His Plays* (London, 1980) p. 197.

7. Quotations are from Edward Bond *Bingo Scenes of Money and Death* (London, 1974).

8. Interestingly enough renaissance dramatists were fond of this sign device as for example the hanging body of the Governor of Damascus in Marlowe's *Tamburlaine* (1587/8) or the exposed corpse of Feliche that dominates at least half of the action of John Marston's *Antonio's Revenge* (1599).

9. Hay and Roberts, pp. 180f.

10. Bond in the play is not interested in historical accuracy. The play is not meant as a biography of Shakespeare. So he writes '. . . I admit that I'm not really interested in Shakespeare's true biography in the

way a historian might be. Part of the play is about the relationship between any writer and his society', Introduction, *Bingo*, p. vii. The most accessible biography of Shakespeare is Samuel Schoenbaum, *Shakespeare: A Documentary Life* (Oxford, 1975). Recently a new hypothesis has been put forward concerning Shakespeare's early life and his Catholic connections. See E. A. J. Honigmann, *Shakespeare: the "Lost Years"* (Manchester, 1985).

11. Ben Jonson, *To the Memory of My Beloved, the Author, Mr William Shakespeare: and what he hath left us*. Lines 17–24, 41–3. The poem was written for the publication of the First Folio, 1623. Lines 19–21 allude to William Basse's *Elegy on Shakespeare* where the three poets mentioned were asked 'to make room/For Shakespeare in your threefold, fourfold tomb'.

12. Edward Bond, 'The Rational Theatre' in *Bond Plays: Two* (London, 1978) pp. ix–x.

13. See Hay and Roberts, p. 196, for a discussion of this scene in the early draft versions of the play.

14. Tony Coult, *The Plays of Edward Bond*, rev. edn (London, 1979) p. 21.

15. For a discussion of Shakespear's handling of his source material see Kenneth Muir, *The Sources of Shakespeare's Plays* (London, 1977) pp. 196–208.

16. See Jan Kott, *Shakespeare Our Contemporary*, rev. edn (London 1967) and G. Wilson Knight, *The Wheel of Fire*, rev. edn (London, 1949).

17. The 1982 RSC season included the Shakespeare play at *The Royal Shakespeare Theatre* and Bond's *Lear* at The Other Place. Bond didn't totally like the Barry Kyle production of his play – see David L. Hirst *Edward Bond* (London and Basingstoke, 1985) p. 132. Gregory Dark's production file of the Royal Court performance can be found in *Theatre Quarterly*, vol. 2, no. 5, 1972.

18. For an introduction to the performance of the play see Gāmini Salgādo, *King Lear: Text and Performance* (London and Basingstoke, 1984).

19. Quotations are from Edward Bond, *Lear* (London and Basingstoke, 1972).

20. Trevor Griffiths, *Comedians* (London, 1976) pp. 17–18, 22.

21. David L. Hirst, *Edward Bond*, pp. 133f. discusses Bond's 'aggro effects' relating them to Brecht's 'V-effect'. Instructively he quotes from a Bond statement in *Theatre Quarterly* 30:

> Alienation is vulnerable to the audience's decision about it. Sometimes it is necessary to emotionally commit the audience – which is why I have aggro-effects. Without this the V-effect can deteriorate into an aesthetic style. Brecht then becomes 'our Brecht' in the same sloppy patriotic way that Shakespeare becomes 'our Shakespeare'. I've seen good German audiences in the stalls chewing their chocolates in time to Brecht's music – and they were most certainly not seeing the world in a new way.

22. For the diehard *cognescenti* in the audience of course the whole debate about Brook's production omitting the flax and egg whites provides another residual level operating from Bond's dramatic image. Brook's decision is discussed further in Chapter 9.

23. In *Author's Preface*, p. xiii, Bond writes:
 'Lear is blind till they take his eyes away, and by then he has begun to see, to understand. (Blindness is a dramatic metaphor for insight, that is why Gloucester, Oedipus and Tiresias are blind)'.
 At the end of *Ghosts* (1881) the debilitated Oswald asks Mrs Alving for 'the sun'.
24. Alan Sinfield *'King Lear* versus *Lear* at Stratford'. *Critical Quarterly*, 24 (Winter, 1982) 5–14; pp. 5–6.
25. Salgādo, 1984, p. 10.

CHAPTER 4: DEMYTHOLOGISING SHYLOCK

1. Charles Marowitz, Introduction, *The Marowitz Shakespeare* (London, 1978) p. 22. All quotations from Marowitz, *Variations on the Merchant of Venice* are from this volume, pp. 226–83.
2. W. H. Auden, 'Brothers and Others', *The Dyers Hand* (London, 1948) p. 223.
3. Leslie Fiedler, *The Stranger in Shakespeare* (Frogmore, St Albans, 1974) pp. 81–2 writes: 'It took three generations of nineteenth-century romantic actors to make the Jew seem sympathetic as well as central, so that the poet Heine, sitting in the audience, could feel free to weep at his discomfiture. The final and irrevocable redemption of Shylock, however, was the inadvertent achievement of the greatest anti-Semite of all time, who did not appear until the twentieth century was almost three decades old. Since Hitler's 'final solution' to the terror which cues the uneasy laughter of *The Merchant of Venice*, it has seemed immoral to question the process by which Shylock has been converted from a false-nosed, red-wigged monster (his hair the colour of Judas's) half spook and half clown, into a sympathetic victim'.
4. Arnold Wesker, Preface, *The Merchant* With Commentary and Notes by Glenda Leeming (London, 1983) p. l. (The preface was first published as an article in *The Guardian*, 29 August 1981). All quotations from *The Merchant* are from this edition.
5. Keir Elam, *The Semiotics of Theatre and Drama* (London, 1980) p. 86, makes an interesting comment about extra-textual considerations concerning the performance of plays using Olivier as Shylock as an example: 'The individual actor as recognised figure or 'personality' will bring to the performance extra-textual connotations which play no small part in the audience's decoding of the text (the mere presence of, say Olivier in *The Merchant of Venice* will influence very substantially the aesthetic information which his admirers derive from the performance, since the prestigious connotation 'great actor' is established *a priori*). A well-known actor will bring to his performance, moreover, an 'intertextual' history which invites the spectator to compare it with past performances, thus drawing attention to the performer's idiolectal traits (common to all his performances).'
6. For a stage history of Shylock see Toby Lelyveld, *Shylock on the Stage* (London, 1961). For a biography of Macklin see William W. Appleton,

Charles Macklin: an Actor's Life (Cambridge Mass. and London, 1961).

7. Patrick Stewart in John Barton, *Playing Shakespeare* (London, 1984) p. 179.

8. Patrick Stewart, 'Shylock' in *Players of Shakespeare Essays in Shakespearean Performance* by *Twelve Players of the Royal Shakespeare Company*, ed. by Philip Brockbank (Cambridge, 1985) p. 14.

9. The play had been adapted by George Granville (Lord Lansdowne) as *The Jew of Venice*. See amongst others George C. Odell, *Shakespeare from Betterton to Irving*, 2 vols (New York, 1966), vol. 1, pp. 76–9. See also p. 227.

10. Appleton, pp. 44f. We cannot say for certain that Burbage played Shylock comically. There is an overriding problem with the character's significance. If the 'Hath not a Jew eyes' speech combined with the overall perception of the character allows for a tragic dimension which many would argue, then a further critical question has to be asked. Does Shakespeare in this comic romance invest a figure, who appears very little, with a tragic humanity which overwhelms the comic concerns which appear to be the author's main intent? Shylock disappears from the play at the end of Act 4. Act 5 in Belmont is clearly the intended concluding focus of the drama but has its function been usurped by Shylock's tragic exit? The proposition that Burbage acted Shylock comically rescues Shakespeare to some extent from charges that he failed to balance his drama and to be consistent in his intent. The stage history of the play linked to our historical knowledge of Elizabethan attitudes towards Jews implies that an Elizabethan comic Shylock was a real possibility.

Commonly accepted textual readings – influenced I would hold by the intertextual critical and performance history of the play – favour the tragic Jew. That is the insoluble dilemma. For the purpose of my argument in this chapter I have favoured the former reading. I do not think that my conclusions concerning the Wesker and Marowitz versions would have been much changed if I had taken the latter reading, although the argument to those conclusions would have been different being based on the Shakespearean imbalance of the play.

11. Moelwyn Merchant, Introduction, *The Merchant of Venice*, New Penguin edition (Harmondsworth, 1967) pp. 46f. notes that Kean first played the role at the Theatre Royal, Exeter on 3 December 1811.

12. Richard Findlater, *The Player Kings*, 2nd edn (London, 1971) pp. 113f.

13. A. C. Sprague, *Shakespearean Players and Performances*, Greenwood edn, (New York, 1969) p. 109.

14. Alan Hughes, *Henry Irving, Shakespearean* (Cambridge, 1981) pp. 224–41 gives a good account of Irving's interpretation but also see Sprague, pp. 104–20.

15. Hughes, p. 240, writes 'The worlds of Christians and Jews were separated by hatred and suspicion, like the houses of Capulet and Montague. There were no villains, and it was not the tragedy of Shylock alone; he was not the only one who failed to know himself or his world. Portia and her friends were pleasant young people who behaved as though they were living in a comedy, but they ignorantly

defended their way of life by denying Shylock his humanity. Thus in a sense they denied that part of their own humanity which was akin to his.'

16. *Shaw on Shakespeare: an Anthology of Bernard Shaw's Writings on the Plays and Production of Shakespeare*, edited with an introduction by Edwin Wilson (London, 1962) p. 53. See also p. 252, 'His huge and enduring success as Shylock was due to his absolutely refusing to allow Shylock to be the discomfited villain of the piece. The Merchant of Venice became the Martrydom of Irving, which was, it must be confessed, far finer than the Tricking of Shylock'.

17. A possible exception may have been Ian McDiarmid's portrayal in John Caird's RSC production of 1984. The production, however, was a hotch-potch, shameful affair, so entirely lacking discipline that it is difficult to say anything positive about it or indeed to be clear what they were doing.

18. See also Bond's portrayal of Florence Nightingale and Queen Victoria in *Early Morning* (1968).

19. Marowitz, Introduction, pp. 22–3.

20. Christopher Marlowe, *The Jew of Malta* (1589/90) ed. Richard Van Fossen (London, 1965) II.iii.310–14; II.iii.170–3.

21. See Christopher Marlowe, *Tamburlaine the Great* (1587/8) ed. John D. Jump (London, 1967) Part Two II i–iii, in which the Christians break their sworn oaths of peace and are subsequently defeated by Orcanes who claims 'And Christ or Mahomet hath been my friend' (Pt.2.II.iii.11).

22. Not all would agree with this. Bill Overton, Loughborough University, for example, feels that the Marowitz version is a more successful drama in that it allows action to develop whereas Wesker's version, he feels, is rather static. I am grateful to Bill Overton for discussing some of the issues in this chapter with me. He considers briefly the two versions in Bill Overton, *The Merchant of Venice: Text and Performance* (London and Basingstoke, 1987) pp. 70–4. In an article 'Giving them Hell', *Plays and Players* (July 1977) pp. 15–16, Charles Marowitz answers some of the rather hostile critical reviews – by among others Irving Wardle, Michael Billington, John Peter and Robert Cushman – of his play. Catherine Itzin, 'The Trouble with Shylock', reviews the play in the same edition p. 17.

23. See Arnold Wesker, *Chicken Soup with Barley, Roots, I'm Talking About Jerusalem* (Harmondsworth, 1964).

24. See John Barton, 1984, p. 170.

25. Ralph Berry, *Shakespeare and the Awareness of the Audience* (London and Basingstoke, 1985) p. 46.

26. Berry, p. 47.

CHAPTER 5: FRUSTRATING DRAMATIC STRUCTURE

1. John Fletcher and John Spurling, *Beckett: a Study of His Plays*, 2nd edn (London, 1978) p. 143. See also Ruby Cohn, *Modern Shakespeare*

Offshoots (Princeton, 1976) p. 378 and her earlier article 'Beckett and Shakespeare', *Modern Drama*, vol. XV (1972–3) pp. 223–230.
Two essays from the 1960s by John Russell Brown are of interest: Mr Pinter's Shakespeare', *Critical Quarterly*, vol. 5, no. 3 (1963) pp. 251–64; 'Mr Beckett's Shakespeare', *Critical Quarterly*, vol. 5, no. 4 (1963) pp. 310–26. The latter is reprinted in *Shakespeare's wide and universal stage*, ed. C. B. Cox and D. J. Palmer (Manchester, 1984) pp. 1–17.

2. Jan Kott, *Shakespeare Our Contemporary*, 2nd edn (London, 1967) pp. 111–12.

3. Gāmini Salgādo, 1984, p. 6. It is useful to compare Salgādo's account of the role of the fool in this production with Kott's statements about his significance: '. . . the Fool . . . rejects all appearances, of law, justice, moral order. He sees brute force, cruelty and lust. He has no illusions and does not seek consolation in the existence of natural or supernatural order, which provides for the punishment of evil and the reward of good. Lear, insisting on his fictitious majesty, seems ridiculous to him. All the more ridiculous because he does not see how ridiculous he is. But the Fool does not desert his ridiculous, degraded king, and accompanies him on his way to madness. The Fool knows that the only true madness is to recognise the world as rational. The feudal order is absurd and can be described only in terms of the absurd. The world stands upside down . . .', Kott, p. 132.

4. Alan Sinfield, 'Royal Shakespeare' in *Political Shakespeare*, p. 171. Salgādo, 1984, p. 63 suggests that the Fool as a circus clown in Noble's production was possibly inspired by Brook's famous production of *A Midsummer Night's Dream*, RSC 1970. In Noble's 1982 *King Lear*, Michael Gambon played King Lear, Antony Sher, the Fool.

5. See Michael Scott, *Renaissance Drama and a Modern Audience* (London and Basingstoke, 1982) pp. 29f for a brief discussion of this production.

6. John Northam, 'Waiting for Prospero' in *English Drama Forms and Development Essays in Honour of Muriel Clara Bradbrook*, ed. Marie Axton and Raymond Williams (Cambridge, 1977) p. 186.

7. Cohn, 1976, pp. 376–77.

8. Emrys Jones, *Scenic Form in Shakespeare* (Oxford, 1971). See for example Jones's chapter on *Othello* which draws structural parallels with for example *The Merry Wives of Windsor*.

9. Any analysis of Shakespearean structure is in danger of accusations of being reductive. One of the most prominent analyses of comic structure is that of Northrop Frye *Anatomy of Criticism* (Princeton, 1977). This has come under increasing criticism in recent years. See note 16 below.

10. Marilyn French, *Shakespeare's Division of Experience* (London, 1982) p. 119, comments on Viola: 'In the terms of the play-world, she has no identity because she has no place, but she is in a way the psyche or searching mind of all the characters. It is perhaps impossible to live with anarchy of the soul: something(s) has to be more important than others, which is to say, structure is probably necessary. But a happy structure – one which merges the gender principles – cannot be imposed, must be discovered. For the revelation of this, Viola trusts

to time. And just as she represents a part of all the characters, Viola becomes pivotal in the discoveries they make, as well. Her place, when discovered, determines theirs.'

11. Catherine Belsey, 'Disrupting sexual difference' in *Alternative Shakespeares*, ed. John Drakakis (London, 1985) p. 187. I have benefited greatly from this excellent essay.

12. Belsey, 1985, p. 188. Catherine Belsey, *The Subject of Tradedy. Identity and Difference in Renaissance Drama* (London and New York, 1985) pp. 195–6 pertinently comments on the role of Portia in *The Merchant of Venice*: 'Portia, like the other heroines of Shakespeare's romantic comedies, is invested with authority by her auditors within the fiction on condition that she changes her clothes and speaks with the voice of a man. In Shakespearean comedy women literally 'personate masculine virtue', with the effect of bringing about reconciliation and integeration, but it is on the grounds of their discursive and subjective discontinuity that they are presented as able to do so. Moreover, Portia is not free to choose among her suitors, but is subject to the will of her father, whose binding wisdom is shown in the casket scene to reach from beyond the grave.'

13. F. R. Boas first coined the term 'problem plays' as applied to these dramas. See for example one of the best studies of these plays, Ernest Schanzer, *The Problem Plays of Shakespeare* (London, 1963) p. 106 where he comments on *Measure for Measure*: 'We have found in it a concern with a moral problem which is central to it, presented in such a manner that we are unsure of our moral bearings, so that uncertain and divided responses to it in the minds of the audience are possible or even probable.'

14. The other is *The Comedy of Errors* (1593). It can be argued that *The Taming of the Shrew* (1593) also follows the unities but the structure of this play as we have it is somewhat confused, the frame not being adequately closed.

15. Northam, 1977, p. 188.

16. In the 1950s and 1960s criticism the perception of this movement of characters from one place to another led a number of critics, most notably C. L. Barber, *Shakespeare's Festive Comedy: a Study of Dramatic Form in Relation to Social Custom* (Princeton, 1959) and Northrop Frye, *A Natural Perspective: the Development of Shakespearean Comedy and Romance* (New York, 1965), to draw parallels with festive patterns and social customs and to discuss matters such as 'the green world' in the plays. In recent years their work has become increasingly challenged. See for example Malcolm Evans, 'Deconstructing Shakespeare's *Comedies*' in Drakakis, 1985, pp. 67–94, and in particular the seminal work of Robert Weimann, *Shakespeare and the Popular Tradition in the Theater*, ed. R. Schwartz (Baltimore and London, 1978). If historically and culturally the Beckett work we are discussing is placed at the time of its composition in the 1950s and 1960s, the influence of the ideas current – as manifested for example in the work of these 'festive' critics – should not be forgotten. An interesting anthropological essay on patterns of festivity which though not related to Shakespeare

specifically is highly informative is E. R. Leach, *Rethinking Anthropology*, London School of Economics Monographs on Social Anthropology, no. 22 (London, 1961) pp. 132–6. I have discussed this briefly elsewhere, Scott (1982), p. 105. The influence of the festive critics on Shakespearean production at Stratford was particularly marked in the 1970s. See Chapter 9.

17. Samuel Beckett, *Waiting for Godot* (London, 1965) p. 15. All references to the play are from this edition.
18. Cohn, 1976, p. 380.
19. Samuel Beckett, *Endgame* (London, 1964) p. 15. All quotations from the play are to this edition.
20. *The Tempest*, 5.1.183.
21. Cohn (1976) p. 377.
22. Eugene Ionesco in *The Bald Prima Donna* (1950) satirises the whole notion of Aristotelean anagnorisis by an absurd parody in which Mr and Mrs Martin recognise themselves to be man and wife by an elaborate discussion culminating in reference to their child Alice who has one red eye and one white eye. The audience is confidentially told by the maid, in an aside that they are wrong: '. . . whereas it's the right eye of Donald's child that's red and the left eye that's white, it is the left eye of Elizabeth's child that's red and the right eye that's white', Eugene Ionesco, *Plays*, trans D. Watson (London, 1958) vol. 1, p. 96.
23. See Eugene Ionesco, *Notes and Counter Notes*, trans. by D. Watson (London, 1964) pp. 92–6.
24. Wallace Stevens, 'Sunday Morning' in *Selected Poems* (London, 1967) pp. 30–4; in *Collected Poems* (London, 1955) pp. 66–70.

CHAPTER 6: MODERN MORALITY PLAYS

1. M. C. Bradbrook, *English Dramatic Form in the Old Drama and the New* (London, 1970) p. 185. Ionesco's reading of the play is in the tradition of romantic Shakespearean criticism. In 'Experience of the Theatre', *Notes and Counter Notes*, p. 30 he writes:

When Richard II dies, it is really the death of all I hold most dear that I am watching; it is *I* who dies with Richard II. Richard II makes me sharply conscious of the eternal truth that we forget in all these stories, the truth we fail to think about, though it is simple and absolutely commonplace: I die, he dies, you die. So it is not history after all that Shakespeare is writing, although he makes use of history; it is not History that he shows me, but *my* story and *our* story – *my* truth, which independent of my 'times' and in the spectrum of a time that transcends Time, repeats a universal and inexorable truth.

2. References to *Exit the King* are from Eugene Ionesco, *Plays*, vol. V trans. Donald Watson (London, 1963) pp. 9–93. For an example of the erratic clock see Ionesco's first play, *The Bald Prima Donna*.
3. Christopher Marlowe, *Dr. Faustus*, ed. John J. Jump, (London, 1968,

Manchester, 1976). For a discussion of some of the parallels between *Dr. Faustus* and *Exit the King* see Scott (1982) pp. 18–30.

4. For a discussion of 'time' in Shakespeare's comedies see Leo Salingar, 'Time and Art in Shakespeare's Romance', *Renaissance Drama*, 9 (1966) pp. 3–35.

5. Interestingly enough Marlowe's deposed King Edward II hears a drum beating out the rhythm of his ebbing time. See *Edward II*, Act V, scene V.

6. For a discussion of language of *Richard II* see M. M. Mahood, *Shakespeare's Word Play* (London, 1957) and Terence Hawkes, *Shakespeare's Talking Animals: Language and Drama in Society* (London, 1973).

7. *Why Do I Write* in Eugene Ionesco, *Plays*, vol. XI, trans. D. Watson and C. Williams (London, 1979) pp. 119–35. The quotation is from pp. 123–4. Ionesco's empiricism here would be strongly challenged by cultural materialists and critical theorists. As indicated later in the chapter Edward Bond finds such a philosophy an anathema. Catherine Belsey, *Critical Practice* (London, 1980) provides a good introductory critique of literary criticism based on 'common sense' attitudes.

8. I John 1.8 The next verse reads 'If we confess our sins, he is fruitful and just, and will forgive our sins and cleanse us from all unrighteousness'.

9. Richard N. Coe, *Ionesco: a Study of his Plays*, rev. edn (London, 1971).

10. Rosette C. Lamont, 'From *Macbeth* to *Macbett*', *Modern Drama*, vol. XV (1972–73) pp. 231–53. The influence of *Ubi Roi* is also briefly discussed by Ronald Hayman, *Theatre and Anti-Theatre: New Movements since Beckett* (London, 1979) p. 69 (see also pp. 54–55) and by Ruby Cohn (1976) p. 87, who quotes Ionesco as saying that *Macbett* 'leans more . . . towards Jarry's *Ubu Roi* [than toward Shakespeare's *Macbeth*]. In any case there is none of Shakespeare's compassion". In Adrian Noble's RSC production of *Macbeth*, 1986, with Jonathan Pryce as Macbeth, the final scenes were acted out with Macbeth being portrayed as almost insane. Scenically reminiscent of Akira Kurosowa's 1957 film *Throne of Blood* they also came close to portraying Shakespeare's concluding act in terms not dissimilar from absurd drama. Comically but uncannily, earlier in the play, David Troughton's obscene, gross and discomforting Porter bore an ominous resemblance to Jarry's Père Ubu.

11. Lamont, p. 234.

12. Quoted in *Plays and Players* (June 1973) p. 57.

13. Quotations from *Macbett* are from Charles Marowitz's translation (New York, 1973). This was the translation employed for the first performance of the play in English, 16 March 1973 at the Yale Repertory Theatre. The play may also be found in Eugene Ionesco *Plays*, vol. IX, trans. D. Watson (London, 1973).

14. Edward Bond, 'The Rationale Theatre', *Plays Two*, p. x. See also Bond's attack on Beckett in his article '*The Romans* and the Establishment's Figleaf', *The Guardian*, 3 November 1980. See David L. Hirst, *Edward Bond*, p. 89.

16. *Why Do I Write?* p. 130.

17. Edward Bond, *Summer* (London, 1982) pp. 20–1.
18. Reviewing the first English language production, *Plays and Players* (June 1973) p. 57, notes that there was a slight difference in the delivery of the speeches between the two characters: 'They speak exactly the same lines, recount exactly the same indefensible carnage, but for Macbett it's all in a day's work. . . . From Banco the same lines convey a substantial degree of doubt'.
19. Lamont, p. 234.
20. Ionesco's most useful non-dramatic statement in English to date of this philosophy is found in the essay *Why Do I Write?*
21. I am thinking for example of the Wife of Bath's tale in Chaucer's *The Canterbury Tales*.
22. 'No philosophy or theology, not even Marxism, has ever been able to resolve the problem of evil or explain its presence. No society, and above all no communist society, has ever succeeded in removing or reducing it', *Why Do I Write?*, p. 126.
23. See *Troilus and Cressida* Act 5 scene 6. In the same way that the Lemonade Seller fears the second soldier so Thersites is threatened first by Hector and then by the bastard, Margarelon.
24. *Why Do I Write?*, p. 124.

CHAPTER 7: THE JACOBEAN PINTER

1. See for example Martin Esslin, *Pinter the Playwright* (London, 1982) pp. 153–61 reprinted as 'A Case for *The Homecoming*' in Michael Scott, ed., *Harold Pinter: 'The Birthday Party', 'The Caretaker' and 'The Homecoming': a Selection of Critical Essays*, Macmillan Casebook Series (London and Basingstoke, 1986) pp. 172–8. Esslin draws parallels with *Hamlet*, *King Lear* and *Oedipus*. The Introduction to the Casebook draws parallels with *The Revenger's Tragedy* and *The Changeling*. Hugh Nelson, 'The Homecoming Kith and Kin' in John Russell Brown, ed., *Modern British Dramatists* (Englewood Cliffs, N.J. 1968) draws parallels with *Troilus and Cressida*.
2. See Esslin, p. 31.
3. Simon Trussler, *The Plays of Harold Pinter* (London, 1973) pp. 123f reprinted as 'A Case Against *The Homecoming*' in Casebook, pp. 178–85.
4. Esslin, p. 154.
5. Harold Pinter, Between the Lines, *The Sunday Times*, 4 March 1962.
6. Harold Pinter, Speech Hamburg, 1970 first published in *Theatre Quarterly* 1, no. 3 (1971). In 'A play and Its Politics: a Conversation Between Harold Pinter and Nicholas Hern', *One for the Road* (London, 1985) pp. 5–23 Hern suggests that for some people Pinter's plays over the years have been operating on a 'political level invisibly'. Pinter affirms, as he has done before, that his 'political awareness' during his career has not been dead (pp. 11–12). Later he reflects on the irony of him now writing an overtly didactic drama: '. . . I'll always find agit-prop insulting and objectionable. And now, of course, I'm doing

exactly the same thing. There's very little I can say about it. I'm aware of that great danger, this great irritant to an audience . . .' (p. 18).

7. Mel Gussow, 'A Conversation with Harold Pinter', *New York Times Magazine*, 5 December 1971.
8. Esslin, pp. 58–9.
9. Antonin Artaud, *The Theatre and Its Double*, p. 71.
10. Esslin, p. 175.
11. Quotations from *The Homecoming* are from the 2nd edn (London, 1966).
12. *Oedipus King of Thebes*, trans Gilbert Murray (London, 1911) p. 71.
13. *The Revenger's Tragedy*, ed. R. A. Foakes, (London, 1966) I ii 180–9. The authorship of the play is uncertain but it is commonly ascribed to Cyril Tourneur.

CHAPTER 8: THEATRICAL DISCONTINUITY

1. Charles Marowitz, *Confessions of a Counterfeit Critic: a London Theatre Notebook 1958–1971* (London, 1973) p. 6.
2. In addition to translating Ionesco's *Macbett*, Marowitz has written his own version of the play, which has three Macbeth figures. It is to this version which I am referring. Marowitz regards it as a less interesting collage than his *Hamlet*. See Introduction, *The Marowitz Shakespeare*, p. 15.
3. See Peter Brook, *The Empty Space* (Harmondsworth, 1972) which helps show his attempt to bring together and thereby extend the theatres of Brecht and Artaud.
4. Charles Marowitz, *The Act of Being* (London, 1978) p. 65.
5. *The Act of Being*, p. 66.
6. *The Marowitz Shakespeare* (London, 1978) is a collection of adaptations of *Hamlet, Macbeth, The Taming of the Shrew, Measure for Measure* and *The Merchant of Venice. An Othello* has been published in another volume, *Open Space Plays* (Harmondsworth, 1974).
7. Charles Marowitz, Introduction, *The Marowitz Hamlet and The Tragical History of Dr Faustus* (Harmondsworth, 1970) p. 10. The lengthy introduction to this volume is not included in *The Marowitz Shakespeare*.
8. Marowitz (1970) p. 23.
9. Marowitz (1970) p. 34.
10. Guido Almansi (1982) p. 97 describing the preface to the Marowitz *Hamlet* as a 'madcap piece' still sees it as 'a welcome change to the hair-raising list of solemn articles on the *Hamlet* problem, offering the widest possible range of contradictory interpretations expounded one after another as in a grave funeral procession'.
11. For a discussion of *Variations on The Merchant of Venice* see Chapter 4 above. For a discussion of his adaptation of *Measure for Measure* see Graham Nicholls, *Measure for Measure: Text and Performance* (London and Basingstoke, 1986) pp. 56–8, 64–9, 83–4. See also Scott (1982) pp. 61–78. For a brief discussion of *A Macbeth* see Almansi (1982).
12. Quotations from *The Shrew* are from *The Marowitz Shakespeare*, pp. 132–80.

13. 'Memo from Marowitz for Othello: False Hypotheses re Othello' in 'Charles Marowitz Directs An Othello', *Theatre Quarterly*, vol. II, no. 8, October–December 1972, p. 71. Reprinted in *The Act of Being*, pp. 163–96. I am greatly indebted to this account of the production. References to *An Othello* are from *Open Space Plays* (Harmondsworth, 1974) pp. 253–310.
14. Leslie Fiedler, *The Stranger in Shakespeare*, p. 145. Peter Davison, *Othello: the Critics Debate* (London and Basingstoke, in the press) usefully comments: 'I don't see how a contemporary audience in Britain, America, or a number of other countries, can fail to bring into the theatre attitudes derived from their own innate responses to race. . . . The marriage of a middle-aged black man and a young white girl must, then and now, touch sensitive nerves in black and white. The effects of four centuries of colonialism . . . might modify our responses but they perhaps do no more that stand surrogate for folk-play memories now lost to us'.
15. Almansi, p. 97.
16. Ibid., p. 97.
17. Introduction, *The Marowitz Shakespeare*, p. 13. Quotations from the *Collage Hamlet* are from this volume pp. 28–69.
18. Ibid., pp. 28–69. A brief discussion of the play can be found in Peter Davison, *Hamlet: Text and Performance* (London and Basingstoke, 1983) pp. 72–6. See also Cohn (1976) pp. 218–21.

CHAPTER 9: POSTSCRIPT

1. I am grateful to Professor M. L. Wine of the University of Illinois for sending me this article.
2. Alan Sinfield, 'Royal Shakespeare', in Dollimore and Sinfield (1985) pp. 178–9.
3. See Nigel Smith, 'Confining Canons', *English*, vol. XXXV, no. 151 (Spring 1986) p. 57. Reviewing Jonathan Dollimore, *Radical Tragedy, Religion, Ideology and Power in the Drama of Shakespeare and his Contemporaries* (Brighton, 1985), D. W. Pearson, *Seventeenth Century News* vol. XLIII, no. 3 (Autumn, 1985) p. 32, suggests 'Perhaps the author needs to consider that Marxist criticism, like idealist criticism and Christian humanism and providentialism and other perspectives, is still only another ideology'.
4. Dollimore and Sinfield (1985) p. viii.
5. Harriett Hawkins, *The Devil's Party Critical and Counter Interpretations of Shakespearean Drama* (Oxford, 1985) p. 121.
6. Ann Thompson, *King Lear: The Critics Debate* (London and Basingstoke, 1988) writes: 'This cut could have been justified on textual grounds . . . but as, Charles Marowitz, the assistant director, explained in "Lear Log" [*Tulane Drama Review*, 8, pp. 103–21, 1963] his detailed record of the production, it was done on this occasion "to remove the tint of sympathy usually found at the end of the blinding scene"'. Talking on LWT's *The South Bank Show* on 11 January 1987, devoted

to different productions of *King Lear*, Peter Brook however stated that his approach to Shakespearean production is essentially one deriving from the text, rather than imposing views on it. He stated that as a director he attempts to free his mind of preconceptions and allow the work to develop its own form of communication. I feel his *King Lear* was one of the most significant productions of the late twentieth century and that Brook has been too easily criticised. A useful volume which allows the directors to put their views is Ralph Berry, *On Directing Shakespeare* (London, 1977). Among the seven directors interviewed are Peter Brook, Trevor Nunn and Jonathan Miller.

7. Jan Kott (1967) p. 48.
8. John Barton (1984) p. 190.
9. Ian McKellen in John Barton (1984) pp. 191–2.
10. Trevor Nunn, Programme Note on the Late Plays of Shakespeare, Royal Shakespeare Company Season, 1969.
11. Ibid. For Nunn's thinking about this time see also 'Director in Interview Trevor Nunn talks to Peter Ansorge', *Plays and Players*, vol. 17, no. 12 (September 1970).
12. Sally Beauman, *The Royal Shakespeare Company: a History of Ten Decades* (Oxford, 1982) p. 291.
13. For a discussion of this production see Scott (1982), p. 40–6.
14. In the case of the RSC it is not merely a matter of economics their charter requires them largely to perform Shakespeare in the main Stratford theatre.
15. For a discussion of the way modern society processes Shakespeare see Terence Hawkes (1986).
16. Hawkins (1985) p. 118.
17. David Addenbrooke, *The Royal Shakespeare Company* (London, 1974) p. 171, quoting from the Nunn interview *Plays and Players* (September 1970) p. 17.

Production Dates of Principal Plays Discussed

Tom Stoppard, *Rosencrantz and Guildenstern are Dead*

First performed on 24 August 1966, directed by Brian Daubney for the Oxford Theatre Group at the Edinburgh Festival. Rosencrantz – David Marks, Guildenstern – Clive Cable.
First professional performance 11 April 1967, directed by Derek Goldby for the National Theater Company at the Old Vic Theatre, London. Rosencrantz – John Stride, Guildenstern – Edward Petherbridge.

Edward Bond, *Bingo*

First performed on 14 November 1973, directed by Jane Howell and John Dove, at the Northcott Theatre, Exeter. Shakespeare – Bob Peck.

Edward Bond, *Lear*

First performed on 29 September 1971, directed by William Gaskill for English Stage Company at the Royal Court Theatre, London. Lear – Harry Andrews.
The RSC production referred to in discussion was first performed on 18 June 1982, directed by Barry Kyle at The Other Place, Stratford-upon-Avon. Lear – Bob Peck.

Charles Marowitz, *Variations on The Merchant of Venice*

First performed on 17 May 1977, directed by Charles Marowitz at the Open Space Theatre, London. Shylock – Vladek Sheybal, Portia – Thelma Holt, Antonio – Barry Stanton.

Arnold Wesker, *The Merchant*

First performed on 8 October 1976, directed by Stephen Roos at the Royal Dramaten-theater, Stockholm.
English language première 16 November 1977, directed by John Dexter at the Plymouth Theatre, New York. Shylock – Joseph Leon, Antonio – John Clements.

Samuel Beckett, *En Attendant Godot–Waiting for Godot*

First performed 5 January 1953, directed by Roger Blin at Théâtre de

Babylone, Boulevard Raspail, Paris. Estragon – Pierre Latour, Vladimir – Lucien Raimbourg, Lucky – Jean Martin, Pozzo – Roger Blin, A Boy – Serge Lecointe.
British première 3 August 1955, directed by Peter Hall at the Arts Theatre, London. Vladimir – Paul Daneman, Estragon – Peter Woodthorpe, Pozzo – Peter Bull, Lucky – Timothy Bateson, A Boy – Michael Walker.

Samuel Beckett, *Fin de Partie* – *Endgame*

First performed in French on 3 April 1957, directed by Roger Blin at the Royal Court Theatre, London. Hamm – Roger Blin, Clov – Jean Martin, Nagg – Georges Adet, Nell – Christine Tsingos.
First produced in Beckett's English language translation on 28 October, 1958 at the Royal Court Theatre, London, directed by George Devine. Hamm – George Devine, Clov – Jack MacGowran.

Eugene Ionesco, *Le Roi se Meurt* – *Exit the King*

First performed 15 December 1962, directed by Jacques Mauclair at Théâtre de l'Alliance française à Paris. Berenger – Jacques Mauclair, Marguerite – Tsilla Chelton, Marie – Reine Courtois, Juliette – Rosette Zucchelli, Guard – Marcel Champel, Doctor – Marcel Cuvelier.
British première 12 September 1963, directed by George Devine for the English Stage Company at the Royal Court Theatre, London. Berenger – Alec Guiness, Marguerite – Googie Withers, Marie – Natasha Parry, Juliette – Eileen Aitkens, Guard – Peter Bayliss, Doctor – Graham Crowden.

Eugene Ionesco, *Macbett*

First performed 27 January 1972, directed by Jacques Mauclair at Le Théâtre de la Rive-Gauche, Paris. Macbett – Jacques Mauclair, Lady Duncan – Genevieve Fontanel, Candor – Marcel Champel, Glamiss – Roger Jacquet, Banco – Jacques Dannoville.
English language première 16 March 1973, directed in Charles Marowitz's translation by William Peters, John McAndrew, Alvin Epstein at the Yale Repertory Theatre, New Haven, Connecticut. Macbett – Alvin Epstein, Lady Duncan – Carmen de Lavallade, Candor – William Peters, Glamiss – John McAndrew, Banco – Stephen Joyce.

Harold Pinter, *The Homecoming*

First performed on 3 June 1965, directed by Peter Hall for the Royal Shakespeare Company at the Aldwych Theatre, London. Max – Paul Rogers, Lenny – Ian Holm, Ruth – Vivien Merchant.

Charles Marowitz, *The Shrew*

First performed on 18 October 1973, directed by Charles Marowitz at the

Hot Theatre, The Hague and subsequently at the Open Space Theatre, London. Kate – Thelma Holt, Petruchio – Nikolas Simmonds.

Charles Marowitz, *An Othello*

First performed on 8 June 1972, directed by Charles Marowitz at the Open Space Theatre, London. Othello – Rudolph Walker, Desdemona – Judy Geeson, Iago – Anton Phillips.

Charles Marowitz, *Collage Hamlet*

First version directed by Charles Marowitz and Peter Brook during the Theatre of Cruelty season at Lamda, 1963. Hamlet – Alexis Kanner. First performance of subsequent version 20 January 1965, directed by Charles Marowitz at the Akademie der Künst, Berlin. Hamlet – Alexis Kanner, Claudius – David Lloyd Meridith, Gertrude – Thelma Holt, Clown/Polonius – Anthony Hall; subsequent production at the Jeanetta Cochrane Theatre, London, 5 May 1966. Hamlet – Anthony Ainley, Claudius – Richard Mayes, Gertrude – Thelma Holt, Clown/Polonius – Bill Wallis.

Selected Bibliography

This selected bibliography lists works other than plays which have been referred to directly or indirectly. Texts of plays quoted are given in the notes and references and details are not repeated here unless reference has been made to introductory matter.

Addenbrooke, David, *The Royal Shakespeare Company* (London, 1974).

Almansi, Guido, 'The Thumb-Screwers and the Tongue Twisters', on Shakespearean Avators', *Poetics Today*, vol. 3, no. 3, pp. 87–100.

Ansorge, Peter, 'Director in Interview Trevor Nunn Talks to Peter Ansorge', *Plays and Players*, vol. 17, no. 12 (September, 1970).

Appleton, William W., *Charles Macklin an Actor's Life* (Cambridge, Mass. and London, 1961).

Appia, Adolphe, *Music and the Art of Theatre*, trans. Robert W. Corrigan and Mary Douglas Dirks, ed. B. Hewitt (Coral Cables, Florida, 1962).

Artaud, Antonin, *The Theatre and Its Double*, trans. Victor Corti (London, 1970).

Auden, W. H., *The Dyers Hand* (London, 1948).

Axton, Marie and Williams, Raymond (eds), *English Drama Forms and Development Essays in Honour of Muriel Clara Bradbrook* (Cambridge, 1977).

Barber, C. L., *Shakespeare's Festive Comedy: a Study of Dramatic Form in Relation to Social Custom* (Princeton, 1959).

Barton, John, *Playing Shakespeare* (London, 1984).

Beauman, Sally, *The Royal Shakespeare Company: a History of Ten Decades* (Oxford, 1982).

Belsey, Catherine, *Critical Practice* (London, 1980).

——, *The Subject of Tradedy. Identity and Difference in Renaissance Drama* (London and New York, 1985).

Berry, Ralph, *On Directing Shakespeare* (London, 1977).

——, *Shakespeare and the Awareness of the Audience* (London and Basingstoke, 1985).

Bigsby, C. W. E., *Tom Stoppard* (Harlow, Essex, 1976).

Bond, Edward, Author's Preface, *Lear*, (London, 1972).

——, Introduction, *Bingo* (London, 1974).

——, Introduction, *The Fool and We Come to the River* (London, 1976).

——, 'Drama and the Dialectics of Violence', *Theatre Quarterly*, vol. 2, no. 5 (1972) pp. 4–14.

——, 'The Rational Theatre', *Bond Plays Two* (London, 1978).

——, '*The Romans* and the Establishment's Figleaf', *Guardian*, 3 November 1980.

Bradbrook, M. C., *English Dramatic Form in the Old Drama and the New* (London, 1970).
Brassell, Tim, *Tom Stoppard An Assessment* (London and Basingstoke, 1985).
Braun, Edward (ed.), *Meyerhold on Theatre* (London, 1969).
Brockbank, Philip (ed.), *Players of Shakespeare: Essays in Shakespearean Performance by Twelve Players of the Royal Shakespeare Company* (Cambridge, 1985).
Brook, Peter, *The Empty Space* (Harmondsworth, 1972).
Brown, John Russell, 'Mr. Pinter's Shakespeare', *Critical Quarterly* vol. 5, no. 3 (1963).
——, 'Mr. Beckett's Shakespeare', *Critical Quarterly*, vol. 5, no. 4 (1963).
——, (ed.), *Modern British Dramatists* (Englewood Cliffs, NJ, 1968).
Burgess, John and Marowitz, Charles, 'Production Casebook No 8 Charles Marowitz Directs "An Othello"', *Theatre Quarterly*, vol. 2, no. 8 (1972) pp. 68–71.
Bull, John, *New British Political Dramatists* (London and Basingstoke, 1984).
Chambers, Colin, *Other Spaces: New Theatre and the R.S.C.* (London, 1980).
Coe, Richard N., *Ionesco: a Study of His Plays*, rev. edn. (London, 1971).
Cohn, Ruby, 'Beckett and Shakespeare', *Modern Drama*, vol. XV (1972–73) pp. 223–30.
——, *Currents in Contemporary Drama* (Bloomington and London, 1969).
——, *Modern Shakespeare Offshoots* (Princeton, 1976).
Cook, Ann Jennalie, *The Privileged Playgoers of Shakespeare's London 1576–1642* (Princeton, 1981).
Coult, Tony, *The Plays of Edward Bond*, rev. edn (London 1979).
Cox, C. B. and Palmer, D. J., *Shakespeare's Wide and Universal Stage* (Manchester, 1984).
Dark, Gregory, 'Production Casebook No 5 Edward Bond's Lear at the Royal Court rehearsal log by William Gaskill's assistant director', *Theatre Quarterly*, vol. 2, no. 5 (1972) pp. 20–31.
Davison, Peter, *Contemporary Drama and the Popular Dramatic Tradition in England* (London and Basingstoke, 1982).
——, *Hamlet: Text and Performance* (London and Basingstoke, 1983).
——, *Othello: the Critics Debate* (London and Basingstoke, in the press).
——, *Popular Appeal in English Drama to 1850* (London and Basingstoke, 1982).
Dollimore, J., *Radical Tragedy Religion, Ideology and Power in the Drama of Shakespeare and His Contemporaries* (Brighton, 1984).
Dollimore, J. and Sinfield, A. (eds), *Political Shakespeare: New Essays in Cultural Materialism* (Manchester, 1985).
Drakakis, John (ed.), *Alternative Shakespeares* (London, 1985).
Elam, Keir, *The Semiotics of Theatre and Drama* (London and New York, 1980).
Esslin, Martin, *Pinter the Playwright* (London, 1982).
Fiedler, Leslie, *The Stranger in Shakespeare* (Frogmore, St Albans, 1974).
Findlater, Richard, *The Player Kings*, 2nd edn (London, 1971).
Fletcher, John and Spurling, John, *Beckett: a Study of His Plays*, 2nd edn (London, 1978).
French, Marilyn, *Shakespeare's Division of Experience* (London, 1982).

Frye, Northrop, *A Natural Perspective: the Development of Shakespearean Comedy and Romance* (New York, 1965).
——, *Anatomy of Criticism* (Princeton, 1977).
Goffman, Erving, *Frame Analysis* (Harmondsworth, 1975).
Gordon, Giles, 'Tom Stoppard', *Transatlantic Review*, vol. 29, 1968.
Gurr, Andrew, *Playgoing in Shakespeare's London* (Cambridge, 1987).
Gussow, Mel, 'A Conversation with Harold Pinter', *New York Times Magazine*, 5 December, 1971.
Harbage, Alfred, *Shakespeare and the Rival Traditions* (1952 repr. Ontario, 1970).
Hay, Malcolm and Roberts, Philip, *Bond: a Study of His Plays* (London, 1980).
Hawkes, Terence, *That Shakespeherian Rag: Essays on a Critical Process* (London, 1986).
——, *Shakespeare's Talking Animals: Language and Drama in Society* (London, 1973).
Hawkins, Harriett, *The Devil's Party. 'Critical and Counter Interpretations of Shakespearean Drama* (Oxford, 1985).
Hayman, Ronald, *Artaud and After* (Oxford, 1977).
——, *Theatre and Anti-Theatre: New Movements Since Beckett* (London, 1979).
——, *Tom Stoppard* (London, 1977).
Hinchliffe, Arnold P., *British Theatre 1950/70* (Oxford, 1974).
——, *Volpone: Text and Performance* (London and Basingstoke, 1985).
Hirst, David L., *Edward Bond* (London and Basingstoke, 1985).
Honigmann, E. A. J., *Shakespeare: the Lost Years* (Manchester, 1985).
Hughes, Alan, *Henry Irving, Shakespearean* (Cambridge, 1981).
Hunter, Jim, *Tom Stoppard's Plays* (London, 1982).
Ionesco, Eugene, *Notes and Counter Notes*, trans. D. Watson (London, 1964).
——, 'Why Do I Write?', *Plays*, vol. XI, trans. D. Watson and C. Williams (London, 1979).
Jones, Emrys, *Scenic Form in Shakespeare* (Oxford, 1971).
Knight, G. Wilson, *The Wheel of Fire*, rev. ed. (London, 1949).
Kott, Jan, *Shakespeare Our Contemporary*, rev. ed. (London, 1967).
Lamont, Rosette C., 'From *Macbeth* to *Macbett*', *Modern Drama*, vol. XV (December, 1975) pp. 231–53.
Leach, E. R., 'Rethinking Anthropology', *London School of Economics Monographs on Social Anthropology*, no. 22 (London, 1961).
Lelyveld, Toby, *Shylock on the Stage* (London, 1961).
Marowitz, Charles, *Confessions of a Counterfeit Critic: a London Theatre Notebook 1958–1971* (London, 1973).
——, *The Act of Being* (London, 1978).
——, Introduction, *The Marowitz Hamlet, the Tragical History of Dr Faustus* (Harmondsworth, 1970).
——, Introduction *The Marowitz Shakespeare* (London, 1978).
Mahood, M. M., *Shakespeare's Word Play* (London, 1957).
Muir, Kenneth, *The Sources of Shakespeare's Plays* (London, 1977).
Nicholls, Graham, *Measure for Measure: Text and Performance* (London and Basingstoke, 1986).

Odell, George C. D., *Shakespeare from Betterton to Irving*, 2 vols (1920; Dover edn, New York, 1966).
Overton, Bill, *The Merchant of Venice: Text and Performance* (London and Basingstoke, 1987).
Pinter, Harold, 'Between the Lines', *The Sunday Times*, 4 March, 1962.
——, 'Speech Hamburg', 1970, *Theatre Quarterly*, vol. 1, no. 3 (1971).
——, and Hern, Nicholas, 'A Play and Its Politics', *One for the Road* (London, 1985).
Quigley, Austin, *The Modern Stage and Other Worlds* (London, 1985).
Raby, David Ian, *British and Irish Political Drama in the Twentieth Century* (London and Basingstoke, 1986).
Salgādo, Gāmini, *Eyewitnesses of Shakespeare: First Hand Accounts of Performance 1590–1890* (London, 1975).
——, *King Lear: Text and Performance* (London and Basingstoke, 1984).
Salingar, Leo, 'Time and Art in Shakespeare's Romances', *Renaissance Drama* vol. 9 (1966) pp. 3–35.
Schanzer, Ernest, *The Problem Plays of Shakespeare* (London, 1963).
Schoenbaum, Samuel, *Shakespeare: a Documentary Life* (Oxford, 1975).
Scott, Michael, *Renaissance Drama and a Modern Audience* (London and Basingstoke, 1982, repr. 1985).
——, (ed.), *Harold Pinter: 'The Birthday Party', 'The Caretaker', 'The Homecoming': a Selection of Critical Essays* (London and Basingstoke, 1986).
Sinfield, Alan, '*King Lear* versus *Lear* at Stratford', *Critical Quarterly*, 24 (Winter 1982) pp. 5–14.
Smith, Nigel, 'Confirming Canons', *English* vol. XXXV, no. 151 (Spring 1986).
Sprague, A. C., *Shakespearean Players and Performances*, rpt. edn (New York, 1969).
Stoppard, Tom, 'Is It True What They Say About Shakespeare?, *International Shakespeare Association Occasional Paper*, no. 2 (Oxford, 1982).
Thompson, Ann, *King Lear: the Critics Debate* (London and Basingstoke 1988).
Trussler, Simon, *The Plays of Harold Pinter* (London, 1973).
Vickers, Brian, *Shakespeare: the Critical Heritage Vol 2 1693–1733* (London, 1974).
Weimann, Robert, *Shakespeare and the Popular Tradition in the Theater*, ed. R. Schwartz (Baltimore and London, 1978).
Wells, Stanley, *Literature and Drama with Special Reference to Shakespeare and His Contemporaries* (London, 1970).
Wesker, Arnold, Preface, *The Merchant* with Commentary and Notes by Glenda Leeming (London, 1983).
Whittaker, Thomas R., *Tom Stoppard* (London and Basingstoke, 1985).
Willett, John, *The Theatre of Bertolt Brecht*, rev. edn (London, 1977).
——, (ed.), *Brecht on Theatre* (London, 1965).
Wilson, Edwin (ed.), *Shaw on Shakespeare: an Anthology of Bernard Shaw's Writings on the Plays and Production of Shakespeare* (London, 1962).

Index